Written by Jamie Cardoso

CRAFTING 3D
PHOTOREALISM
Lighting Workflows in 3ds Max, mental ray and V-Ray

Written by Jamie Cardoso

CRAFTING 3D
PHOTOREALISM

Lighting Workflows in 3ds Max, mental ray and V-Ray

3dtotal
PUBLISHING

Contents

Project Files
To help you follow his tutorials and to perfect your lighting workflow, Jamie Cardoso has provided the relevant .max files, as well as textures for his interior and exterior scenes. So before you read on, please download these files to your desktop.

Where to Download
For all the files that you will need to follow this book, please visit: www.3dtotalpublishing.com. Go to the "Resources" section and there you will find information about how to download the files.

Correspondence: publishing@3dtotal.com

Website: www.3dtotalpublishing.com

First published in the United Kingdom, 2013, by 3DTotal Publishing

Paperback ISBN: 978-0-9568171-5-0

Printing & Binding

Everbest Printing (China)

www.everbest.com

Editor: Simon Morse

Sub-editor: Jo Hargreaves

Design and Creation: Christopher Perrins

Image Processing and Layout: Matthew Lewis

Visit www.3dtotalpublishing.com for a complete list of available book titles.

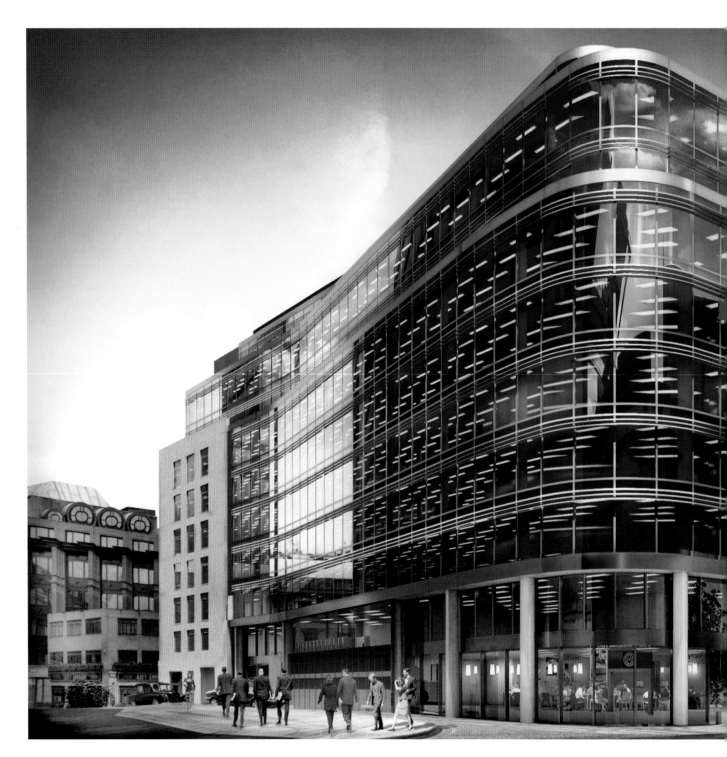

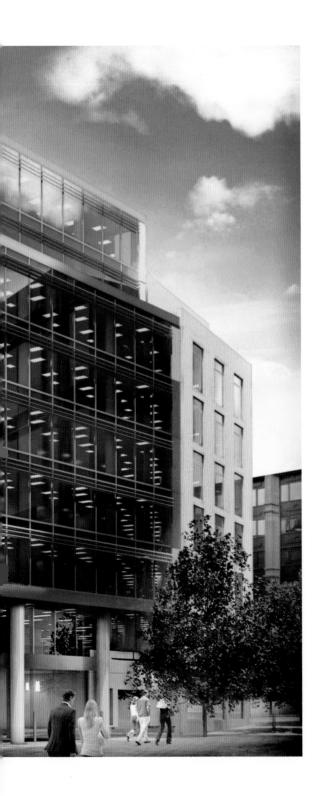

Preface

About This Book

This book is targeted at intermediate and advanced users who are interested in creating materials, shaders, lighting setups and renders that benefit from effective post-production using state of the art techniques that can be applied to real-life projects.

While 3ds Max, V-Ray and mental ray were chosen as the platform with which to demonstrate these techniques, most of the workflows covered in this book can easily be implemented using a variety of tools or render engines.

The book comprises of projects based on real-life scenarios. There will be two environments that will form the base of the tutorials; one is an exterior scene and the other an interior. Both of these scenes will be lit and developed for both daytime and nighttime, and the techniques described will be covered in V-Ray and mental ray.

Each scene and lighting scenario will be split into five tasks or sections, which will be described in detail. These sections will consist of information about pre-production, creating materials, lighting, and rendering and post-production using V-Ray, mental ray and Photoshop.

To open and render the resource scenes you will need a 64-bit version of 3ds Max 2010 or above, with V-Ray and mental ray installed. The minimum system requirements are 4GB of RAM and a 64-bit Windows operating system with an Intel Core i3 CPU with 2.40GHz.

Depending on the computer being used, some readers with old/ inappropriate graphics cards may experience viewport refresh sluggishness while going through the tutorials. To override this potential problem you are advised to use a professional graphics card. For more information about graphics card requirements, visit Autodesk's website.

Chapter 01

01//Introduction

V-Ray and mental ray are two of many rendering engines available that create a digital or raster graphics image by processing the data contained in a 3D scene. This complex and fascinating process is described as "rendering".

In a nutshell, a raster graphics image is a collection of dots of color that make an image (i.e., a dot matrix data structure in a rectangular grid of pixels), which is viewable on a monitor or other display platforms.

Both V-Ray and mental ray rendering engines are capable of producing stunning results while deploying rendering "approximation techniques", that are faster to compute, or more physically accurate approaches (e.g., unbiased). Physically accurate rendering results are technically easier to setup; however, the rendering times are much higher. It is very rare for an art director to choose the unbiased approach in a real production environment.

With the current trend of clients expecting faster and better results, it's common practice for production companies to use optimized "approximation techniques", which are visually correct, but not physically accurate.

All the V-Ray and mental ray step-by-step tutorials in this book are based on visually correct "approximation techniques" that are frequently used by most production companies. Later chapters, however, will demonstrate how to quickly enable the unbiased (i.e., Brute Force) rendering mode with V-Ray and mental ray. Users are encouraged to also implement this rendering mode if desired. As mentioned earlier, using this approach will mean that rendering times will skyrocket.

V-Ray or mental ray?

For a number of years there has been an increasing rivalry amongst users working with one or the other rendering engine. Years ago, mental ray dominated the rendering market for movies, games and the visualization industry. Then V-Ray came along and took the industry by storm. This was mostly attributed to the lack of user support from mental ray and other competing rendering engines.

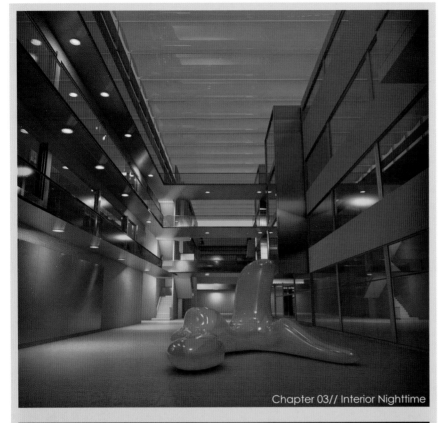

Chapter 03// Interior Nighttime

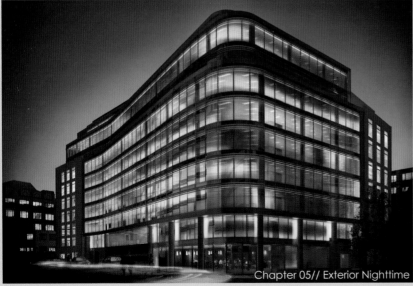

Chapter 05// Exterior Nighttime

In 2009 mental ray made huge improvements on its interface and performance. In addition, they also introduced the revolutionary Arch & Design feature and other user-friendly shaders. This bold move prevented many users from migrating to V-Ray. However, by this time a large number of users from the visualization industry had already adopted V-Ray into their rendering pipelines, even though mental ray was/is still free and integrated into 3ds Max.

V-Ray and mental ray have continued making huge software improvements since, which has divided the visualization rendering market, with most users working with either V-Ray or mental ray. Numerous companies also use multiple rendering engines in their pipeline, depending on what's required for a project.

In the current market it's highly recommended that users are fluent in both (and more) rendering engines in order to secure a variety of different projects. In fact, being knowledgeable of V-Ray, mental ray and other rendering engines will provide users with an array of skills and techniques that can be implemented across multiple rendering engines and platforms.

02//Production Overview

Pre-Production

Most production companies consider the pre-production phase to be one of the most crucial stages of the entire process, and this is true as it's the stage where the client and the studio/user are required to iron out important issues.

Budget and Scope of Work

The budget allocated by the client will set the tone of the entire project. Through drawings and the client's brief, the studio/user will then determine what's achievable within the allocated time and budget. Being able to manage expectations is one of many traits a studio/user should possess.

Art Direction and Composition

While managing the client's expectations, the studio/user should discuss key aspects of the final output. The final art direction is usually signed off when you have followed the client's brief and supplied photographs to the client, which are similar to the ones they supplied as a base for the project. These photos will help provide reference points for: camera position(s), lighting, contrast, materials, effects, etc.

Photo references can be obtained by taking personal photos, or through books, Google, Flickr, etc. Studios/users often present these references through mood boards for the client to choose from. Signing off the art direction early will later prove invaluable.

While changes are always inevitable towards the end of a project, it's always good practice to try to reduce such possibilities (Fig.01).

03 Furthermore, users/studios also use the pre-production phase to sign off the camera position and the composition.

The camera position is quite important to sign off on at this early stage to avoid concentrating on unnecessary areas of the scene when modeling, lighting and texturing. Having the camera position signed off will also help establish the composition.

If the 3D model is not complete at this stage, users would normally help the client sketch out the proposed view(s) on a 2D drawing first, followed by creating a draft model of the areas where the potential camera(s) will be positioned. It's also common practise to place the camera(s) at eye level (e.g., 1.60m to 1.70m) (Fig.02). This rule of thumb will help make the composition more believable and facilitate the integration of other elements in post.

04 In addition, the camera's field of view (FOV) and the Output Size parameters should be tweaked to capture the relevant areas of the scene (Fig.03 – 04).

There may be exceptions when cameras are required to be in unconventional positions such as isometric views, etc. However, in general most 3D camera parameters should reflect commonly used settings and positions. The pre-production photo references should also aid the users to achieve that.

During the process of signing off the art direction and the composition, the studio/user should liaise with the client while positioning featured items within the camera composition (e.g., foreground, middle ground and background).

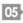

Some users also take this opportunity to add elements to images in Photoshop (e.g., photos, notes, sketches) and other effects on screen grabs or draft renders of the chosen camera viewport. This is to create an artist's impression or a collage in Photoshop (Fig.05 – 06).

This entire process is designed to help the client quickly understand and preview the impact of their design choices and the art direction before they enter the production phase.

While liaising with the client, you can suggest new ideas and effects such as:

- Subtle surface discrepancies
- Lens flares
- Dynamic camera positions
- Depth of field (it is mostly relevant when there are objects in the foreground)
- Glow
- Vignette
- Chromatic aberration (this is one of many effects that you should not mention to the client, but simply add in a very subtle manner).

Resources and Technical Approach

Once the art direction and the camera(s) have been agreed upon, the following task is to quickly evaluate the resources available and choose the best technical approach to execute the project. Later chapters provide an array of techniques frequently implemented by most reputable companies.

Preparation

Prior to entering the production phase it's important to always adopt the file's unit scale

05

06
Photo References for Finishes and Light

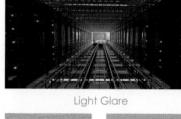
Light Glare

Glass Material

Roof and Stone Material

Roof Light Material

Metal Material

when opening a new file. This will prevent scenes from being rescaled and looking inaccurate.

Once the original settings have been accepted, you can begin inspecting the scene for possible discrepancies. However, there are only a handful of exceptions when you might be required to choose the Rescale the File Objects to the System Unit Scale option. It only happens when the incoming file is not accurate and requires rescaling. You should also use the same approach for incoming gamma settings (Fig.07).

Before importing 2D drawings (DWGs) into 3ds Max, it's important to ensure you have the original 2D drawing completely cleaned/

stripped from AutoCAD or micro station (i.e., omit unnecessary text and other layers). This action will reduce the incoming file size when imported into Max.

Drawings are often created far away from the 0.0.0 point, therefore 3ds Max and most of the other 3D applications will have difficulty displaying/representing lines or objects accurately at such distances. Therefore, it's imperative to reposition the drawings as close to the 0.0.0 point as possible, prior to importing them.

One of the most popular techniques used to reposition the drawings is to first create a dummy/point/line at the 0.0.0 point. Select the drawing layers from the file and move/

snap them onto the previously created dummy/point/line (at the 0.0.0 point). Once the drawings are close or at the 0.0.0 point, it's important to save the file out under a different name to prevent the original file being overwritten.

Before importing the CAD file into Max, ensure that you bind all files in AutoCAD. To bind Xreferenced files, simply type in Xref to enable its dialog box. In the dialog box select the relevant file(s) and right-click to enable its pop-up list. The pop-up list should give you the option to click on the Bind function, or not. In some cases you may be required to explode objects in AutoCAD in order to ensure that specific objects/lines are imported, and without artifacts (Fig.08).

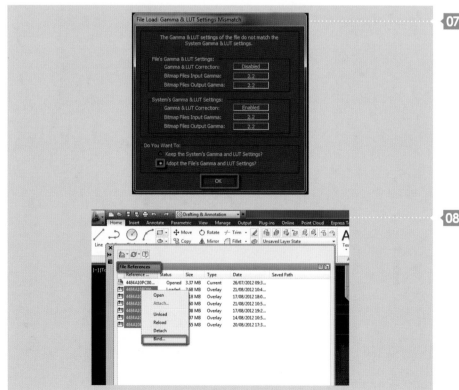

07 There are occasions when drawings will come with multiple elevations and sections. It unwise to import a file like this into 3ds Max. The best approach to working with a file like this is to first use the Rectangular selection tool and click and drag to select a specific area, followed by pressing Ctrl + C to copy the selection. Create a new document by pressing Ctrl + N and paste the previously copied drawing in the new document by pressing Paste, O and the Enter button. Also double-click the middle mouse

08 button anywhere in the viewport.

Professionals often use MicroStation to select areas. They do this by selecting the Fence tool and drawing around the desired area. Once they have done this they type FF= to save out the drawing under a different name.

Note that by default, MicroStation is set to automatically save the file every time a change is made to the drawing. For this reason you will

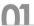

be required to Fence Save your work , prior to moving/snapping the drawings to the dummy line/point/object. It's also worth mentioning that a DGN (i.e., Microstation) file has to be saved as a DWG prior to being imported into 3ds Max.

It's also important to have the metric system setup (millimeters, meters, etc.,) as opposed to keeping the default system, which will be Generic Units.

Also you need to set the system to Respect System Units in Files. These two functions will prove vital when it comes to ensuring that incoming files are not disproportionate in size and/or are automatically re-scaled (Fig.09 – 10).

You should pay extra attention to the Model Scale group in the AutoCad DWG/DFX Import Options dialog box. The Incoming file units function should be left untouched. Simply enable or disable the Rescale function depending on the total value of the Resulting model size function.

The rule of thumb is to always choose the smaller metric value displayed on the Resulting model size text field.

The Curve steps values should be increased if the smooth curves of the incoming drawings are not accurate in the main 3D software. This function will essentially increase the number of vertices in these areas (Fig.11 – 12).

Positioning Your Image in the Scene

Once the drawing is imported into the scene, it's common practice to quickly check the dimensions of walls, stairs, chairs, etc. You can

Long metric value = incorrect

Smaller metric value = correct

do this with the Tape Helper. This precautionary measure is to ensure that the scale of the imported file is correct.

Doors are often 2.2m in height; chairs 400/600mm in width, etc (Fig.13). Some professionals find it easier to continuously switch the metric Display Unit Scale between meters, millimeters and centimeters, depending on the amount of value required to input (i.e., small values = millimeters, large values = meters).

Once the drawing is in the scene, select it in its entirety by first pressing the H key to open the Select From Scene dialog box, followed by clicking on the Select All button and OK to close the box. Alternatively you can press Ctrl + A to select all the objects in the scene. With all objects in the scene selected you can then group them (Fig.14). It is common practice to name the group in accordance to its original name (e.g., "2D_DWG_Level 1").

Some users also choose to create a layer under a similar name. However, the only drawback with doing this is the fact that all the drawing content will be combined into one single color, especially when using imported AutoCAD/ DWG data.

When naming the layer(s) for objects you should use names such as "3D_DWG_Ceiling...", etc. This is to ensure layers of relevance always stay on top of the list as they can easily be overlooked or lost among the other named layers.

Editing Layers

To edit, move or delete layers/folders, you have to select it/them from the dialog list first (e.g.,

highlight). To rename a layer/folder in the list, you will need to double-click it, followed by typing in the name.

Some studios find it easier to work with layers, due to their ease of use and flexibility to provide control over the contents in the scene. To create a layer, simply deselect all objects in the scene, and create a new empty layer in the dialog box. Alternatively, simply select an object(s) in the scene, followed by creating the layer thereafter by clicking on the Create New Layer button (Fig.15). This will ensure that the selected object is automatically added into the newly created layer.

When selecting an object in the scene and creating a new layer, the dialog box essentially adds/moves the selected object in the list into the newly created layer. It works almost like a folder that you can choose to select as a group, or to select individual objects from its content list to turn on/off, or to freeze, etc.

When a layer/folder is created and the objects are automatically moved into this newly created layer/folder, the main layer dialog box list will still retain the unused copies of the object's name(s) in the list. These unused names/layers can be found on the root of the dialog box or inside another layer/folder. It is also common practice to delete all unused layers/objects from the list in order to clean/tidy up the dialog box.

The layer under the name of 0 (default) is the default layer created automatically and should not be deleted (Fig.16). If you don't manually create a new layer/folder, most objects created in the scene will be automatically be added/moved into this default layer/folder. Although

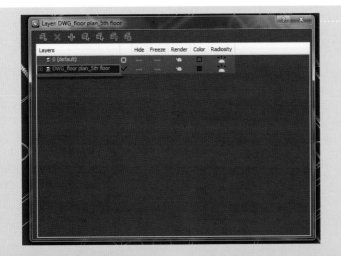

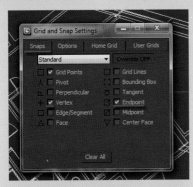

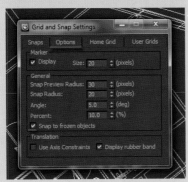

16 you can select and move the contents of this default layer/folder, you are unable to delete it even when it is empty.

As with all new layers/folders created by the user, you are able to select and move its content into a different layer/folder and delete the empty layer/folder thereafter. Only 3ds Max allows users to delete empty layers/folders.

The Snap Tool Setup

Before beginning to trace the drawing to create 3D objects, it is imperative that you set up the Snap tool correctly (Fig.17). Set the Snap tool's parameters and the toggle to 2.5 (2D). Since the **17** drawings are in 2D (e.g., splines), professionals usually change the Snaps toggle from the default 3 to 2.5, by simply left-clicking and holding down on the tool's icon in the main toolbar.

18

To quickly snap the splines while tracing the drawing you will need to change some key parameters. Right-click on the Snaps toggle icon in the main toolbar and its dialog box should pop up. Enable the Vertex and Endpoint functions (Fig.18). Also in the Options tab, enable the Snap to frozen objects function. This will ensure that even frozen drawings/splines can be traced and snapped onto (Fig.19).

19 ## Drawings on Different Planes

Some of you may be wondering why you don't simply extrude the 2D drawing in 3ds Max. Most drawings vertices are not welded (i.e., opened) and are often not drawn on the same plane/level. Therefore they are difficult to extrude as a whole, even when welding vertices globally with a target distance value. Welding the drawings manually often takes much longer than tracing them.

DWG plans are always more accurate than the elevations or sections. To ensure the elevations and sections line up with the plan(s), you should trace/draw the simplest area of the drawing plan(s) that is relevant to the section or elevation first. You can then extrude it and position the elevation or section to match this newly created object. You should use the same procedure to position all the following elevations and sections.

There will be many cases when the elevations or sections don't quite line up with the plans (Fig.20).

Creating a Grid Helper

The following steps are to create a grid by opening the Helpers command:

1: Select the Grid command and then drag the cursor across the top viewport (Fig.21).

2: Ensure that you choose the corner of the squarest part of the drawing, followed by snapping and dragging the cursor along the top viewport. Exit the creation by first releasing the mouse and then right-clicking.

3: Rotate and snap the grid to align it perfectly to the corner of the drawing. In some cases you may be required to set the Snap angle and the Percent function to a specific value in order to snap perfectly (Fig.22).

4: Once aligned perfectly, right-click on the selected grid and choose to activate the grid (Fig.23). Once the grid is activated choose the grid view top viewport by

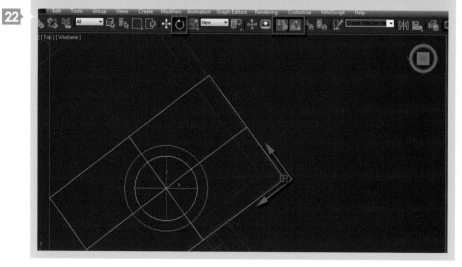

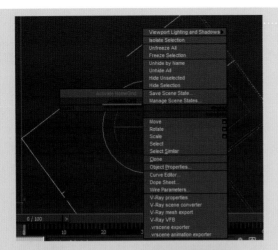

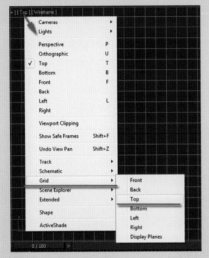

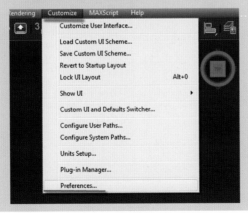

right-clicking on the top viewport text. In the drop-down list, select the Grid option followed by choosing the Top view (Fig.24). Please note that if you are using a newer version of Max then the way to access this tool may be different. For instance, in Max 2013 the user should click on the Top viewport > Extended Viewports > Grid.

The drawing should automatically rotate and position itself correctly. The Grid tool is the ideal solution when working with rotated drawings. This way you will not be required to rotate the drawing(s) individually.

Using the Grid Helper

The grid helper can be very useful when setting Max to automatically create objects at a certain height level (e.g., 2.5 m) without having to manually move the objects from the 0.0.0 point.

To do so, simply do the following:

1: Move the grid to the desired height level in the left or right viewport. Before moving/rotating the grid, ensure you deactivate it and set the view to Normal viewport first (not grid view).

2: Once you have finished moving and rotating the grid helper, simply activate it again. If you need to start tracing lines in the front viewport simply create a grid in the front viewport.

As drawings are produced in plans, elevations and sections, professionals often have to work with a variety of grid helpers, at different height levels, and in different viewports.

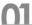
Zoom About Mouse Point

Another important feature to enable is the Zoom about Mouse Point (Orthographic) function. This will help you follow the mouse cursor whilst creating the spline (tracing) by occasionally pressing on the I and Z key. This technique is crucial when creating continuous splines across the viewport.

To enable it simply click on the Customize tab in the main toolbar. In the drop-down list, choose the Preferences option (Fig.25).

In the preferences dialog box, under the Mouse Control group, enable Zoom About Mouse Point (Orthographic). Please note that if you are using a newer version of Max, the way to access these functions may differ (Fig.26).

Creating a Freeze Shortcut

It is also important to set up a shortcut key to freeze selected objects. This is to ensure that even objects that are from opened groups can be frozen without you needing to close the group first. Professionals often resort to this shortcut key as it gives them better selection control of objects when working in dense and complex scenes.

To access this dialog box simply click on the Customize tab and choose the Customize User Interface option from the list. Its dialog box should open (Fig.27).

In the action list, scroll down to the Freeze Selection option. In the Hotkey function box, type in Ctrl + F and click Assign (Fig.28).

Please note that you are advised to save your personal custom keys (*.Kbd) in a secure and

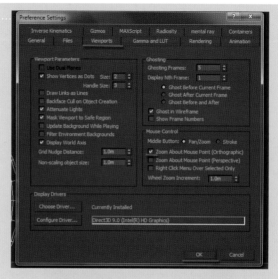

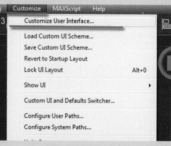

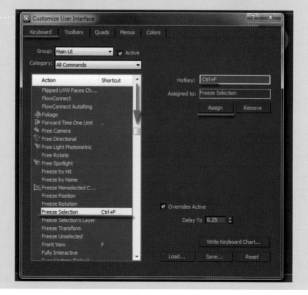

accessible location. This is to prevent losing them in the event of changing your computer or upgrading, etc.

Orbit Tool

It's important to set the viewport Orbit tool to rotate around the selected object. This function enables users to rotate the viewport around the axis of the selected object. These can also be saved (Fig.29).

Common Modify Buttons

3ds Max should be set to show the most commonly used Modify buttons such as Extrude, UVW Map, Editable Spline, Slice, Editable Poly, etc. Doing this will save users time as they will not have to constantly search and pick for commonly used modifiers from the drop-down list menu.

To customize and display the modifier buttons, simply click and hold the Configure Modifier Sets button and choose the same from the pop-up list (Fig.30).

In its dialog box, drag and drop your commonly used modifiers from the list into the Modifiers group buttons (Fig.31). Scroll down the list to pick other useful modifiers. These can also be saved by simply typing in on the Sets name field and clicking on the Save button.

Once you have finished, close the dialog box and set the Configure Modifier Sets to Show Buttons (Fig.32 – 33).

References and Details

While it's important to use photo references and drawings to help create convincing 3D models, you should concentrate mainly on detailing objects that are closer to the camera. Objects in the distance often look acceptable with a realistic texture and a good shader applied. It is also crucial to pay extra attention to scale relationships between objects by using 2D drawings or photos as reference points, as our eyes can inexplicably pinpoint scale discrepancies.

When creating and detailing models it is worth finding efficient ways of navigating in the viewport, by occasionally displaying the less relevant objects as boxes (Box Display mode) and/or hiding them when necessary. This technique will help speed up the viewport performance whilst navigating and creating geometry the 3D scene. Although not always necessary, creating proxies is also a great way of working and rendering efficiently.

Producing Realistic Textures

When textures are applied in a competent manner the 3D scene should look convincing or close to it, even before the lights and the indirect illumination have been implemented.

It's a common mistake for users to take high resolution photos of a small area of an object/surface, as opposed to high resolution photos of the entire object/surface, when taking a photo for a texture. If you do photograph your own textures and take the photos of small areas, it often means that you have to use

Photoshop to create the entire texture by tiling images. This methodology will subsequently cause the final texture to look artificial, tiled and will lack important details that make a texture look convincing and realistic.
To prevent this from occurring you should take high resolution photos of the entire object/surface desired, or take high resolution photos of an extensive area of the relevant object/surface. This approach will capture all the important details of the entire surface (scratches, dust, AO, subtle discrepancies, etc.,) without having to resort to using Photoshop to tile the image.

Lights and Indirect Illumination

When adding lights to the scene, always ensure you render each light created prior to creating the next one. Always create instanced artificial lights whenever possible, as it will help tweak the light parameters globally. In addition, ensure you have most of the lights separated to prevent the scene from becoming scorched. These precautionary steps will help control the overall brightness and depth of the scene. Scenes with enough contrast and depth are often more appealing and realistic.

While the soft shadows from artificial lights may increase the render times, they will also help make visuals more realistic. To offset this bottleneck some professionals opt to set only key artificial lights to cast soft shadows. The remaining lights in the scene will be turned on, but will be set to not cast shadows. This technique will reduce the rendering times by

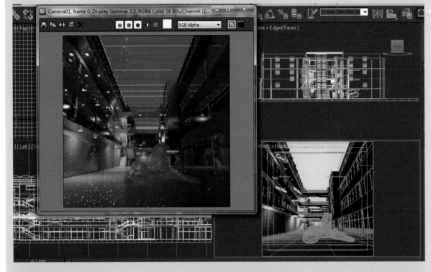

34 half, while maintaining the overall brightness and depth intact (Fig.34 – 35).

The color of lights always plays an important role in setting the mood in a scene. You can use the Color Picker tool to select colors from photo references you find particularly appealing, but in addition to this you should try to have a good idea of what makes certain colors and color combinations appealing (Fig.36).

35 Blue and yellow are always a good combination in architectural photography. The blue tones are often derived from the sky's color, and the yellow comes from the artificial lights. In CG terms you can easily mimic the yellow color by creating artificial lights and setting their color value to be the same as the photo reference.

A quick method of matching colors in a photo for a 3ds Max light is to use the Material Editor's Color Picker (sample screen color) to select the relevant part of a photo. The skylight color can be emulated by simply creating a Skylight object in the scene and setting its color value to match the photo reference. As in real life,

36 the blue tones will affect the indirectly lit areas of the scene the most. You should increase its value so it is high enough to be prominent against the yellow artificial light (Fig.37).

Test Renders

When you are test rendering, always use the fastest and most efficient techniques to reach the final rendering stage. Users frequently implement the following techniques:

1: Enable the Override material.

2: Hardware shading (if available).

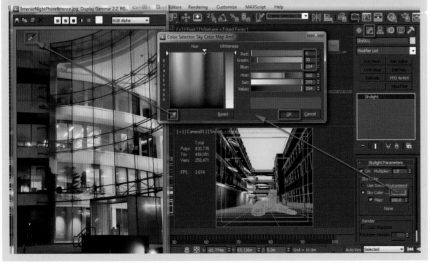

3: Use draft indirect illumination settings while test rendering.

4: Use draft image sampling settings and a small render output size while test rendering.

5: Cache the geometry (if possible).

6: Set up the correct camera Z-depth and the ambient occlusion element during the test rendering process.

7: Uncheck the Override material and the Render Elements, followed by carrying out more test renders.

Preparing for the Final Render

Once you are satisfied with the test render you should begin preparing the scene for the final render by doing the following:

1: Increase the indirect illumination settings and cache it.

2: Increase the render output size and the image sampling.

3: Carry out region renders on relevant areas of the scene by toggling the UI in the rendered frame buffer.

4: Tweak the shaders further (if necessary).

5: Enable and add key render elements.

6: Send the full size, high resolution render.

Post-Production

Post-production is the final step when transforming a good visual into an outstanding one. Prior to beginning work on the final render it's important to have the following documents in Photoshop or any post-production package:

1: The raw rendered file with its channels.

2: Key rendered elements such as the ambient occlusion, object IDs, raw reflections, raw refractions, etc.

3: The main reference previously sourced.

4: Photo elements/layers for effects such as light bloom, light glow, exquisite lens flare, light trails, film grain, etc.

5: People size screen grabs. Professionals often place boxes in the 3ds Max scene with the correct proportion (1.7 meters in height; 1.65 meters etc) and take a screen grab to be used for reference purposes only.

The screen grab should contain the boxes representing the height of people. These boxes should be placed where you think you will place the various cut-out photos of people. Prior to adding all of the cut-out people in Photoshop, you should scale the screen grab proportionally to fit the size of the raw rendered file (Fig.38).

37

38

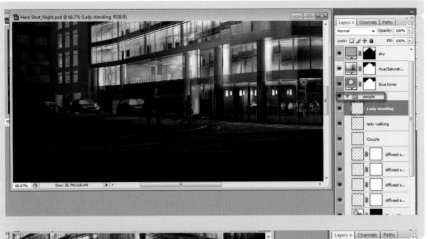

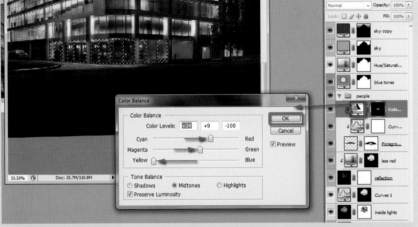

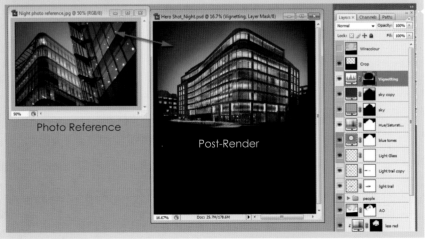

Photo Reference

Post-Render

Cut-Out People

39 It is common practice to be selective with the types of people you add in the visual, as this will help sell the design. Always choose people indulging in some kind of activity as opposed to just posing.

It's good practice to have very few people on their own, many people in groups and others interacting with the space.

40 Ensure that the light cast on people is coherent with the rendered image (no direct shadows cast on people in indirectly lit areas, or no diffused shadows on people in directly lit areas). The people should be color corrected to be integrated with the overall visual (Fig.39).

With all the layers, documents and references in place, you can begin touching up the visual to give it the wow factor while matching it meticulously with the photo reference.

For optimum color correction and depth results, professionals often use key tools such as Curves, Levels, Selective Color, etc. This is to help make the visual more appealing (Fig.40).

41 Although not always necessary, many professionals also use photographic effects/ artifacts such as Vignette, Chromatic Aberration, etc., to help the 3D visual resemble a photo more closely (Fig.41).

Conclusion

By using the described workflow it will ensure that you produce top quality renders consistently.

03//Creating Materials and Shaders in mental ray

The mental ray renderer is fully integrated with 3ds Max and equipped with a number of powerful proprietary shaders tailored to achieve realistic and unrealistic effects. Most of its default settings are very high and other settings are very low. While there's an array of materials available, we will focus mainly on Arch & Design and some of the mental ray legacy shaders.

To access and render any of the mental ray shaders you will need to load the mental ray renderer (Fig.01). This process will be described in more detail later in the book.

Diffuse Group

The first settings to discuss within Arch & Design are the Main material parameters and specifically the Diffuse group (Fig.02).

Diffuse Level: The Diffuse Level value adjusts the level of visibility of the color or texture applied to its toggle. A value of 1.0 will mean the texture or color will appear at full visibility. 0.0 will yield no color or texture. The default value is 1.0

Roughness: The Roughness value determines how coarse the diffuse surface should appear. A value of 0.0 creates a smooth/normal surface and a value of 1.0 will yield darker/coarse surfaces. Its toggle allows users to plug grayscale textures and/or procedural materials into it. When combined with the bump function it can help reinvigorate the surface of an item in your scene. The default value is 0.0 (Fig.03).

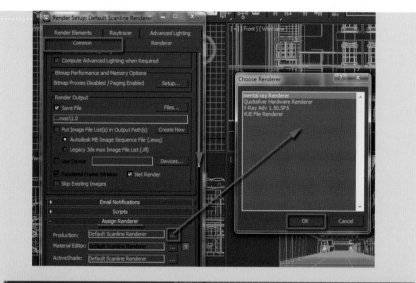

01

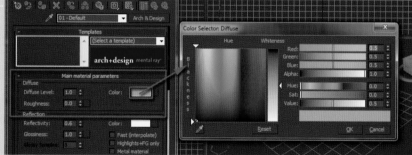

02

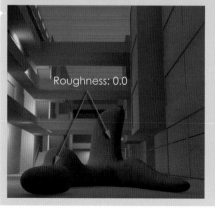
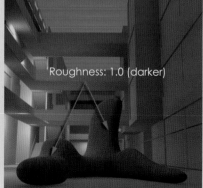

03

Roughness: 0.0

Roughness: 1.0 (darker)

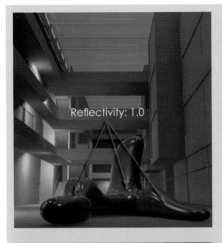

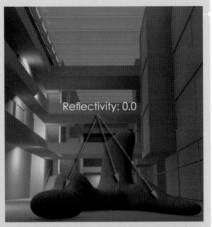

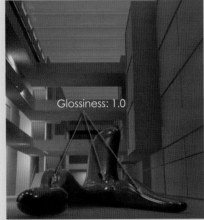

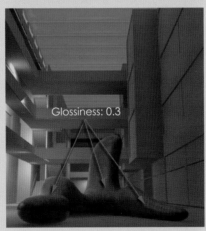

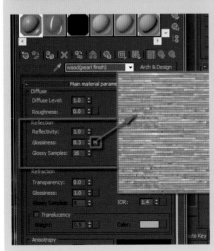

04

Color: This function's color swatch sets the appearance of the surface. Its toggle is used to load textures and/or other procedural maps. Users can also choose a variety of different colors by simply clicking and holding the color swatch.

Reflection Group

Reflectivity: This function determines the amount of reflectivity on the surface of your chosen item. A value of 1.0 will result in a fully reflective surface and 0.0 will yield the opposite results (Fig.04). The default value is 0.6.

05

Glossiness: This function determines the amount of blurriness in the reflections. A value of 1.0 will yield no blurriness and 0.0 will result in very blurry reflections. The default value is 1.0 (Fig.05). Its toggle allows you to use grayscale textures and/or procedural materials. This material/texture will override the numerical values (Fig.06).

06

Glossy Samples: This function only becomes available when the Glossiness values are reduced to less than 1.0. The default value is 8.0. You should only increase the default value when glossy artifacts are apparent as the rendering times will increase slightly.

Color: The color swatch is an alternative to adding values to the Reflectivity function. A white color is the equivalent of full reflectivity and black will yield the opposite results. You can also choose a variety of different colors by simply clicking and holding the color swatch. Alternatively its toggle can be used to load grayscale textures and/or other procedural maps.

Fast (interpolate): When turned on this function will help speed up the process of computing the reflections. However it will yield reflection artifacts. This function is turned off by default.

Highlights + FG only: When turned on this function will ignore the reflections and retain the glossy highlights. This option is quite useful to speed up the process of computing glossy reflections. It is disabled by default (Fig.07).

Metal material: When enabled, this function helps to reinvigorate the main diffuse color or texture, especially when reflections are overwhelming the surface. The function is disabled by default (Fig.08 – 09).

Refraction Group

Transparency: This function determines the visibility of a surface. The default value of 0.0 will yield a fully opaque surface and a value of 1.0 will result in a fully transparent surface (Fig.10 – 11).

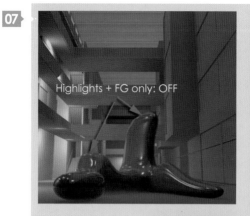
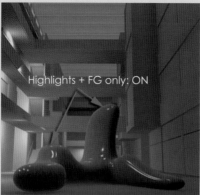

Highlights + FG only: OFF

Highlights + FG only: ON

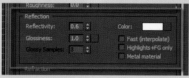

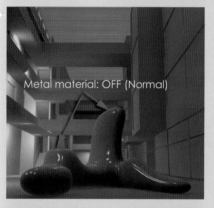
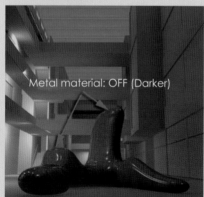

Metal material: OFF (Normal)

Metal material: OFF (Darker)

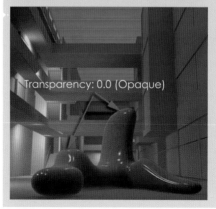
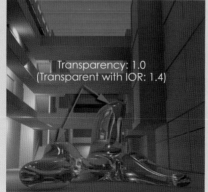

Transparency: 0.0 (Opaque)

Transparency: 1.0
(Transparent with IOR: 1.4)

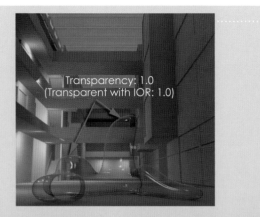

Transparency: 1.0
(Transparent with IOR: 1.0)

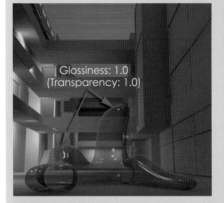

Glossiness: 1.0
(Transparency: 1.0)

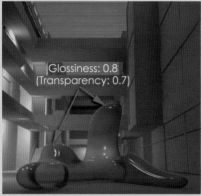

Glossiness: 0.8
(Transparency: 0.7)

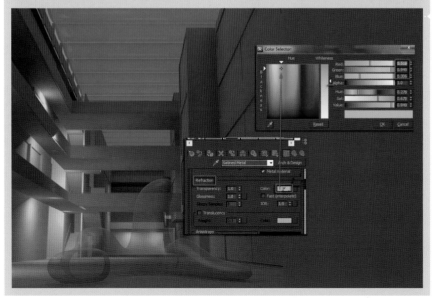

Glossiness: This function determines the blurriness of the transparency. The default value of 1.0 is equal to no blurriness or transparency and 0.0 will result in a very blurry transparency (like frosted glass). Please note that lower values will result in longer rendering times. For visible Glossiness results, the Transparency value needs to be less than 1.0 (Fig.12).

Glossy Samples: This function only becomes available when the Glossiness values are reduced to less than 1.0. The default value is 8.0. You should only increase the default values when glossy artifacts are apparent as the rendering times will increase dramatically.

Color: This color swatch is an alternative to adding values to the Transparency function. The default white color is equivalent to a fully opaque surface and black will yield the opposite results. You can also choose a variety of different colors to set the glass color by simply clicking and holding the color swatch (Fig.13). Alternatively its toggle can also be used to load grayscale textures and/or other procedural maps.

Fast (interpolate): When on, this function will help speed up the rendering process of the Glossiness values. However, it may create glossy artifacts. The function is turned off by default.

IOR: The Index Of Refraction function sets the amount of refractions on a surface. The default value is 1.4 (Fig.14). Alternatively its toggle can also be used to load grayscale textures and/ or other procedural maps. You can hover with the mouse on its value to see more information about this function (Fig.15 – 16).

Translucency: This function adds translucency to objects. The Weight value determines how much of the color should be seen through the main diffuse. Please note that it is imperative to also have the Thin-walled (can use single faces) function enabled when using the Translucency effect. It can be found under the Advanced Rendering Options rollout in the Advanced Transparency Options group (Fig.17 – 18).

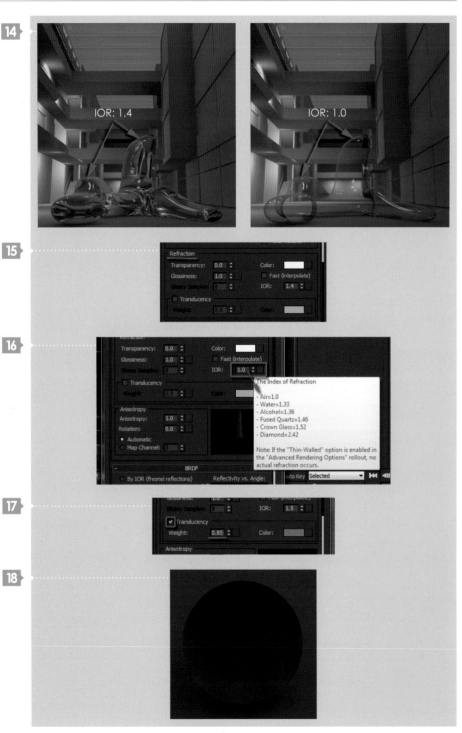

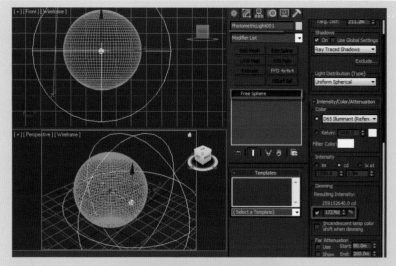

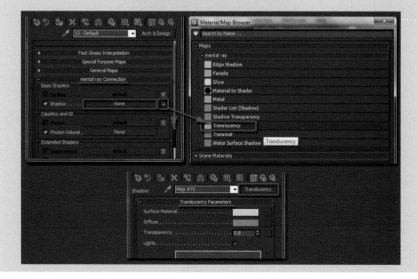

If there are lights in the scene, it also controls the amount of light coming through (more weight = less light through, less weight = more light through) (Fig.19 – 20).

In addition to enabling the Translucency function to create translucency similar to a curtains or leaves, you are advised to also scroll down to the mental ray Connection rollout, unlock the Shadow toggle and plug in the Translucency shader from the Material/Map Browser list (Fig.21).

Surface Material: This function refers to the surface facing the light source directly. It allows users to plug in textures/procedural maps, or simply use its color swatch.

Diffuse: This function refers to the side facing the light source indirectly (backlit). It allows users to plug in textures/procedural maps to it, or simply use its color swatch.

Transparency: This function controls how much of the Diffuse surface will be see-through (low values = less diffuse and high values = more diffuse). This also allows users to plug textures/procedural maps into it, or simply use its color swatch (Fig.22).

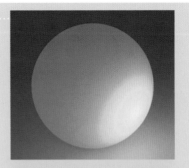

Anisotropy Group

Anisotropy: This function determines how stretched the highlights and the reflections will be (Fig.23). Lower values will yield more stretched results. The default value is 1.0. Alternatively its toggle can also be used to load grayscale textures and/or other procedural maps (Fig.24).

Rotation: This function determines the rotation angle of the anisotropy. The default value is 0.0. Also its toggle can be used to load grayscale textures and/or other procedural maps

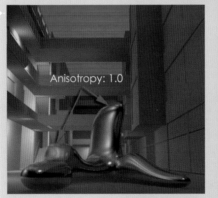

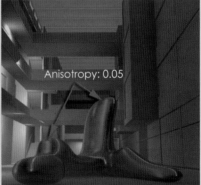

Automatic: This function automatically calculates the anisotropy angle. It is turned on by default.

Map Channel: When enabled and when the user chooses to load a grayscale texture and/or other procedural maps, the anisotropy comes from the U direction. It's disabled by default.

BRDF Rollout

By IOR (Fresnel reflections): When enabled, the reflections are automatically calculated based on the IOR and the angle. This function is disabled by default.

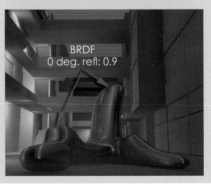

Custom Reflectivity Function > 0 deg. refl: This function determines the amount of reflectivity on the surface when parallel to the viewer/camera (0.0 degrees). Higher values will yield more reflectivity. The default is 0.2 (Fig.25).

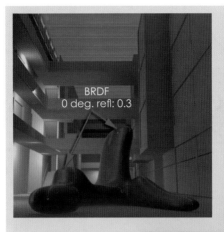

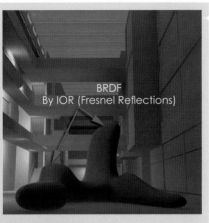

BRDF
0 deg. refl: 0.3

BRDF
By IOR (Fresnel Reflections)

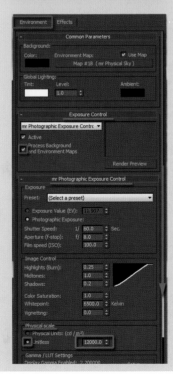

90 deg. refl: This function determines the reflectivity of the surface perpendicular to the viewer (90.0 degrees). The default value is 1.0.

Curve shape: This function allows users to tweak the reflectivity curve (Fig.26 – 27).

Self Illumination (Glow) Rollout

Color: This function allows you to choose from a range of pre-set common lamp specifications.

Color > Kelvin: This function allows you to type in numerical values assigned to color temperature. The default value is 6500.00 (Fig.28). Search online for more information about color temperature values.

Filter: This function allows you to manually pick a color by clicking and holding down on its color swatch.

Luminance Group > Physical Units: (cd/ m2): This function determines the brightness in candelas (cd) per square meter (m2). The default value is 1500.0. This function often yields inaccurate results, especially on reflections (Fig.29).

Unitless: This function is recommended for most scenes as it allows users to enter a numerical value. For optimum results it's better used in conjunction with the Physical scale from the Environment and Effects dialog box. The Physical scale group should be set to Unitless and have a value of 80000 or higher. I find that 120000 works for me.

Glow options > Visible in Reflections: When enabled, this function allows the glow to be visible in reflections. If the Luminance parameters are not set properly, as discussed

earlier, the glow reflections will yield artifacts. This function is enabled by default.

Illuminates the Scene (when using FG):
When enabled, this function uses the glow in conjunction with the Final Gather to illuminate the scene. It's disabled by default. Please note that it works better with physical lights in the scene and with FG interpolation set higher than 30.

Special Effects Rollout

Ambient Occlusion > Samples: If enabled, Ambient Occlusion adds connecting shadows when another object touches this material. It's worth noting that it's only visible on indirectly lit areas. The Samples function helps define the smoothness of the Ambient Occlusion (connecting shadows). The default value is 16. Higher values will yield smoother results at the cost of higher rendering times.

Max Distance: This function determines the distance/radius of the Ambient Occlusion (connecting shadows). Depending on your hardware, the results are only visible at render time. The default value is set to 100 millimeters (Fig.30 – 31).

Use Color From Other Materials (Exact AO):
By default the Ambient Occlusion color is gray/black. When this function is enabled, it uses the color of the touching material/object as the color for the main connecting shadows (Fig.32).

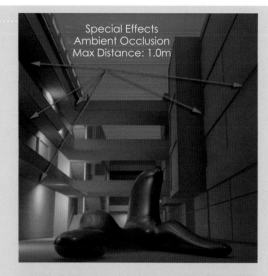

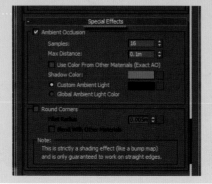

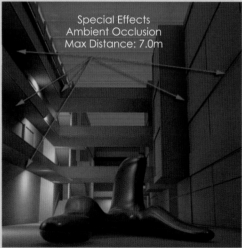

Shadow Color: This function determines the main color of the AO. The default color is gray, however for more visible results you can use darker colors (R: 0.0, G: 0.0, B: 0.0). To change it simply click and hold down on its color swatch or use the toggle to plug in a custom material.

Custom Ambient Light: This function uses its default color swatch (black) to compute the ambient light. To change it, simply click and hold down on its color swatch or use the toggle to plug in a custom material.

Global Ambient Light Color: This function uses the Environment dialog box light color.

Round Corners > Fillet Radius: When enabled, this function bevels the material according to the values entered. To determine the correct value to enter, simply create a chamfer box from the Extended Primitives command panel and tweak its Fillet values. This chamfer box should be of similar scale to the object using the round corners function. The above technique is mainly used when the fillet radius results are visible at render time only (similar to the bump values). The default value is 5mm (Fig.33 – 34).

Blend with Other Materials: This function blends/melts the fillet radius with other touching objects. This option is quite useful when demonstrating inverted round corners, which are often apparent on the corners of walls made of plasterboard, etc.

Advanced Rendering Options Rollout

Reflections > Max Distance: This function will limit the reflections according to the value entered.

Fade to end color: When enabled, the reflection will fade to the color depicted in the color swatch (gray), otherwise it will use the environment color to fade the reflection. It's disabled by default.

Max Trace Depth: This function determines the accuracy of the reflections. Low values will yield artifacts in the reflections and very high values may result in slow rendering times. The default value is 4.

Cutoff Threshold: This function determines the level at which the reflections will begin to be optimized. The default value is 0.01.

Refraction > Max Distance: When enabled, this function will limit the refractions according to the value entered (Fig.35).

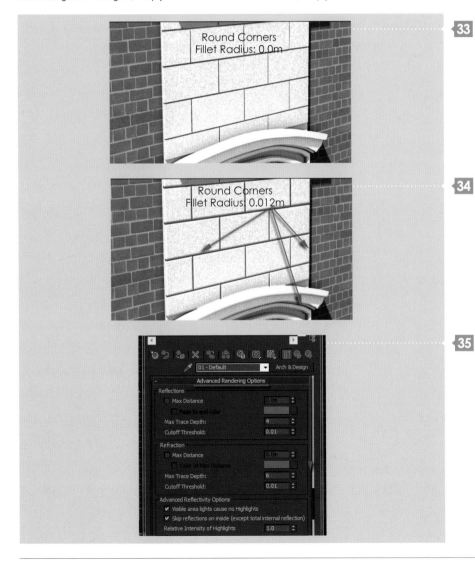

Color at Max Distance: When enabled, the refraction will fade to the color depicted on the color swatch (gray), otherwise it will use the environment color to fade the refraction.

Max Trace Depth: This function determines the accuracy of the refractions. Low values will yield artifacts and very high values may result in slow rendering times.

Cutoff Threshold: This function determines the level at which the refractions will begin to be optimized. The default value is 0.01.

Advanced Reflectivity Options > Visible area lights cause no Highlights: This function allows only the area light intensity to be visible on reflections, not the light model itself. If disabled, the light model will also be visible, subsequently doubling the highlight's intensity on the reflection.

Skip reflections on inside (except total internal reflection): This function bypasses the computation of internal reflections of a surface (which are often minor), resulting in a much faster render time.

Relative Intensity of Highlights: This function helps to reiterate reflected highlights of the environment on a surface. A number of professionals increase its default value on objects such as metal, etc., to help make the material more appealing (Fig.36 – 37).

Advanced Transparency Options > Solid (requires two sides on every object): This function takes into consideration multiple faces of an object when computing transparency and reflections. It is enabled by default. Do not use this function when rendering a single face object, as you will waste time rendering multiple faces unnecessarily.

Thin-walled (can use single faces): This function is specifically designed to render single face objects faster (e.g., office glass window). When this is enabled, it disables the IOR and the translucency functions.

Refract light and generate Caustic effects: When enabled, and in conjunction with the Caustics function, this option allows a transparent object to refract light and create caustics.

Use Transparent Shadows: This function allows the light to pass through a transparent object and cast transparent shadows containing some of the object's physical color. It's very important that users enable this function on transparent objects.

Back Face Culling: This function is quite useful when you need to fix problems on geometry

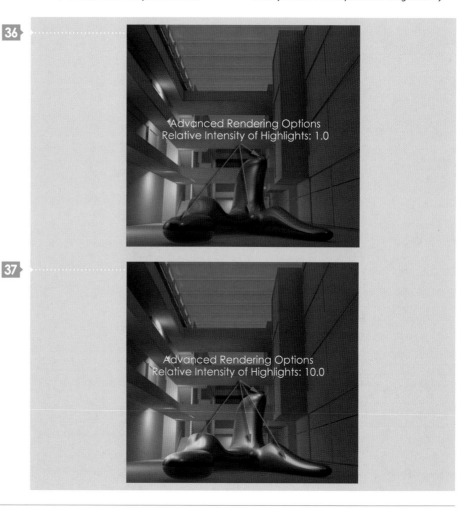

36

37

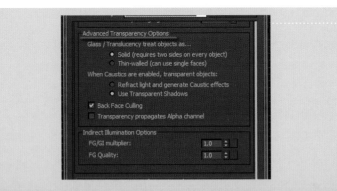

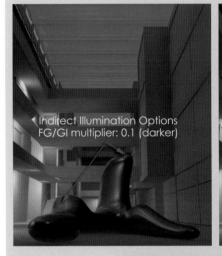

Indirect Illumination Options
FG/GI multiplier: 0.1 (darker)

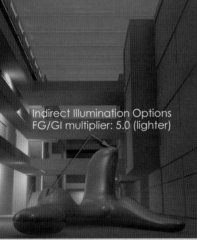

Indirect Illumination Options
FG/GI multiplier: 5.0 (lighter)

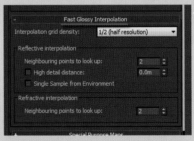

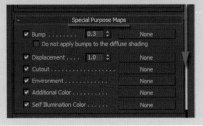

38 faces. For instance, it turns inward faces of an object visible when seen from the outside.

Transparency propagates Alpha channel:
When saving alpha channels on final renders, this function can be useful to capture refractions and the transparency levels of the material (Fig.38).

39 **Indirect Illumination Options > FG/GI multiplier**: This function is quite useful to control the properties of a material. Some professionals use it to control the contrast of an object (darker/lighter) in indirectly lit areas, with the help of Final Gather. High values will result in a brighter object and low values will yield the opposite results. The default value is 1.0 (Fig.39).

FG Quality: This function determines the FG quality in indirectly lit areas of an object.

Fast Glossy Interpolation Rollout

Interpolation grid density: This function helps control the quality of the glossy reflections.
40 The default value of 1/2 (half resolution) may yield draft results. Settings such as 1 (same as rendering) or higher will yield smoother results at the cost of slower rendering times (Fig.40).

Special Purpose Maps Rollout

Bump: This function allows you to set the bump values and plug a grayscale texture into its toggle. Alternatively, you can also use
41 procedural maps (Fig.41).

Do not apply bumps to the diffuse shading: When enabled, this function doesn't affect the basic diffuse shading, only the reflection and refraction.

Displacement: This function allows you to set the displacement values and plug a grayscale texture into its toggle. Alternatively, you can also use procedural maps (Fig.42). For acceptable displacement results, you are advised to create objects/geometry with a certain degree of density (segments).

Cutout: This function uses black/white textures or procedural maps to cut through a surface. Black represents the cut out/transparent areas and white represents the opaque areas. You can invert colors using the Invert function in the bitmap Output rollout (Fig.43 – 46).

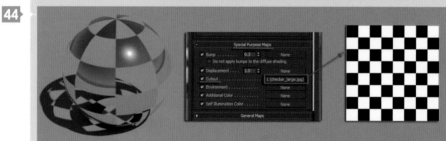

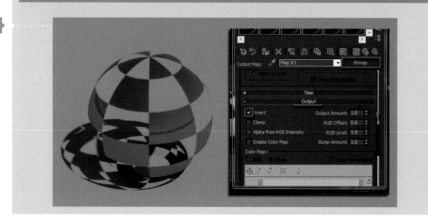

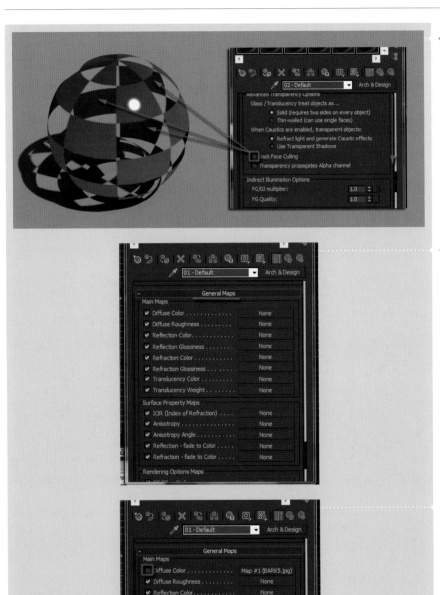

46 **Environment**: This function allows you to plug in an environment map to affect the material only.

Additional Color: This function allows you to plug in an additional color to the main surface.

Self Illumination Color: This function allows users to plug in an extra self illumination color to the surface.

General Maps Rollout

47 This rollout allows you to enable or disable the toggles associated with each listed function. When a toggle is disabled, the uppercase letter M will automatically become lowercase. Some of the preset material templates have the Diffuse toggle disabled and its value reduced (Fig.47 – 49).

48

49

mental ray Connection Rollout

The mental ray connection rollout allows you to connect additional shaders to a list of different shaders. To use any of them, you are required to unlock the padlock button by simply clicking on its button. You can also click on its toggle to plug in textures, procedural maps and/or shaders (Fig.50 – 51).

Advanced Shaders > Contour: Contour is one of the mental ray connection shaders that is used by many artists. The most popular contour shader used is Contour Simple (Fig.52 – 53). Its parameters are self-explanatory.

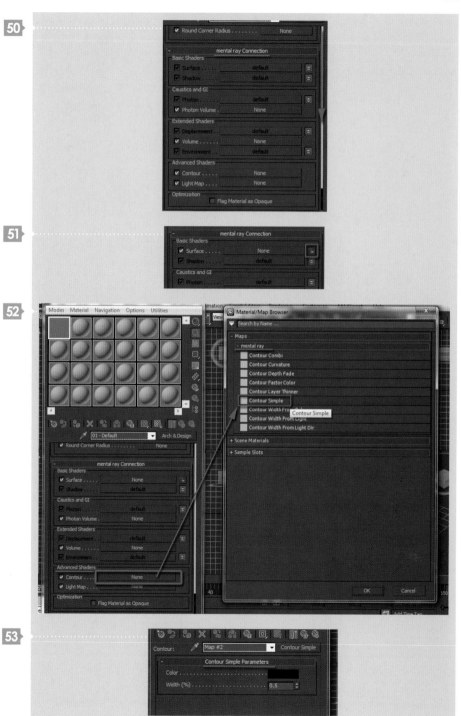

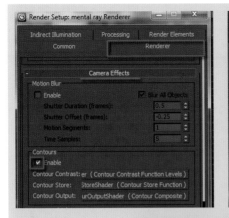

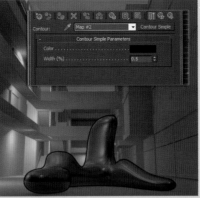

 In order to have the contour effect in the render, you will be required to enable the Contours function. To access it, simply open the Render Setup dialog box (F10). In the Renderer tab, scroll down to the Camera Effects rollout and enable the Contours function (Fig.54).

Arch & Design Templates Overview

Most Arch & Design templates have been created to help users speed up the process of creating and tweaking materials in a production environment. Each template comes with written text explaining its core functions. As mentioned earlier, some of its parameters may come with high values, low values or even be disabled.

In some cases you may be required to enable or disable certain functions, depending on the results intended. There may also be cases when you may want to edit predefined parameters or textures. However, all parameters derive from the settings discussed earlier (Fig.55).

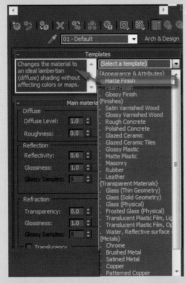

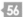

Car Paint

This shader is quite powerful when emulating the physical properties of a car paint material. You can access it directly from the Shader toggle or through the mental ray legacy shader (Fig.56).

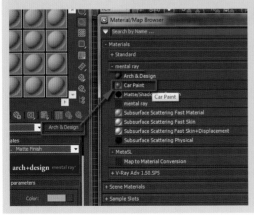

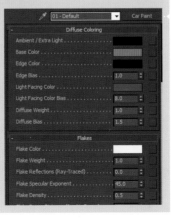

Diffuse Coloring > Ambient/Extra Light:
This function is used to increase the overall brightness of the material. Alternatively, you can use its toggle to plug in a texture or a procedural map.

Base Color: This function sets the base color of the material. Alternatively, you can use its toggle to plug in a texture or a procedural map (Fig.57 – 58).

Edge Color: This function acts as a rim color on the edges of the overall surface.

Edge Bias: This function controls the falloff/smoothness between the edge colors.

Light Facing Color Bias: This function sets the color that faces the light source. It essentially adds an extra color/tone to the Base Color. Its appearance is very much dependent on the position of the light source.

Diffuse Weight and Diffuse Bias: These two functions increase the prominence of the Base Color (i.e., similar to self-illumination).

Matte/Shadow/Reflection

This shader is useful when blending object(s) with the background and/or partially omitting objects from the camera. You can access it directly from the Shader toggle (Fig.59 – 60).

Camera Mapped Background: This function is often used as an instanced material of the Environment Map toggle (bitmap, mr physical sky or the environment background switcher). This toggle is designed to accommodate images in a color range between 0 -1 (e.g., bitmaps), so when using mr physical sky as an instanced map in this toggle you should have

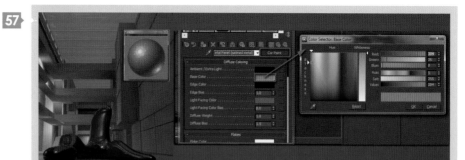

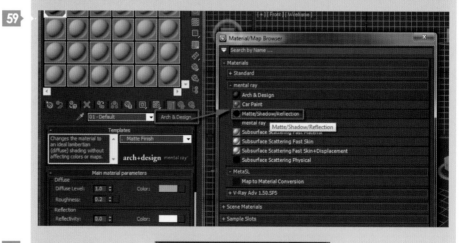

the environment physical scale set to Unitless (90000.0 or higher) to compensate for it. Otherwise there will be artifacts on the matte/shadow/reflection material.

Mask/Opacity: This function allows you to add a black and white/grayscale map to its toggle.

Bump: The Bump function allows you to add a bump material to its toggle.

Bump Amount: This function allows the Bump Amount function to control the intensity of the bump display.

Shadows > Receive Shadows: This allows shadows to be cast onto the matte surface.

Ambient/Shadow Intensity: This function controls the intensity of the AO appearance on the matte surface (0 = fully transparent).

Ambient/Shadow Color: The Ambient/Shadow Color function controls the prominence of the direct shadows on the matte surface (white = fully blended, black = not blended/very dark).

Shadow Casting Lights List: When turned on, this function disregards the direct shadows of

all other lights not listed in its name field. You can add, replace and delete lights accordingly. The remaining parameters are self-explanatory.

Ambient/Reflective Occlusion

This shader is a more complete version of the AO from Arch & Design discussed earlier. While the AO from Arch & Design only affects indirectly lit areas, this shader can be set to affect both directly and indirectly lit areas. It's accessible from the Material Browser dialog box and can be plugged into the Diffuse toggle or set as a Material Override. When used in the Diffuse toggle you can still plug textures into its Bright toggle (Fig.61 – 62).

Samples: This function controls the quality of the shadows. Higher values produce smoother results at the cost of slower rendering times. The default value is 16. You can also plug a texture or a procedural map into its toggle.

Bright: This function determines the color or texture of the main diffuse surface. Its default color is white and users can also plug a texture and/or a procedural map into its toggle.

Dark: This function sets the color of the connecting shadows. The default color is black and you can also plug a texture and/or a procedural map into its toggle.

Spread: This function controls the radius of the connecting shadows. The default value is 0.75. You can also plug a texture and/or a procedural map into its toggle.

Max distance: This function sets the fading distance of the Spread values. The default value is 0.4m. You can plug a texture and/or a procedural map into its toggle.

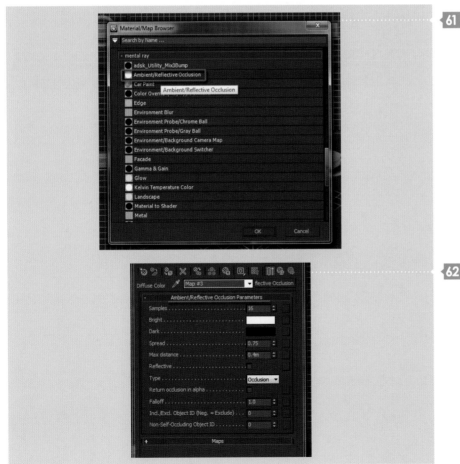
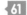

Color Override/Ray Type Switcher

This shader provides you with an array of options to override the eye rays, transparency, reflections, refraction, shadows, final gather, photons and environment of any base material. It's accessible from the Material/Map Browser dialog box list (Fig.63 – 65).

Default: This toggle contains the parameters of the original shader.

Eye Rays: This toggle overrides/replaces the color/texture of the relevant surface. Note that these changes do not affect its surface when reflected from a different object. To override its original color/texture when reflected on other surfaces, you are required to copy and paste/instance the eye rays contents onto the Reflections toggle. When used on surfaces artists often apply the object color and/or the Ambient/Reflective Occlusion shader. It's worth noting that the Eye Rays function can also be plugged into the Environment Map toggle, especially when using IBL files.

Reflections/Refractions: These functions override/replace the colors/textures of the relevant surfaces.

Environment & Indirect Illumination Override > Final Gather: This function overrides/replaces the Final Gather contribution of the relevant surface's color and/or texture. This option is quite useful to eliminate color bleeding from surfaces.

Photons: This function overrides/replaces the Global illumination contribution of the relevant surface's color/texture. It is also quite useful to eliminate color bleeding from surfaces. As

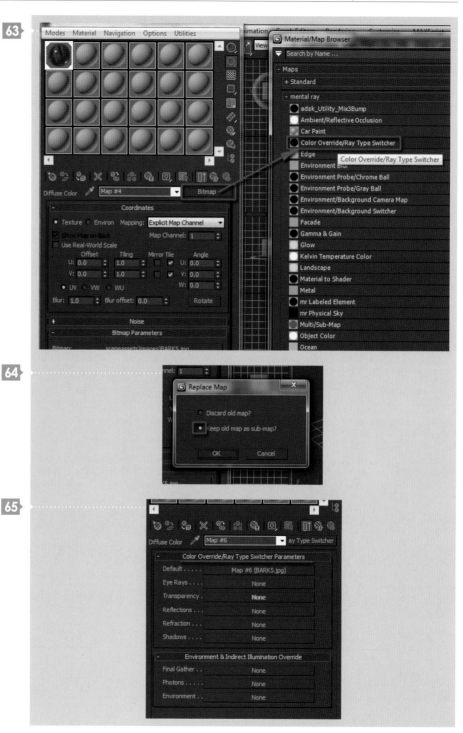

mentioned earlier, all the Color Override/Ray Type Switcher Parameter functions can also be plugged into the Environment Map toggle, especially when using IBL files.

Enabling mental ray Hidden Shaders

As 3ds Max progresses, there are a number of existing and new useful shaders that have been hidden by Autodesk. One of many of these shaders is the adsk_Utility_Mix3Bump. To enable it you are required to do the following:

1: Before starting, ensure you have 3ds Max closed and click on the Windows Start button.

2: In the Search box, type "notepad" to bring up the Notepad program. Click on its icon to open it.

3: Open the Explorer Dialog box and go to: C:\Program Files\Autodesk\3ds Max Design 2012\mentalimages\shaders_standard\mentalray\include, or if you are using Max 2013 go to: C:\Program Files\Autodesk\3ds Max 2013\NVIDIA\shaders_standard\mentalray\include. If you are using an older or newer version of Max, the location may vary.

4: In the include folder, scroll down and locate adsk_Utility_Shaders.mi from the list. While Notepad is still open, drag the adsk_Utility_Shaders.mi file from the Explorer dialog box and drop it into Notepad to edit it. Its text info should be displayed in Notepad.

5: The next step is to find the # adsk_Utility_Mix3Bump (to plug it into the bump slot of A&D) from the list by scrolling down to the dialog box. Alternatively, simply press Ctrl + F, followed by searching for # adsk_Utility_Mix3Bump.

6: In its section, find the text line that reads:

gui "gui_adsk_Utility_Mix3Bump" { control "Global" "Global" ("hidden") }".

Delete/omit the text that reads: ("hidden") (Fig.66 – 67).

7: Override this edited Notepad file by choosing to Save As from the File drop-down list. In the Save As dialog box, choose All Files for the Save as type and

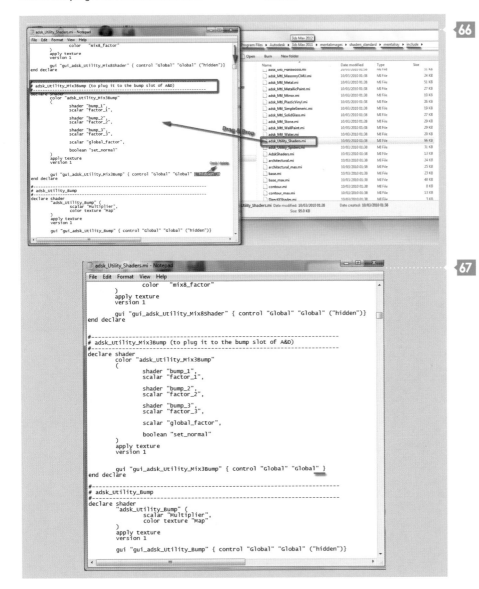

double-click on the existing adsk_Utility_Shaders.mi file to override it.

8: In the Confirm Save As dialog box, click Yes to replace it (Fig.68). It's worth mentioning that you can save a copy of the file at the beginning of the process if desired. Some users have the habit of saving a copy of the original file at a later stage as a matter of preference. In addition, you can also add comments in the .mi file where the changes were made (at your own peril). This may help to navigate through the text if changes are required at a later stage. For example:

#--- Changed for tutorial note here
#gui "gui_adsk_Utility_Mix3Bump" {
control "Global" "Global" ("hidden")}
gui "gui_adsk_Utility_Mix3Bump" { control
"Global" "Global"}

9: At times, some users choose to save a copy of the original "adsk_Utility_Shaders.mi" with the hidden tag in a different folder in case they need to refer back to it.

10: Next open 3ds Max and enable the mental ray renderer. Load up the Arch & Design shader, scroll down to the Special Purpose Maps rollout and click on the Bump toggle. The Material/Map Browser dialog box should pop up (Fig.69).

11: Scroll down to the mental ray rollout and choose adsk_Utility_Mix3Bump from the list (Fig.70).

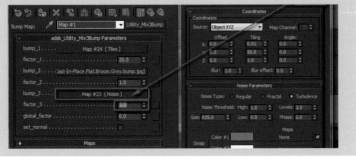

71 In real life most surfaces consist of multiple undulations, so this spectacular shader enables you to emulate exactly that, by allowing multiple bump textures (grayscale) or procedural maps to be plugged into its toggles.

adsk_Utility_Mix3Bump Parameters > bump_: These toggles allow you to plug textures (grayscale) or procedural maps into them.

72 **factor_**: These functions allows you to control their prominence/influence in relation to the other toggles by adding values. Alternatively, you can plug textures (grayscale) or procedural maps into their toggles (Fig.71 – 74).

global_factor: This function sets the prominence/influence of all factors by multiplying their values. For quick and optimum results you are advised to plug in and tweak and test render one texture/procedural

73 map at time, before moving onto the next. This approach will prove much quicker when controlling the influence of three different factors simultaneously.

74

04//Creating Materials and Shaders in V-Ray

The V-Ray renderer for 3ds Max is fully integrated and comes with a host of powerful shaders to help artists and studios achieve unsurpassed results. Most of its settings are set to default. The following discussion will focus mainly on the VRayMtl and some of the other popular V-Ray shaders. To access and render any of the V-Ray shaders you will need to load the V-Ray renderer first (Fig.01).

Diffuse Group

Diffuse: The Diffuse color swatch sets the color or texture (when applied to its toggle) of the main diffuse surface. Its default color is gray: R:128; G:128; B:128 (Fig.02).

Roughness: This function determines how coarse the diffuse surface should appear. A value of 0.0 equals a smooth/normal surface and a value of 1.0 will yield a darker/coarse surface. Its toggle allows users to plug in grayscale textures and/or procedural materials. When combined with the bump function it can help reinvigorate the surface. Results are more apparent on directly lit areas of the surface, when a texture (grayscale) or a procedural map has been applied to its toggle. The default value is 0.0 (Fig.03 – 05).

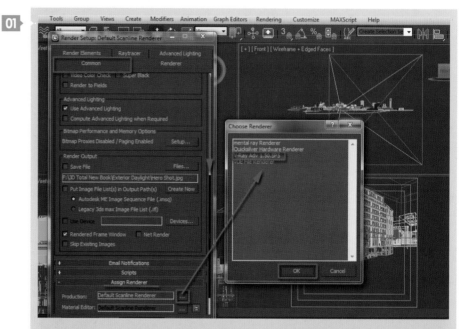

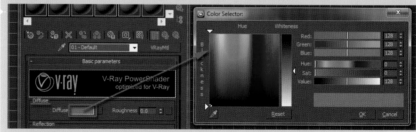

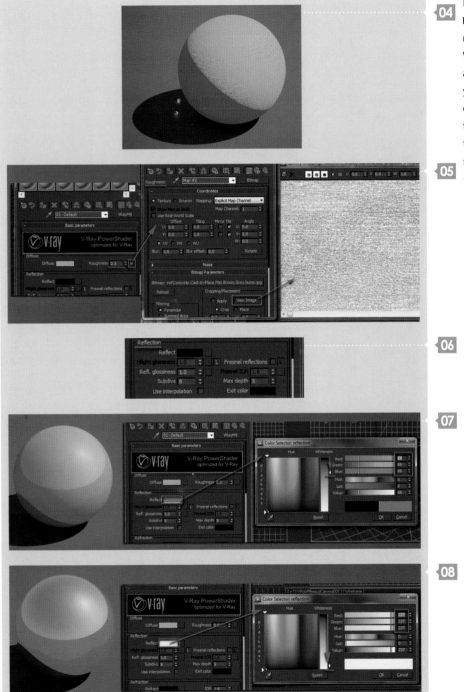

04

05

06

07

08

Reflection Group

Reflect: This function sets the amount of reflectivity on the surface (Fig.06). By default V-Ray uses a color swatch to determine the amount of reflectivity on a surface. Dark colors yield no reflectivity and bright colors have the opposite effect. You can also plug in a grayscale texture or a procedural map into its adjacent toggle to set the amount of reflectivity on the surface. The default color swatch is black (Fig.07 – 08).

Hilight glossiness: This function only becomes available when the automatic glossiness button (L) is disabled. By default V-Ray automatically calculates (links/locks) the Hilight glossiness value with the Refl. glossiness parameters. Both Refl. glossiness and Hilight glossiness values only work when the Reflect values are higher than 0.0. This function is disabled by default (grayed out). When enabled, a value of 1.0 creates a minuscule glossy highlight. Lower values increase its glossy highlight size and blurriness (Fig.09). Its toggle allows users to plug in grayscale textures and/or procedural materials. The grayscale textures can be inverted depending on the effect intended (Fig.10 – 12).

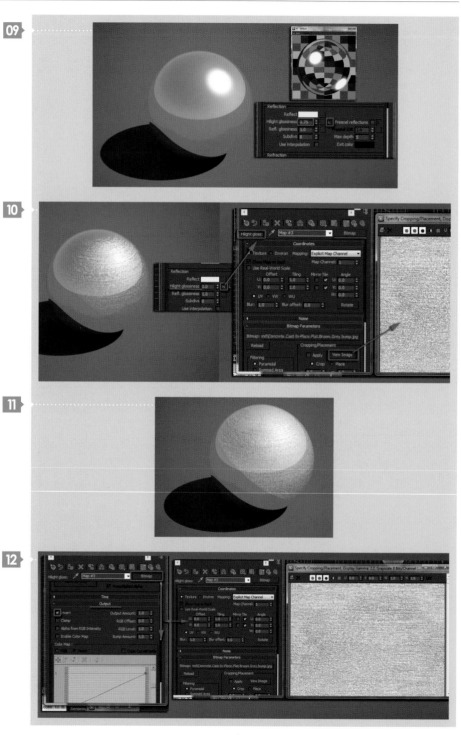

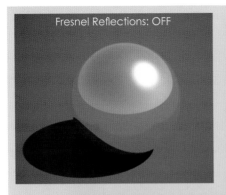

Fresnel Reflections: OFF

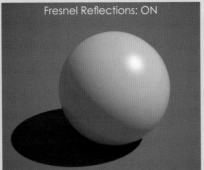

Fresnel Reflections: ON

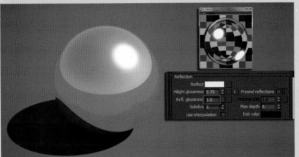

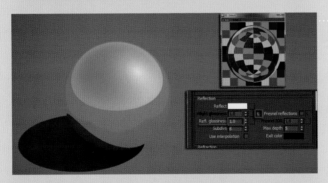

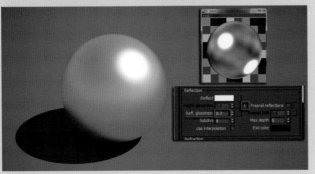

Fresnel reflections: When enabled, the reflections are automatically calculated based on the IOR (Index Of Refraction) and the angle. This function is turned off by default (Fig.13).

Refl. glossiness: This function sets the amount of blurriness in the reflections. A value of 1.0 will yield no blurriness and 0.0 will result in very blurry reflections. The default value is 1.0 (Fig.14). Its toggle allows you to plug in grayscale textures and/or procedural materials (Fig.15 – 16).

Fresnel IOR: This function only becomes available when the Fresnel Reflections function is enabled. When turned on, its value sets the IOR of the fresnel. The default value is 1.6. Alternatively, its toggle can also be used to load grayscale textures and/or other procedural maps. It's often locked to the Refraction IOR settings, but you can unlock it for finer control.

Subdivs: This function determines the smoothness of the glossy surface. The default value of 8 is often sufficient for most cases. However, when there are glossy artifacts (white grains) on the surface you will be required to increase the default value in order to achieve smooth glossy results, especially when the Refl. glossiness values are low.

Max depth: This function sets the number of times a ray can be reflected. The default value of 5 is often okay. However, complex scenes with numerous reflections may require higher values.

Use interpolation: When enabled, this function will speed up the rendering process of glossy reflections. However, it may yield artifacts. It's disabled by default.

Exit color: This function sets the color displayed on the reflection when depth is reached (5) and it cannot trace any further. When this occurs you can either increase the Max depth value or change the exit color being displayed (to blend with the environment). The second option has less impact on the rendering times. Its default color swatch is black.

Refraction Group

Refract: This function's color swatch or texture (when applied to its adjacent toggle) sets the level of refraction/transparency of the surface (Fig.17). Black corresponds to a fully opaque surface and white will yield the opposite result (transparent). Its default color is black/opaque. It's worth noting that if the Reflect value is too high, it may obstruct the transparency values. For this reason you will often find yourself having to reduce the reflectivity slightly in order to make the transparency results more apparent (Fig.18 – 21).

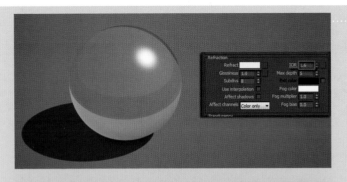

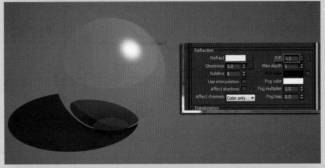

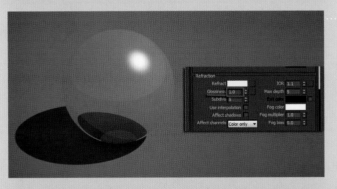

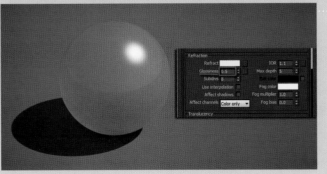

22

IOR: This Index Of Refraction function sets the amount of refraction on the transparent areas. The default value is 1.6. To emulate standard non-refractive window glass, professionals often use a value of **1.1** (Fig.22 – 23). Alternatively, its toggle can also be used to load grayscale textures and/or other procedural maps.

23

Glossiness: This function sets the translucency of the transparency. The default value of 1.0 yields no translucency. Lower values will yield more obvious translucency. Users often tweak its IOR values to achieve specific results (Fig.24 – 25).

24

25

Max depth: This function sets the number of times a ray can be reflected.

Subdivs: This function sets the quality of the Glossiness function. Low values yield grainy results and high values produce smoother results.

Exit color: When enabled, this function sets the color displayed on the reflection when depth is reached (5) and it cannot trace any further.

Use interpolation: When enabled, this function will speed up the rendering process of glossy refractions. However, it may yield artifacts. It's disabled by default.

Fog color: This function can be used to emphasize the glass color. Its default color swatch is white (Fig.26 – 29).

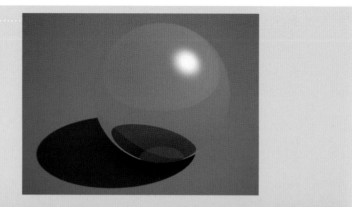

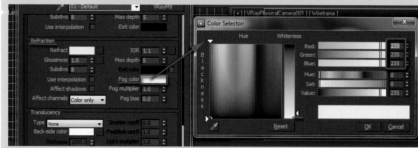

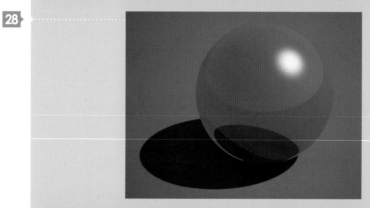

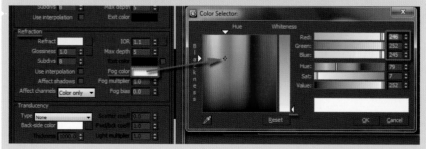

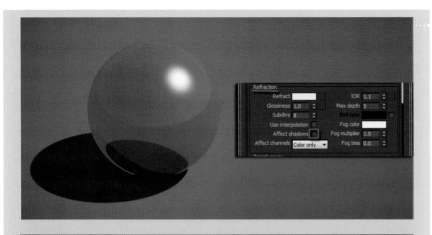

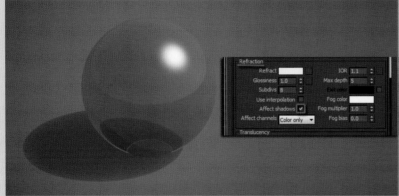

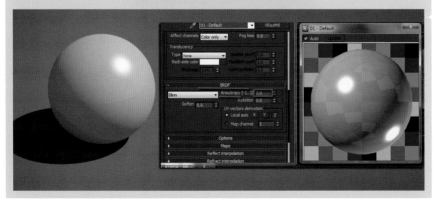

30 **Affect shadows**: This function is widely used to allow light rays to pass through a transparent surface and subsequently cast transparent shadows with the surface's color. This option is also great for interior renders, especially when the sunlight is coming through glass windows. It's disabled by default (Fig.30 – 31).

Fog multiplier: This function helps to accentuate the Fog color. The default value is 1.0.

Affect channels: This enables users to **31** determine which channels are affected by the transparency of the material.

Color only: Sets the transparency to affect only the RGB channel of the render.

Color + alpha: Sets the material to transmit the alpha of refracted surfaces. It is worth pointing out that it may only work with clear refractions.

All channels: This function sets all the channels and render elements so they are affected by the **32** transparency of the material.

Fog bias: This function reinvigorates the Fog color.

33 BRDF Group

Type: The BRDF sets the type of highlights and glossy reflections displayed on the surface of a material. There are three types of BRDF in the pull-down list: Blinn, Phong and Ward. The default BRDF type is Blinn (Fig.32).

Anisotropy (-1..1): This function sets the direction/shape of the highlight on the surface. The default value is 0.0 (Fig.33). For brushed surfaces you will need to tweak its default value

by either entering positive or negative values. In addition, you are required to tinker with the Reflection group parameters to achieve specific glossy and reflection results. The specific value of -0.7, in addition to using a metal brushed texture, will yield a very realistic brushed finish (Fig.34 – 37).

Rotation: This function sets the orientation in degrees of the anisotropy effect/display on the surface.

Soften: This function determines how soft the anisotropy effect should appear on the surface. Negative values yield a sharp anisotropy effect and positive values yield soft results.

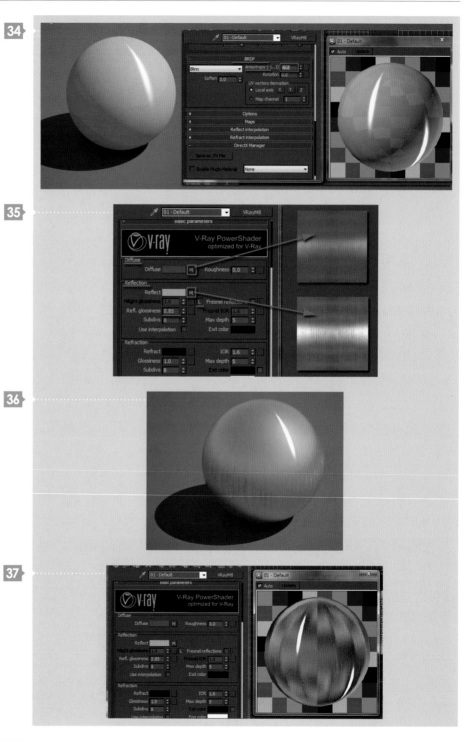

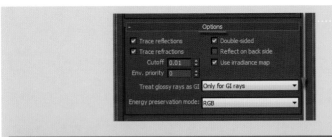

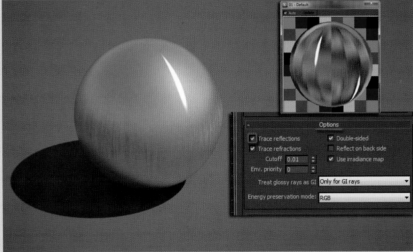

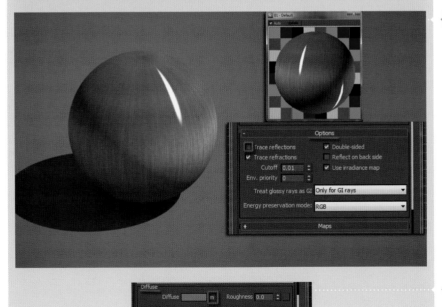

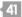

Options Group

38 **Trace reflections**: This function allows reflections to occur on the surface when enabled in the Reflect function (Fig.38). For fast results while maintaining the glossy highlights on the surface, users often disable this function (Fig.39 – 40).

39 **Double-sided**: When enabled, this function will automatically flip the normal side of a back-facing surface when encountered.

Trace refractions: This function allows refractions to occur on the surface when enabled.

Reflect on back side: When enabled, this function will calculate reflections for back-facing surfaces. Please note that this may slow down the rendering times.

Cutoff: This function determines at which point the rays will not be traced. Users are advised **40** not to decrease this value to 0.0 as it may increase the rendering times.

Use irradiance map: This function helps speed up the renders by automatically using the irradiance map (when enabled in the rendering settings) to calculate the indirect illumination. Otherwise Brute Force will be triggered to compute this material more accurately at the cost of slower rendering times.

Maps Rollout

This rollout allows users to enable or disable the toggles associated with each listed function. When a toggle is disabled the **41** uppercase letter (M) will automatically become lowercase (Fig.41).

Bump: This determines the amount of bump visible on the surface, if a texture or a procedural map is plugged into its toggle.

Displace: This function determines the amount of displacement visible on the surface if a texture or a procedural map is plugged into its toggle. It's worth mentioning that professionals often prefer to use the VRayDisplacementMod from the modifier list instead as it's faster to render. For best results the object's geometry needs to have a certain degree of density/detail (Fig.42 – 43).

1: To use the VRayDisplacementMod, simply select the relevant object and open the Modify command. Open the Modify list and press V to quickly scroll down the list and choose the VRayDisplacementMod.

2: Its parameters should load up. In the Type group choose 2D mapping (landscape). This mapping type is much faster to render, while it maintains the integrity of the displacement coordinates.

3: In the Common params group, plug a grayscale texture or a procedural map into its toggle using the Material/Map Browser dialog box (Fig.44).

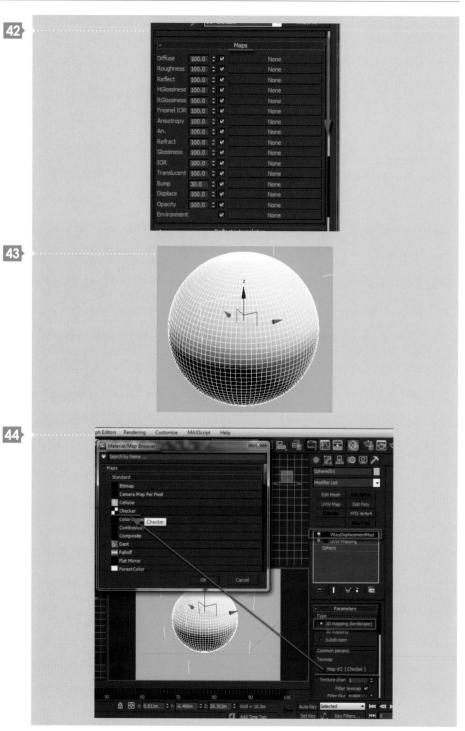

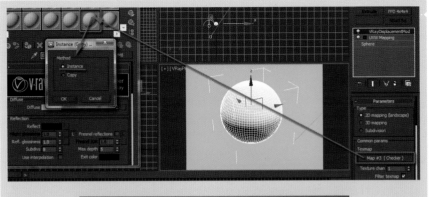

4: Once the map has been chosen, open the Material Editor dialog box and drag/drop it into a new material slot. Choose the Instance option. This will ensure that both the VRayDisplacementMod and the material slot are linked (Fig.45 – 47).

5: To tweak the UVW mapping coordinates professionals often apply the same texture from a different Material Editor slot to have the map displayed in the viewport. Once you are satisfied with the tweaked UVW Map modifier and the texture coordinates you can then copy/instance it to the VRayDisplacementMod texture toggle (Fig.48).

Opacity: This function sets the amount of opacity on the surface if a texture or a procedural map is plugged into its toggle. The default value of 100 yields a fully opaque surface.

Environment: This function allows you to plug in an environment map to affect the material only.

V-Ray Materials and Shaders

Some of the parameters and shaders not mentioned here are covered in the tutorial section later on. The following settings and features are other V-Ray materials/shaders you may find interesting that can be accessed in the material browser.

VRayLightMtl

This material is widely used to emulate self-illuminated objects such as light bulbs, recessed lights, etc. You are required to have a physical light source in the scene in order to prevent GI artifacts (Fig.49 – 50).

Color: This function allows you to choose the color of the self-illuminated material and set its intensity value through the color swatch or its toggle. Depending on the exposure parameters being used, you may sometimes be required to increase its value to 500.0 or higher in order for it to be visible in the render.

Opacity: This function allows you to plug a grayscale or black and white texture into its toggle to be used as a light source. V-Ray interprets white pixels as transparent.

Emit light on back side: This function allows the self-illumination to be visible from the back of the surface.

Direct illumination: When enabled, it casts direct light from the self-illuminated areas. Please note that this may increase the render times slightly.

Subdivs: This function determines the accuracy of the light samples (low values = a faster render and grains/artifacts).

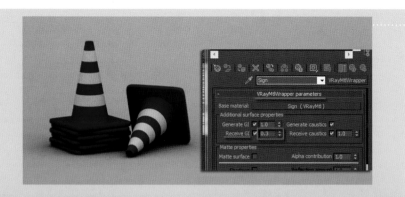

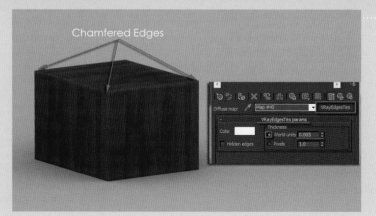

VRayMtlWrapper

52 Professionals often use this shader on top of an existing material (wraps on top of the VRayMtl) to control its GI contribution (Fig.51).

Base material: This toggle should contain the original VRayMtl.

Advanced surface properties > Generate GI: This function sets the amount of global illumination this material should emit. At a **53** value of 1.0 no changes occur to the base material.

Receive GI: This function sets the amount of GI this material should receive. This is quite useful to brighten or darken an object independently of the scene's overall illumination (Fig.52).

Matte properties > Matte surface: This function turns the current Base material into a matte object. This is quite a useful tool for editing in post-production.

Alpha contribution: At a value of 1.0 the matte is visible in the alpha channel. At the value of -1.0 it's invisible in the alpha channel.

VRayEdgesTex

54 This shader can be used in the Diffuse toggle to create geometry edge lines or as a bump material to create chamfered edges (Fig.53). When using two different bump channels, you may be required to use the Mix procedural map from 3ds Max to mix both channels. When entering very small values it's best to set the Display Unit Scale to millimeters temporarily (Fig.54 – 55).

Color: This swatch allows you to pick and choose a color.

Hidden edges: When enabled, this function allows the back edges of geometry to become visible in the render.

Thickness: This function sets the size of the edge lines in World units or Pixels (Fig.56 – 57).

VRayDirt

The VRayDirt material can be used to emulate a variety of effects, such as connecting shadows or an Ambient Occlusion pass. When used in the Diffuse toggle the connecting shadows will be visible in directly lit areas of a surface (Fig.58).

Radius: This determines the size/diameter of the connecting shadows. The default value of 100.0m is often too big. Its toggle allows you to plug a texture/procedural map into it. To access the toggle simply scroll down to the bottom of the VRayDirt parameters.

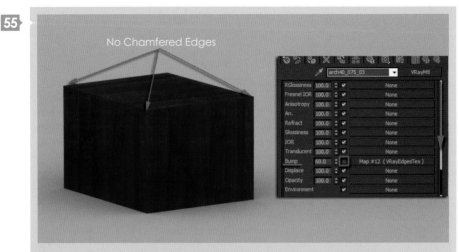

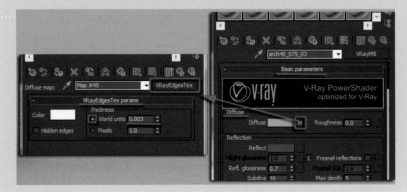

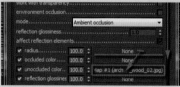

No VRayDirt on the Diffuse toggle

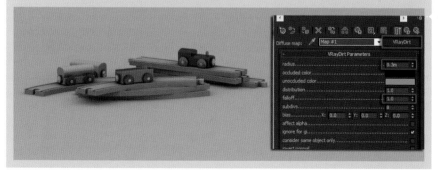

58 **Occluded color**: This swatch color determines the color of the connecting shadows. To change it, simply click and hold on its color swatch. Its toggle allows you to plug a texture/procedural map into it. To access the toggle simply scroll down to the bottom of the VRayDirt parameters.

Unoccluded color: This swatch determines the main diffuse color/texture of the surface. If you are not using a texture/procedural map, you should simply copy the main diffuse color swatch and paste it into here. Its toggle allows you to plug textures/procedural maps into it. To access the toggle simply scroll down to the bottom of the VRayDirt parameters. When the VRayDirt is used on top of an existing texture

59 /procedural map it automatically goes to the Radius toggle. You are required to manually move it to the Unoccluded Color toggle (Fig.59).

Distribution: This function sets the

60 concentration of the connecting shadows.

Falloff: This function sets the feather/ smoothness of the connecting shadows. A value of 1.0 should be okay for most situations.

Subdivs: This function sets the number of samples it takes to calculate the dirt effect. The default value of should work for most situations

61 (Fig.60 – 61).

Invert normal: By default, the VRayDirt affects only the corners/crevices of objects. By enabling this function, it will also affect the open corners of objects which is great for dirt details (Fig.62 – 63).

VRay2SidedMtl

This shader is quite useful when emulating translucent materials that are affected by light such as tree leafs, curtains, etc. It's often used on top of an existing VRayMtl (Fig.64 – 65).

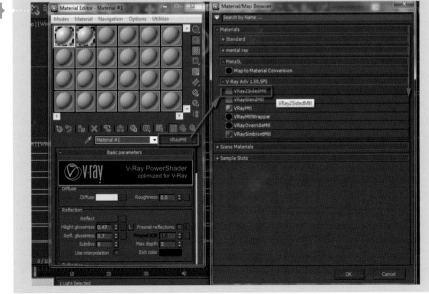

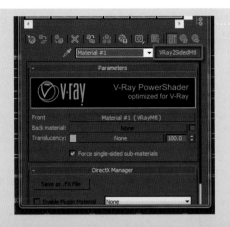

Front: This toggle represents the original shader facing the light source directly. It allows you to plug a VRayMtl or other shader into it.

Back material: This toggle represents the side facing the light source indirectly. It's disabled by default. If enabled, it allows you to plug a VRayMtl or another shader into it. Users often copy the Front toggle component into the Back material and set its diffuse color/texture lighter than the Front toggle (Fig.66).

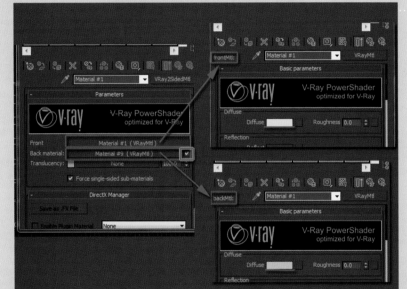

Translucency: This function controls how much of the Back material should be seen through the light (dark color = less light through; light color = more light through). If no material is applied to its toggle, the color swatch is used by default to control the translucency (R: 128; G: 128; B: 128). If the toggle is being used, then the adjacent spinner value can be tweaked to control its translucency (Fig.67).

The VRay2SidedMtl effects are more apparent when there's a physical light source affecting its surface (Fig.68 – 69).

VRayBlendMtl

This shader is commonly used on top of an existing VRayMtl to create further VRayMtl shaders within the same surface. This shader can be useful when controlling specific areas of a surface (Fig.70 – 71).

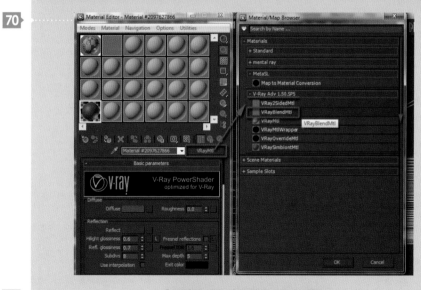

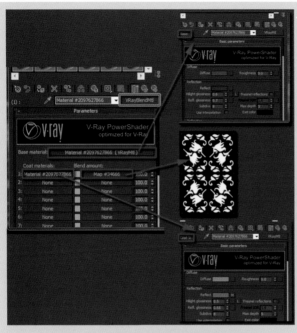

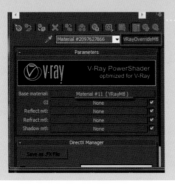

 Base material: This toggle often contains the main, original VRayMtl to apply coat materials onto.

Coat materials: This list of toggles is often used to plug in a new VRayMtl to blend with the Base material.

Blend amount: This list of toggles is commonly used to plug in black and white textures or procedural maps to define the blending area(s) (coat materials area). Its adjacent spinner controls the amount of blending between the Coat materials and the Base material (Fig.72 – 73).

VRayOverrideMtl

 This shader provides you with an array of options to override the GI contribution of an object, reflections, refractions and shadows. For instance, it's common for professionals to use it to override color bleeds or/and reflections. It's widely used on top of an existing shader (Fig.74).

Base material: This toggle contains the parameters of the original shader.

GI: This function overrides/replaces the global illumination contribution of the relevant surface's color/texture. It is also quite useful to eliminate color bleeding from surfaces.

Reflect/Refract/Shadow mtl: These functions override/replace the color/texture contribution of the relevant surface in the scene.

05//Lighting in mental ray

While the general approach to lighting a scene is similar across most rendering engines, there are a few differences when setting up a scene for lighting. As mentioned earlier you will be required to load either V-Ray or mental ray in order to have full access to all the relevant materials/shaders. For fast rendering results, professionals often apply a basic white/whitish, non-reflective global override material to the entire scene prior to creating the lights.

Material Override Settings

This function is quite useful to globally apply one material to the entire scene. This function is disabled by default. To utilize its toggle you will need to enable it first from the Renderer Setup dialog box. It's common for users to apply a basic, white, opaque surface with a non-reflective finish for quick test renders. You can simply drag and drop a predefined material from the Material Editor slot onto its toggle (Fig.01).

Light Models

There are a number of useful 3ds Max lights available for mental ray. To access these lights you will need to first open the Create command panel and go to the Lights group. Under the Photometric group, the Object Type rollout should display three distinctive light types: Target Light, Free Light and mr Sky Portal.

In addition, you will also have the Daylight System. The Daylight System can be accessed from the main toolbar. To create any of the light models from the command panel you are advised to first click on the relevant light

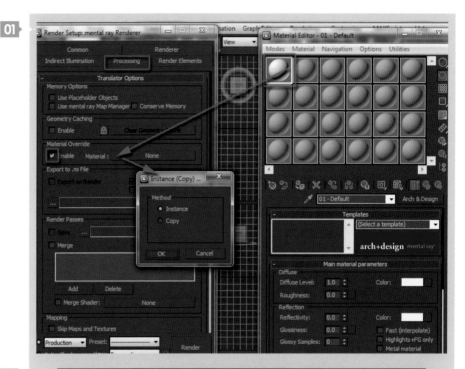

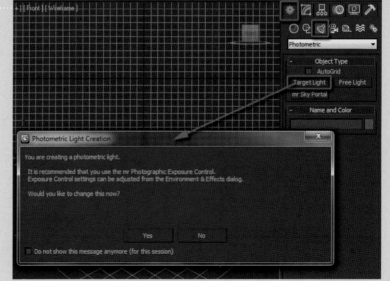

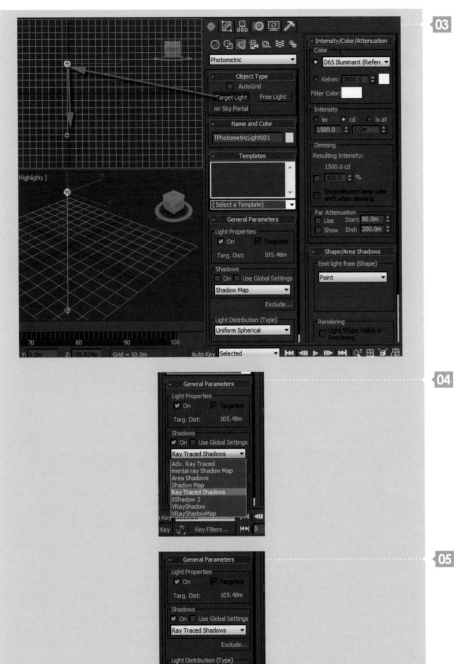

model. The Photometric Light Creation dialog box should be prompted automatically, recommending the usage of mr Photographic Exposure Control in the Environment & Effects dialog box. Click Yes, followed by clicking and dragging it on the viewport to create it (Fig.02 – 03).

General Parameters Rollout

Light Properties > On: This function allows you to either enable or disable the light by ticking the box.

Targeted: This function determines whether the light model will have a target point or not by ticking the On or Off option.

Shadows > On: This function allows you to either enable or disable the shadow by ticking the box.

Shadows type: This pull-down list allows you to choose the shadow type for the light. Ray Traced shadows work best with mental ray.

Use Global Settings: When enabled this function enables the Shadow Map type shadows (Fig.04).

Exclude: This toggle allows you to include or exclude objects listed in its dialog box from being affected by this light.

Light Distribution (Type) > Uniform Spherical: This light distribution emits light from all directions uniformly (light bulb) (Fig.05).

Uniform Diffuse: This light distribution emits light in a hemispheric manner (half sphere), in the direction of the target light.

Spotlight: This light distribution emits light in the form of a coned shape. The function called Cone visible in viewport when unselected allows you to light cone-shaped dimensions in the viewport. The Hotspot/Beam value determines the radius/size of the pool of light. The Falloff/Field value determines the feather/softness of the edges of the pool of light. Always ensure you have this value slightly higher than the Hotspot/Beam. A value of 150.0 yields soft shadows and very appealing results.

Photometric Web: This light distribution allows you to load a light web into its Choose Photometric File toggle (Fig.06). Its thumbnail enables you to preview the 3D representation of the light distribution and intensity. 3ds Max comes with numerous web files, or you can access them on the internet (Fig.07 – 08).

Intensity/Color/Attenuation

Color pull-down list: This pull-down list allows you to choose from a list of common lamp specifications of approximate light colors.

Kelvin: This function determines the color of the light by allowing you to input numerical Kelvin values. The default temperature value is set to 3600. Its adjacent thumbnail allows you to preview the color values. You will be able to find more information about Kelvin temperature values online.

Filter Color: This color swatch allows you to pick and add colors to the existing pre-defined color.

06

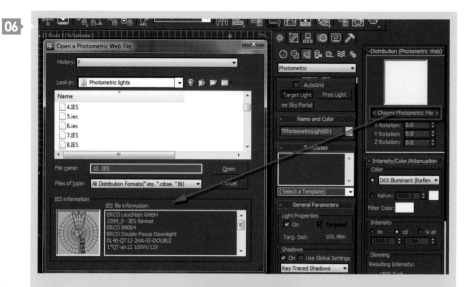

07

08

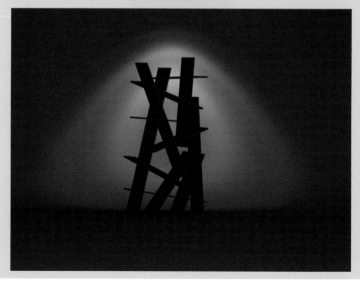

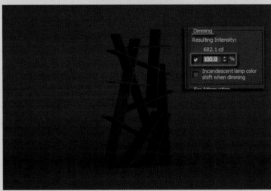

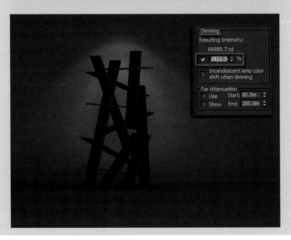

09 **Intensity > lm (luminous flux):** This light unit sets the total perceived power emitted by a light in all directions, using the luminous flux units. These are pre-defined values. A 100-watt bulb is equivalent to about 1750 lm.

cd: This light unit determines the luminous power of the light in candela units. These are pre-defined values. A 100-watt bulb is equivalent to about 139 cd.

lx at: This light unit sets the luminance caused by the light in lux at a given distance. These are pre-defined values. Lux is an international scene unit that is equal to about 1 lumen per square meter (Fig.09).

10 **Dimming > Resulting Intensity (%):** This function determines the overall intensity of the light by increasing or decreasing its default value. At 100% the light power is set at its maximum. It's worth noting that depending on the exposure values being used, you may be required to increase this value in order for the light intensity to be visible in the render (Fig.10 – 11).

Incandescent lamp color shift when
11 **dimming:** When enabled, this function emulates an incandescent light color (yellowish) when the Resulting Intensity value is decreased (dimmed).

Shape/Area Shadows Rollout

Emit light from (Shape): This pull-down list provides you with a list of light shapes to choose from. The light shape determines the type of shadows being cast. The Disc type provides you with easier methods of producing soft shadows by increasing its Radius to 45.0m or higher, especially when using photometric

lights. The Rectangle light shape is also another option to help produce soft shadows, by simply increasing its default dimension values.

Rendering > Light Shape Visible in Rendering: This function allows the chosen light shape to become visible in the render and on reflections. However, its intensity/brightness may also cause the shape to have jagged edges.

Shadow Samples: This function controls the shadow quality. This is quite useful to help reduce rendering times, especially when using soft shadows (Fig.12). For high resolution renders 16 should be high enough to produce acceptable results.

Atmospheres & Effects

This rollout allows you to load Volume Light (volumetric light/fog, etc.,) and Lens Effects to the light by simply clicking on the Add button and choosing the desired effect from its dialog box. Once the effect has been chosen, you can then tweak its parameters by simply clicking on the Setup button (Fig.13 – 14).

Free Light: This light model is similar to the Target light, only it doesn't have anywhere to aim to. You can convert this light model to a target type by simply enabling the Targeted function.

mr Sky Portal

This function works best in conjunction with an environment light (mr Skylight from the Daylight System or a standard Skylight object). The mr Sky Portal object was created to help redirect/channel the environment light into an interior scene in a speedy manner (faster FG calculations). This is why it's important to

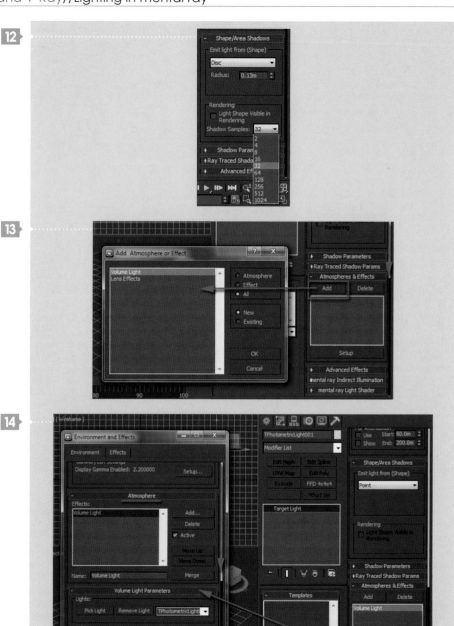

position it next to windows and openings in an interior scene. Its arrow indicates the direction of the light (Fig.15).

On: This function enables or disables the light.

Multiplier: This function sets the intensity of the light.

Filter Color: This function sets the color of the skylight.

Shadows > On: This function enables or disables shadows.

From "Outdoors": When enabled, this function casts soft shadows from objects outside the portal, therefore potentially increasing the rendering times.

Shadow Samples: This function determines the quality of the shadows. A value of 16 should work well for the majority of scenes. However, more complex scenes may require higher values such as 32 or higher, to smooth out grainy results.

Dimensions > Length and Width: These functions determine the dimensions of the mr Sky Portal object.

Flip Light Flux Direction: When enabled, it flips the direction (arrow) of the current light.

Advanced Parameters Rollout

Visible To Renderer: When enabled, its shape becomes visible in the render and on the reflections.

Transparency: This function filters the view outside the window/opening. When the color swatch is changed it only darkens the objects outside the window/opening, it doesn't affect the light coming in. At times, darkening objects outside may help correct overexposed areas.

Color Source > Use existing Skylight: This function uses the skylight object Color toggle as the color source.

Use Scene Environment: This function uses the scenes environment Color toggle as the color source.

Custom: This function allows you to plug custom shaders such as Kelvin Temperature Color into its toggle (Fig.16 – 18).

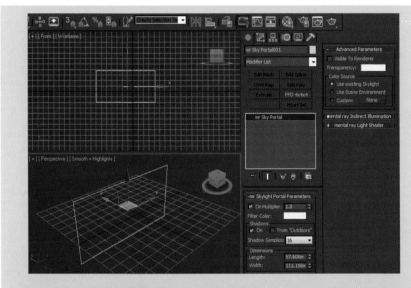

15

16

Kelvin Temperature Color Shader

When used as a custom shader it works as
a light card and independently from any
environment light source. Professionals may
also use it to build studio light rigs, etc.

Kelvin Temperature: This function determines
the numerical measurement of the color's
appearance. A value of 6500.0 represents a
bright/cool color.

Intensity: This function sets the brightness of
the color's temperature (Fig.19).

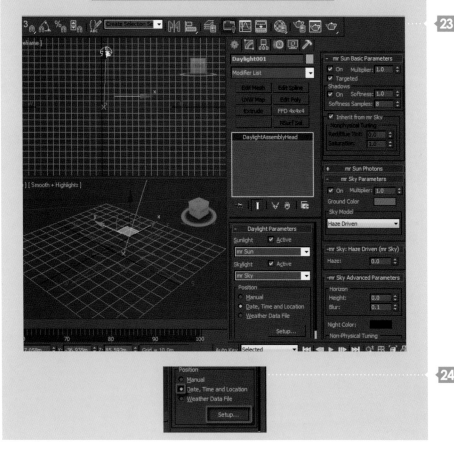

Daylight System

Daylight System mimics the physical properties of a real daylight system. It consists of a mr Sun and a mr Sky. When the system is created you will be prompted with dialog boxes and asked to plug the mr Physical Sky into the Environment Map toggle and the mr photographic Exposure control. You can create a daylight system through the Create pull-down menu in the Main toolbar (Fig.20 – 23).

mr Sun Parameters

In the Daylight System parameters you can adjust several settings that will allow you to create different effects for the sun. The following parameters are in the mr Sun Parameters rollout (Fig.24).

Manual: This function allows you to manually position the Daylight System.

Date, Time and Location: This function allows you to automatically and accurately set up the Daylight System by clicking on the Setup toggle. The Time group allows you to input specific times of the day, month, year and the time zone. You can get a geographical location in the world by simply clicking on the Get Location toggle, and it's also possible for you to

retrieve your location data (Latitude, Longitude and the North Direction) using smart phones (Fig.25). Alternatively you can choose the Weather Data File system by simply clicking on its toggle (Fig.26). This function allows you to load accurate real weather data files created by energy companies. These can be found online.

Most of these files you will download are in .zip format and will need to be unzipped. Inside the zip file you should find a .epw file (Fig.27). Once the epw file has been loaded, you can then tweak a number of its parameters to select a time period (Fig.28).

mr Sun Basic Parameters Rollout

Multiplier: The multiplier affects the overall intensity of the light from a given source. When the Inherit from mr Sky option is unchecked you will have access to a few additional options which allow further control over the lighting.

Nonphysical Tuning > Red/Blue tint: Sets the color (tint) of the sun. Negative values start from -0.1, which is equivalent to light tones of blue, down to darker tones of blue, which is equivalent to -1.0. Positive values start from 0.1, which is equivalent to light tones of yellow, down to darker tones of yellow, which is 1.0.

Saturation: Sets the saturation of the red/blue tint. This option is useful to tone down strong colors like dark blue (-1.0) or dark yellow (1.0).

mr Sky Parameters Rollouts

In the Daylight System parameters you can adjust several values that will allow you to create different effects for the sky. The following parameters are in the mr Sky Parameters rollouts (Fig.29).

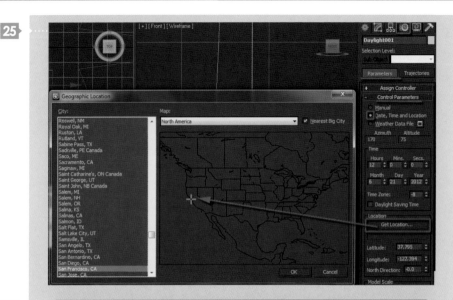

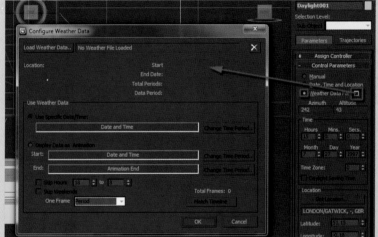

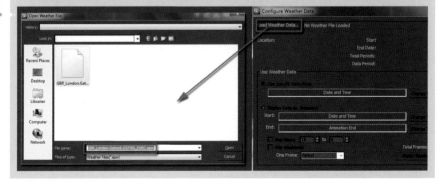

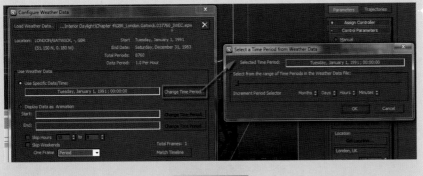

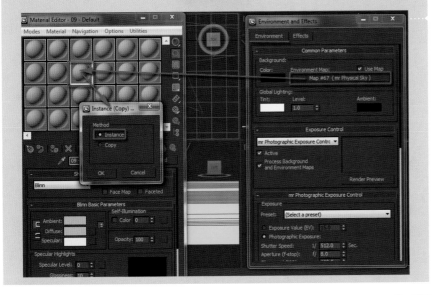

 28

Multiplier: The multiplier affects the overall intensity of the light from a given source.

Sky Model: Choices range between Haze Driven (default), Perez All Weather and CIE. Perez and CIE are physically accurate sky models whereas the Haze model provides you with a range of values to control the number of particles in the air and therefore affects the intensity of color in the scene.

29 **mr Sky: Haze Driven (mr Sky) > Haze**: The Haze value can vary between 0.0 (clear) and 15.0 (extremely overcast).

mr Sky Advanced Parameters > Horizon > Height: Allows you to control the height of the horizon of the mr Physical Sky background.

Blur: Allows you to blur the ground/sky transition at the horizon.

Non-Physical Tuning > Red/Blue Tint: Sets the color (tint) of the sun. Negative values start from -0.1, which is equivalent to light tones

30 of blue ,down to darker tones of blue, which is -1.0. Positive values start from 0.1, which is equivalent to light tones of yellow, down to darker tones of yellow, which is 1.0.

Saturation: Sets the saturation of the red/blue tint. This option is useful to tone down strong colors like dark blue (-1.0) or dark yellow (1.0).

When the mr Physical Sky is automatically created in the Environment map it's automatically linked with the daylight object. As mentioned earlier, you can unlink it by un-checking the Inherit from mr Sky function. In addition to this you can also edit the mr Physical Sky display in the environment by

simply dragging and dropping it from the Environment map toggle onto a material slot (Fig.30). It's worth noting that the mr Physical Sky parameters only affect the sky environment display and reflections.

Sun Disk Appearance > Disk Intensity: This function determines the intensity of the sun.

Glow Intensity: This function determines the intensity of the glow around the sun.

Scale: This function determines the size of the sun in the sky.

You can also un-check the Inherit from mr Sky function in order to have access to the grayed out parameters still linked to the daylight object parameters in the scene. Most of its parameters are similar to the daylight object parameters.

To load a different sky, simply plug a HDRI map into the Haze toggle. If you are using a standard bitmap (not high dynamic range) you will need to tweak its output settings in order for it to be visible and blend with the sky (Fig.31 – 32).

In the Horizon and Ground group, the Horizon Height value needs to be equal to the daylight object in the scene. This will prevent environment display artifacts from occurring (Fig.33).

It's also common for users to want specific environment effects, such as one image to be displayed in the background and a different image to be seen on reflections, etc. For such complex effects most professionals resort to the Environment/Background Switcher shader (Fig.34 – 35).

31

32

33

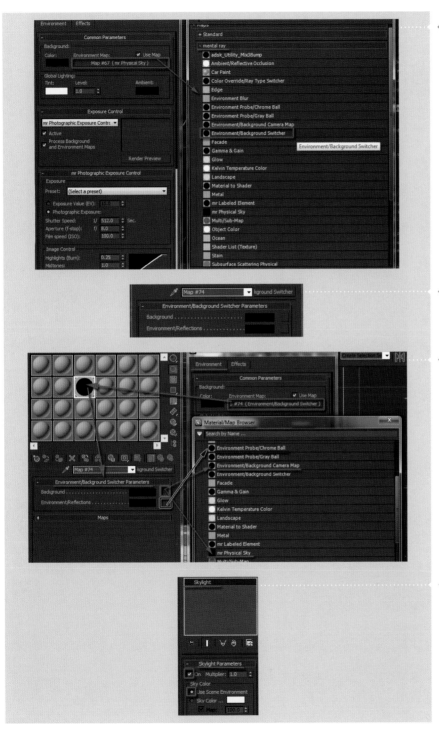

34 To view its parameters you will need to drag it from the Environment Map toggle into an empty material editor slot as an instance.

Environment/Background Switcher Parameters > Background: This function allows you to plug a number of shaders into its toggle. Two of the most common shaders to plug in are the Environment Probe/Gray Ball or the mr Physical Sky.

Environment/Reflections: This function allows you to plug a number of shaders into its toggle. One of the most popular ones is the Environment Probe/Chrome Ball shader. The environment probe/chrome ball (mi) works

35 best with IBL (image base lighting), JPEG, BMP, TIFF or HDR spherical images captured from a chrome ball. This shader uses this spherical map information accurately for bitmap reflections

36 and FG calculation (Fig.36).

Its FG functionalities are more visible when the skylight of the Daylight object is disabled and a separate skylight object (standard) is created, with the Use Scene Environment function enabled.

There are occasions when the Skylight Multiplier values may require increasing (Fig.37).

37 For more information on this subject please check the following post - http://jamiecardoso-mentalray.blogspot.co.uk/2010/01/mental-rayvaluable-tips-2.html

06//Lighting in V-Ray

The process of lighting a scene is similar across all render engines, however a greater knowledge of each engine can help you set up and improve the quality of your environments. In this section will be looking at the ideal settings for lighting a scene in V-Ray, so the first step is to load the V-Ray render engine.

Override mtl

This function is quite useful when you need to globally apply one material to the entire scene. It is disabled by default. To utilize its toggle you will need to enable it first and access the relevant material from the Material Browser.

It's common for users to apply the VRayMtl shader with a white opaque and non-reflective surface for quick test renders. Alternatively, you can simply drag and drop a predefined material from the Material Editor slot. The Override Exclude toggle allows you to choose which objects are to be included or excluded (Fig.01).

Light Models

There are a number of useful V-Ray-specific lights available to users in 3ds Max. To access these lights you need to first open the Create command panel, choose the Lights group, click on Photometric then choose V-Ray from the pull-down list. The Object Type rollout should load up. Three of the main V-Ray light types are: VRayLight, VRayIES and VRaySun (Fig.02).

To create any of the light models, you are advised to first click on the relevant light model, followed by clicking and dragging it on the viewport to create it (Fig.03).

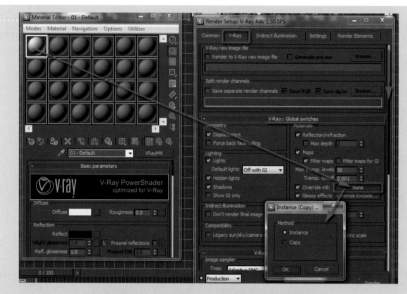

VRayLight Properties Rollout

VRayLight's main General parameters come with the following functions (Fig.04):

On: This function allows you to enable or disable the lights by either checking or un-checking the tick box.

Exclude: This toggle allows you to choose from its dialog list which objects to include or exclude from being affected by the light.

Type: This function allows users to pick from the types of light in the pull-down list:

Plane: This light model creates rectangular/square light shapes depending on its physical dimensions. Its default arrow indicates where the light is being emitted from and in which direction it is going (pointing towards).

Dome: This light model emulates the skylight illumination, which affects mostly indirectly lit areas of a scene. Users often implement it with indirect illumination and in conjunction with the VRaySun.

Sphere: This light model emulates a sphere-type light that emits light in all directions.

Mesh: This light model allows you to replace the default emitter with any specific mesh/geometry. However, for fast results you are advised to enable the Store with irradiance map function in addition to using an irradiance map to help calculate the indirect illumination. Otherwise it will yield grainy results and take a considerable amount of time to render (Fig.05).

Intensity Group

Units: This function allows you to choose the light units. The default unit is set to image, which is determined by the color of the light in the color swatch (white). There are also other unit types in the pull-down list, such as Luminous power (lm), Luminance (lm/m^2/sr), Radiant power (W) and Radiance (W/m^2/sr).

Multiplier: This function determines the brightness of the light color that is set in units.

Mode: This function allows you to choose the color of the light depicted.

Color: This function uses the color depicted in the swatch as the main color of the light (white). To change the default color, simply click and hold on its color swatch to bring up the Color Selector dialog box.

Temperature: This function sets the color of the light by allowing users to input Kelvin values. The default temperature value is set to 6500.0. For more information about Kelvin temperatures, search online (Fig.06).

Size Group

By simply typing in the values, this function determines the size of the light model in the viewport. Larger values yield softer shadows.

Options Group

Cast shadows: This function enables the light model to cast shadows onto other surfaces. It's enabled by default.

Double-sided: When enabled, this function allows the Plane light model type to emit light from both sides regardless of the direction of the arrow. It's disabled by default.

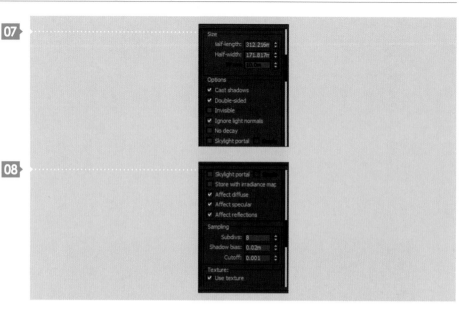

Invisible: This function turns the light model invisible in the render. It's disabled by default.

Ignore light normals: Generally the light is equally emitted from its model source. When this function is disabled, the light model will emit most of its energy from its surface's normals. This function is enabled by default.

No decay: Most light sources decay/feather away (gradient) into darkness. When this function is enabled, it prevents it from happening. It's disabled by default.

Skylight portal: When enabled, this function behaves like a skylight portal, subsequently ignoring the light color and its multiplier. Instead it uses the environment light as its source. This function is disabled by default (Fig.07).

Store with irradiance map: When enabled, this function uses the irradiance map settings from the indirect illumination parameters to process the render. This function helps speed up rendering times, especially when using real geometry as a light source and the Dome light type. It's disabled by default.

Affect diffuse: This function allows the light source to affect the diffuse of any surface. It's enabled by default.

Affect specular: This function allows the light source to affect the specular of any surface. There are cases when the light source causes the specular highlights of a surface to yield artifacts. Having this function disabled may help rectify the problem. It's enabled by default.

Affect reflections: This function allows the light source to be visible on reflective surfaces. There are cases when the light source is not complementary in reflections. Having this function disabled may help rectify the problem. Alternatively, you can use the Exclude toggle to help bypass the problem. It's enabled by default.

Sampling Group

Subdivis: This function sets the smoothness/accuracy of the light samples. The default value of 8.0 is usually sufficient to achieve acceptable results. Lower values yield grainier results and higher values produce the opposite result.

Shadow bias: This function determines whether or not shadows cast are away from the relevant object. Most importantly, lower values will help pick up shadows of minute objects in the scene.

Cutoff: This function determines from what distance the light source will not be computed. Some professionals may find this function useful, especially when working on heavily lit scenes. A value of 0.0 will prompt V-Ray to compute this light source in all surfaces (Fig.08).

Texture Group

Use texture: This function allows a texture to be used. It works best with indirect illumination. Its toggle allows you to plug in most textures and a VRayHDRI map which is affected by the light model multiplier values. To have an HDR map cast direct shadows in the scene, drag the VRayHDRI map from the Use Texture toggle onto the Material Editor slot as an instanced copy. Following that you will need to locate and load the relevant HDRI in the HDR map toggle. It's common to also copy/instance this HDR map into the Environment Map toggle.

Depending on the results intended you may need to tweak its Overall mult and Render mult values. In addition, its Horiz. rotation and Vert. rotation may also require tweaking to make the HDR map cast shadows (Fig.09). You can use the Show Background options to view the HDR map in the viewport interactively while the VRayHDRI parameters are being changed.

Resolution: This function sets the resolution at which the texture will be re-sampled.

Adaptiveness: This function determines the amount of light to be sampled with the bright parts of the texture.

Dome Light Options Group

Spherical (full dome): When a dome light is being used, this function will determine if the dome light will be emitted as an half dome or a full dome. It's common to use the full dome option to ensure the skylight light affects most parts of the scene.

Photon Emission Group

Target radius: When a dome light type is being used, this function defines the hemisphere around the light model from where the photons are being shot. It's only relevant when mapped caustics or photons are being used.

Emit radius: When a dome light is being used, this function defines the radius of where the photons are concentrated and being shot from (from the target radius outwards) (Fig.10).

Mesh Light Options Group

Flip normals: When a mesh light is being used, this function allows the normals of the relevant mesh light object to be flipped. This option may only be useful for single face surfaces.

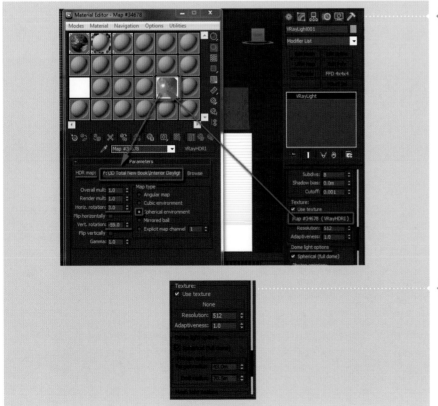

09

10

Pick mesh: This function allows you to pick the mesh/geometry in the scene by first clicking on the toggle, followed by selecting any given object in the scene.

Replace mesh with light: This function allows the light model to automatically become/replace the mesh/geometry. In doing so the VRayLight will become a modifier. Otherwise a separate light mesh will be created while the mesh/geometry will remain intact.

Extra mesh as node: This button is quite useful when retrieving the original mesh/geometry from the light mesh. This button only becomes available if the user had the Replaced mesh with light function enabled prior to creating the light mesh (Fig.11).

VRayIES

While V-Ray users can use the default photometric lights from 3ds Max, the VRayIES lights will always yield more accurate and artifact-free results.

VRayIES Parameters Rollout

Enabled: This function enables users to enable or disable the light source (Fig.12).

Targeted: This function determines whether or not the light source should have a target.

None: This toggle allows you to locate and load any specific IES photometric web file. To preview the web files in 3ds Max, create a standard 3ds Max photometric light in the scene and disable it. Disabling it will prevent the light from affecting the scene, since its core purpose is to only preview the web file.

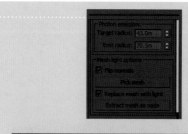

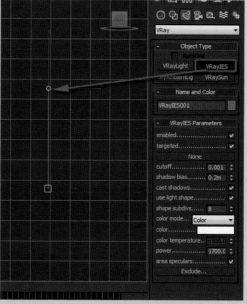

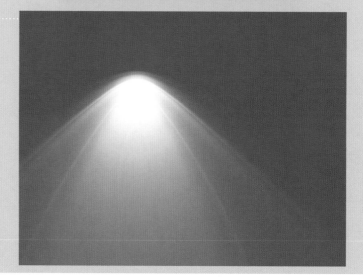

14 Next, scroll down to the Light Distribution Type group and click on the Choose Photometric file toggle to preview the relevant web files in Max. Once you are satisfied you can simply locate and plug it into a VRayIES light (Fig.13).

Cutoff: This function determines from which distance the light source will not be computed. Some professionals may find this function useful, especially when working on heavily lit scenes. A value of 0.0 will prompt V-Ray to compute this light source on all surfaces.

15 **Shadow bias**: This function determines whether or not shadows cast are away from the relevant object. Most importantly, lower values will help pick up shadows of minute objects in the scene. The default values always require reducing in order for the light to cast shadows from small objects (Fig.14 – 17).

16 **Cast shadows**: This function enables shadows to be cast onto other objects.

Use light shape: This function allows the IES light shape to be taken into consideration when the shadows are being computed.

Shape subdivs: This function determines the accuracy of the light samples. The default value of 8 is often okay for acceptable results. However, high values yield better results at the cost of slower render times.

17

Color mode: This function allows you to choose the color of the light source. The default mode is Color (white).

Power: This function determines the intensity of the light in lumens. The default value is 1700.0. At times you will be required to enter very high values in order for them to be visible in the scene (Fig.18 – 21).

Area speculars: This function determines the shape of the specular highlight being reflected. If disabled, the specular reflection will be a point light.

Exclude: This toggle allows you to include or exclude objects from being affected by the light source.

 22

Making Soft Shadows with VRayIES lights

Soft shadows are usually more appealing in most visuals. In order to soften the shadows with VRayIES lights you will need to change the numeric values of the web files. To do this you will need to do the following:

1: Open the Notepad program by clicking on the Windows Start button and typing "notepad" into the search box. Once you see the option, open it (Fig.22).

2: Locate the relevant IES web files in the respective folder.

3: While Notepad is still open, drag the IES web file from the folder into Notepad. Its numeric values should appear. To soften the shadows there are only three values to change. These values are often the three zeros that appear after the numbers 1, 1 and 2 (Fig.23 – 24).

23

24

4: Change the three zeros to 0.5. These values worked well for the level of softness intended, but you may want to enter different values if desired (Fig.25).

5: The next step is to save this edited file under a different name. Click on File, then Save As and change the Save As type to All Files (Fig.26).

6: In the dialog box, select the relevant web file. Rename it and save it (Fig.27).

7: Back in the 3ds Max file, replace the current web file with the newly created one. At times you may be required to replace the new IES web file twice in order for the changes to occur.

VRaySun

The VRaySun model was designed to emulate the real characteristics of the sunlight system. This light model works in conjunction with the VRaySky, therefore it is created automatically when the VRaySun is used. You will be required to accept this in a dialog box when you make this selection (Fig.28 – 29).

VRaySun Parameters Rollout

Turbidity: This function sets the color of the sky and the sun. Higher values yield yellowy/orange sky, while lower values will produce clearer/blue skies.

Ozone: This function mainly affects the tone/color of the sunlight. Lower values yield more yellow tones and higher values will produce bluer tones.

Intensity multiplier: This value sets the intensity of the sunlight.

28 **Size multiplier**: This function controls the size of the sun in the sky and how soft the sunlight shadows appear in the render. These values are also visible on reflections. High values yield soft shadows and lower values yield the opposite effect.

Shadow subdivs: This function determines the accuracy of the light samples. The default value of 3 is often fine for acceptable results. However, high values yield better results at the

29 cost of slower render times.

Shadow bias: This function determines whether or not shadows cast are away from the relevant object. But most importantly, lower values will help pick up shadows of minute objects in the scene.

Photon emit radius: This function determines the areas of the scene that the photons will be shot at when photons are being used in the scene. This may also help decrease the rendering times.

30 **Sky model**: This function allows you to pick the adequate sky model to generate the VRaySky.

VRaySky Parameters Rollout

Manual sun node: When enabled this allows you to tweak the VRaySky parameters.

Sun node: This function allows you to choose the light source to be used with the VRaySky. It's worth noting that when linked, the light source parameters will be reflected on the VRaySky and vice versa (Fig.30).

Finally, the VRayHDRI can also be used in the Environment Map toggle as an alternative to VRaySky.

07//Rendering Overview

The following section will focus on an overview of the parameters you are most likely to use in production and a general rendering workflow.

One of the quickest ways to begin test rendering a scene is to set the direction of the sunlight and its color first. A good graphics card may help to interactively see the direction of the sunlight in the viewport. Otherwise you would have to switch off the Global Illumination (GI) and apply a basic white, non-reflective override material in order to speed up the test renders.

When using the override material on interior scenes with mental ray, the glass windows should have the Cast Shadows function disabled temporarily, using the Object Properties dialog box (Fig.01 – 02).

If you are using V-Ray you can simply open the Override Exclude toggle to exclude specific objects (Fig.03). The white, non-reflective override material surface can also be used to accurately match light colors in photo references. You can easily determine the original color of the light sources by looking at the white areas of the reference photograph.

Once the direction of the sunlight and its color are set, the next step is to enable the GI and the exposure controls, and begin creating the artificial lights.

When using V-Ray you can simply create a VrayPhysicalCamera in order to enable the exposure. This camera comes when the

01

02

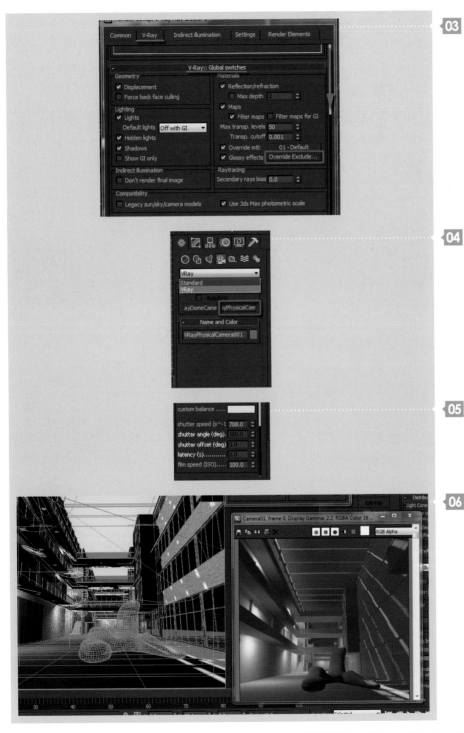

03 Exposure function is enabled. In addition, the VrayPhysicalCamera also comes with a number of other useful parameters similar to a real camera. Most parameters can be animated (Fig.04 – 05).

The shutter speed function sets the amount of brightness in the scene. Higher values yield less brightness and low values produce the opposite results. The white balance pull-down list allows you to load a number of preset colors to be taken into consideration in the rendered image output. The default D65 white balance **04** works best for most scenes.

The vertical shift and the horizontal shift functions allow you to correct the camera distortions. A similar tool is also available for mental ray from the Quad menu if you right-click (Apply camera correction modifier).

05 While using the Material Override for test renders, most global parameters should be set to Draft. This approach is often adopted for fast turnarounds and to quickly assess the overall lighting. Another rule of thumb is to avoid using the sky portal unless absolutely necessary.

06 While the sky portal is a very powerful way to redirect and concentrate the sun rays in specific areas of the scene, it can be time-consuming at render time. Users often have to increase its shadow samples in order to achieve smooth and clean results (32 or higher).

When artificial lights are being created, it's not wise to create more lights than necessary. It's a common mistake to create as many artificial lights as indicated on the ceiling plan. Certain reflected ceiling plans may come with 100, 300

or more artificial lights. However, in rendering technical terms it would be suicidal to create that many lights on one floor.

In this position professionals would normally create and place fewer lights than suggested on the plan by simply positioning them in crucial and strategic areas of the scene to emulate a similar amount of brightness without straining the computer with too many lights.

While soft shadows are important in renders, they will also increase the rendering times. For this reason professionals often set fewer lights in the scene to cast soft shadows. All the above changes should result in a balanced and nicely lit scene that renders in a reasonable amount of time (Fig.06).

Once you are satisfied with the overall lighting you can disable the Material Override function and begin fine-tuning the final light settings, shaders and the textures in the scene. At this point the image will begin taking slightly longer to render.

This phase may require you to do regional high resolution renders of the scene to prevent unexpected results in the final render. As mentioned earlier, it's imperative that you continuously compare the renders and the photo references to closely match the shaders, textures and lights (Fig.07).

You should try to be conscious of the key elements that make a render appealing. This will be things like the highlights and glossy highlights, reflections, diffused reflections, diffused glossy highlights and depth. You will find that a lot of the most striking photos contain all these elements (Fig.08).

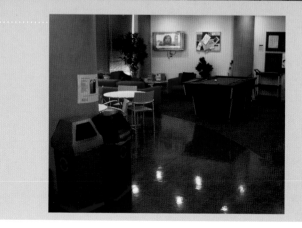

Complementary Colors

Having excellent shaders, lighting and content, etc., is not entirely sufficient to make a render look appealing. Having a scene where the colors and textures complement each other will play an important role in making an image striking. Whenever possible you should liaise with the client about textures and light colors that may complement the scene (Fig.09).

Direct and Diffused Shadows

Direct and diffused shadows are present in most photos, therefore our eyes expect the presence of both in most images. It is imperative to have these elements in the render whenever possible (Fig.10).

Appealing Design and Detailed Models

While the scale of the 3D models need to be correct, it is also important to have appealing and detailed 3D models in the scene. Our eyes can easily detect when an object is not detailed enough and therefore we perceive it to be unrealistic (e.g., CG). Most critics also have a clear sense of what looks appealing (e.g., round and organic shapes, chamfered corners on sharp edges) (Fig.11). It's important to add as much detail as possible to a 3D model when using 3D contents that are perceived as being appealing.

Random Positions

Most striking photos contain objects that are positioned in a natural (irregular) manner. In real life it's difficult to position objects in a symmetrical way, so whenever possible you should try to position 3D objects in a natural and random manner (Fig.12).

Ambient Occlusion (AO)

The ambient occlusion often helps to ground objects in the scene and create depth. Therefore, it's important to use it when possible or necessary.

Subtle Discrepancies

Our eyes are accustomed to seeing prominent and subtle discrepancies around us (smudges, scratches, creases, chipped corners, cracks, dirt, irregular bumps, dust, etc.). When these are absent in an image we will subconsciously perceive it to be unnatural (CG). For this reason it's important to add these natural discrepancies to trick our eyes into thinking what we are seeing is real (Fig.13). Professional 3D visualizers tend to make it as subtle as possible as clients often expect their buildings to appear relatively new.

Fig.14 depicts one of my numerous 3D visuals that involved me having to manually paint subtle discrepancies in order to fully integrate the shot. While these are very subtle discrepancies, they helped make the shot more photorealistic and they went unnoticed by the client.

In real life, during the construction of any building (one, two, or more years) surfaces are constantly exposed to adverse weather conditions and human activity (rain, wind, dust, sun rays, scratches and splotches) that will affect the finishes/surfaces over a period of time. While these natural effects are visible, they still look subtle and acceptable.

Distributed Bucket Rendering

This rendering technique enables you to use multiple machines without needing to load the 3D scene onto different computers. While

13

14

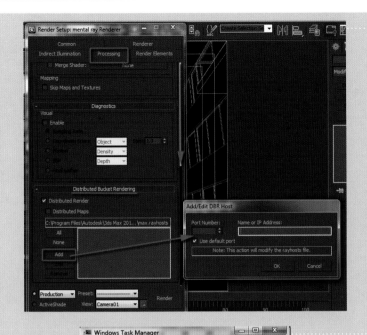

15 DBR is faster than Net Rendering, it's only recommended for still images. This rendering technique is also very useful when working on large scenes, as the main file will not be loaded in the host's system (Fig.15).

However, whilst rendering in mental ray you cannot vacate or switch off the main machine rendering without having to cancel the entire rendering process. To partially override this inconvenience, professionals often use the Windows Task Manager to set the number of processors (CPUs) assigned to the rendering task.

To do this, simply go to the Windows Task Manager > Processes > right-click on 3dsmax. exe > Set Affinity (Fig.16). This window lists **16** the number of CPUs your computer is using to process the render. Prior to using the DBR, ensure that all your files (FG Map, bitmaps, file output path etc.,) are in a shared network drive (not a local drive such as C).

With V-Ray distributed rendering there are no such problems. However, you are advised to save out all files in a shared network drive. Prior to start using the DR (distributed rendering) you will need to start the vrayspawnerXX.exe program from the Start menu (Start menu > Programs > Chaos Group > V-Ray… for 3dsmax > Distributed rendering > Launch V-Ray DR **17** spawner) (Fig.17).

The Add server button allows you to manually add a server by typing in its IP address or network name. The Remove server button allows users to delete the selected server(s) from the list. The Resolve servers button resolves the IP addresses of all the servers. This function is quite useful to reconnect

missing servers. The Restart slaves on render end function enables the render slaves to be restarted once a DR render is finished. This function is widely used to help stabilize the subsequent renders.

When the Distributed rendering function is enabled and the servers are added, the listed server names should appear on the rendering buckets of the frame buffer. This fantastic and unique V-Ray feature is quite useful to see which servers/render nodes are working (Fig.18 – 19).

To find out the IP addresses to type in the Server name field, simply do the following:

1: Open the Backburner Queue Monitor from the Windows Start Menu and the Manager dialogue box (Fig.20).

2: Connect to the Manager (Fig.21).

3: Under the Server tab select any server from the list and right-click. In the drop-down list choose the Column Chooser selection. The Server Columns dialog box should appear.

4: Select and drag the IP Address tab from the Server Columns dialog box and drop it into the Backburner Queue Monitor under the Server tab. This will allow you to view all the IP address numbers that will later be typed in the Name field (Fig.22).

Alternatively you can go to Windows Start Menu > Search > type in run > type in cmd > type in ipconfig for each machine to be assigned to the DBR. You are advised to

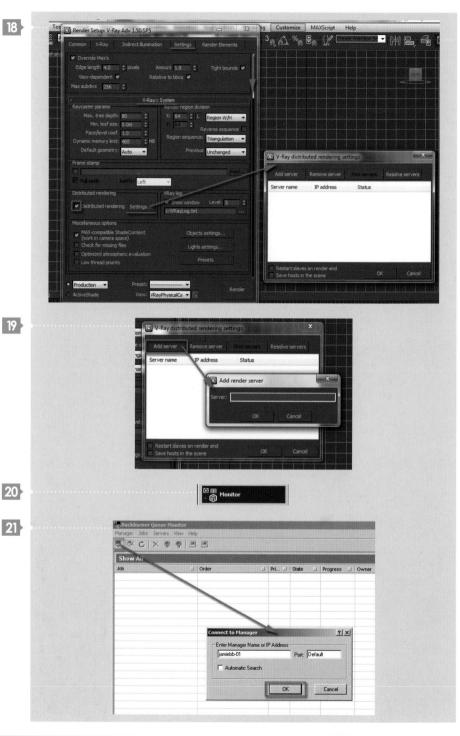

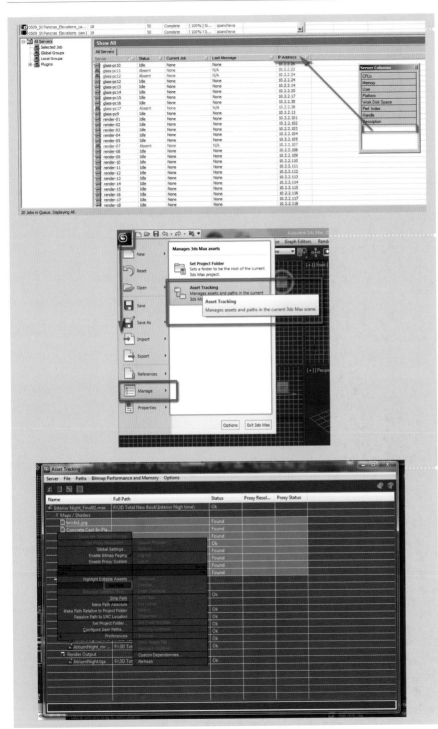

22

pre-save and freeze any Global Illumination calculations otherwise the rendered frames, regions/crops will differ in results. It's important for users to install similar software (e.g., DLLs) on each assigned machine prior to beginning a render, otherwise rendering errors will occur.

Net Render

23

Net render is the process of sending a job/ render to one, or multiple computers from your machine to the Backburner in the network. One of the many advantages of using this rendering technique is that you can safely assign or remove servers/computers from jobs/renders randomly whilst the render is taking place. This also includes the machine from where the main renders were sent from. All renders are handled over the network through the Backburner. In order for any of the assigned machines to pick up the job renders you will need to launch the Server dialog box from each of the assigned computers/machines.

24

When the server is launched it automatically loads up the entire Max file prior to rendering it. Loading huge 3D files may sometimes generate errors in the Backburner. When using the Backburner, it's imperative for the assigned machines to possess similar software (DLLs, textures, XRefs, etc.,) prior to beginning the render otherwise errors will occur. Professionals often use the Asset Tracking tool (Shift + T) to help re-path any missing textures or XRefs (Fig.23).

You can select one or multiple files/paths from the list, followed by right-clicking to access the Quad menu (Fig.24). You will be given two types of Quad menus depending on the file/path, or files/paths selected. For more information about this please check the

Autodesk help files by simply typing in Asset Tracking (Fig.25 – 26).

To send a Max file to network render you will need to do the following:

1: Ensure that the Net Render option is checked and click Render. The Network Job Assignment dialog box will appear.

2: Click Connect to see all the available machines in the server. Select the machines desired from the server field name.

3: In the Server Usage group, choose Use Selected to enable only the selected machines.

4: In the Options group, choose the Split Scan Lines option, followed by clicking on the Define button. The Strips Setup dialog box will appear; set it to Pixels and set Overlap to 2, Number of Strips to 10 and Strip Height to 48.

5: Click OK to close the dialog box and then click Submit (Fig.27).

The Dependencies toggle in the Priority group is very useful when setting up FG files and final renders. For example, submit the first Max file to compute the final FG only on the network. It is good practice to submit this to one computer as opposed to several computers.

Re-submit the same Max file (second Max file) not to compute the FG, but to read the FG and compute the final render. This time use multiple machines to do this. Before submitting the second Max file to render on the network,

open the Job Dependencies dialog box. In the Existing Jobs name field, select the first Max file submitted to compute the FG file only. Once selected, add it to the Jobs Your Job Depends On name field. Click OK to close the dialog box.

Note: Name each Max file according to their tasks (e.g., "Atrium_GI" when the task is to compute the FG only and "Atrium_FINAL RENDER" when the task is to compute the final render only). This way it is easier to pick, add and edit jobs from the list (Fig.28). To follow the progress of your renders, simply open the Monitor icon from your desktop or from your Windows Start menu, and connect to the Backburner Manager.

It's worth mentioning that if most of its toggles are grayed out it is an indication that the user is not in control of the Backburner Queue Monitor. To control the Backburner Queue Monitor, click the Manager menu and select Request Queue Control (Fig.29).

The next step is to choose any job from the list and click the Refresh button several times until buttons such as Delete Job and Suspend Job become available. When this happens it indicates that you have the full control of the Backburner Queue Monitor (Fig.30 – 31).

Once you are in control you can then select any given job from the list, right-click it and choose and edit any of the available settings (Fig.32 – 33). In addition you can also use tools such as Assign to Selected Jobs selection and the Remove From Selected Jobs selection in the Show All Servers list (Fig.34 – 35).

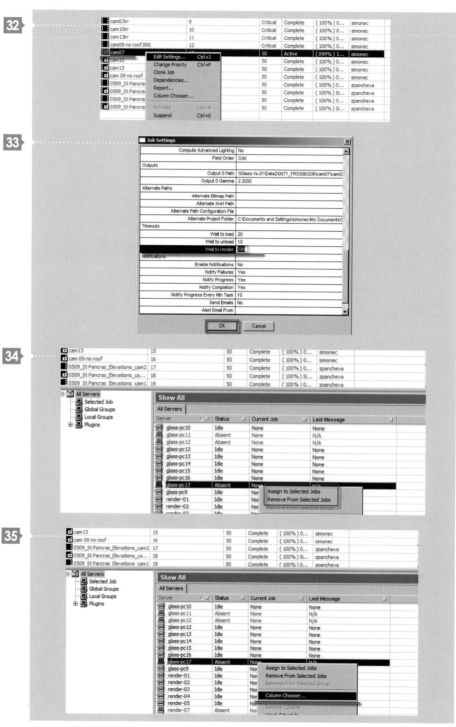

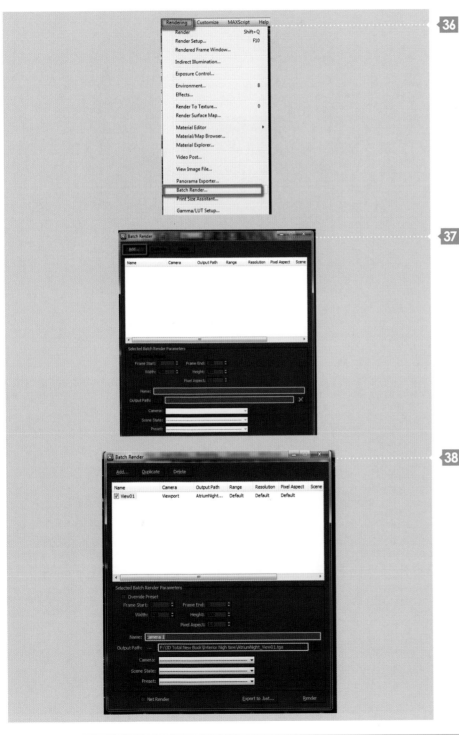

Batch Rendering

36 When rendering multiple camera views in the same 3ds Max scene, which require different Global Illumination settings and some changes to objects (turned off or moved), there is a very useful tool named Batch Render. To access this tool, simply click on the Rendering main toolbar. In the drop-down list choose the Batch Render option (Fig.36 – 37).

To start adding cameras, click on the Add button. By default, the first camera will be named "view01". To edit this, go to the Name **37** field and type in the camera name desired (in this case, "camera01"). It is worth noting that by simply typing in the camera name, the text will not change. You are required to type in the name first, followed by pressing Enter in order for the name to change.

In addition, the Output Path toggle allows you to set the output image name of the rendered camera view. This function overrides the Save File Name toggle from the Render Setup dialog box under the Render output group in the **38** Common tab (Fig.38).

The next step is to assign a camera from the scene to correspond to the named camera. To do so, click on the Camera bar and select the desired camera from the list (Fig.39).

Next you will need to set the scene state. Generally, when sending a variety of views to render you may require different light settings, to change some material parameters and perhaps move/hide some objects in the scene. Before saving the scene state(s) you will need to make the relevant changes in the scene first (e.g., material, light changes). To save a scene state, click on Tools in the main toolbar, followed by choosing the Manage Scene States option from its drop-down list (Fig.40).

In the Manage Scene States dialog box, click on the Save toggle. In the Save Scene State dialog box, name the scene state the same as the camera, choose the parts of the scene you want to save from the Select Parts list and then click Save.

In the Manage Scene States dialog box you can choose to Restore, Rename or Delete the saved highlighted scene state. Repeat the previous steps to save additional camera views (Fig.41).

42 It's worth noting that the Restore button is also useful to check parts of the scene state saved, without having to actually restore the state. You may need to save the entire list of parts for each scene if only the lighting has changed (Fig.42). In the Batch Render dialog box, select and choose the saved scene state from the list (Fig.43).

The Preset option is very useful when saving numerous GI settings for different views. To save a preset, first open the Render Setup dialog box. Click on the Presets list at the **43** bottom of the dialog box and choose the Save Preset option (Fig.44).

44

In the Render Presets Save dialog box, name the file after the camera name ("camera1"). Click Save (Fig.45). The Select Preset Categories dialog box should open; choose all categories required and click Save. Now that it has been stored, you can load it into the Batch Render (Fig.46 – 48).

The Override Preset function needs to be checked, should you require to override some of the default presets. If you need to submit numerous camera views to render along with the saved GI settings for each camera view, it is worth sending the first batch of renders dedicated only to creating these GI files.

Name the cameras accordingly in the Name field of the Batch Render dialog box (e.g., "camera1_GI"). Then the second batch of final renders can be set up to be dependent on the first batch of GI renders, in the Network Render dialog box.

Finally, it is very important to enable the Override Preset function to ensure all files are in the render (Fig.49). The aforementioned approach can help maintain a good grip on the project and workflow, as things can quickly become complex and unmanageable when setting up presets, scene states, etc.

Global Parameters

Planning the manner in which the global rendering parameters will be used throughout the project will play an important role in handling the speed and efficiency of the project. BSP parameters are one of the first parameters to be looked at.

In scenes with over 1.000.000 triangles you are strongly advised to switch to the BSP2 method, to ensure that the geometry is handled more efficiently (Fig.50).

To view the scene's statistics, simply press the 7 key. Also, on the main toolbar, click on the Views tab. On the drop-down list, choose the Viewport Configuration option. In the Viewport Configuration dialog box, open the Statistics tab. Enable the Triangle Count and the Total function, followed by pressing OK to close it (Fig.51). The selected viewport should now contain the scene's statistics and display the number of triangles and polys, etc (Fig.52).

When rendering you are advised to monitor the rendering process for possible errors related to the BSP tree, materials, Active Shade, etc. The Render Message Window dialog box will provide you with all the above information. To bring up its dialog box, simply click on the Rendering main toolbar and choose the Render Message Window option from the drop-down list (Fig.53).

54 The dialog box is divided into three tabs: Production, Material Editor and Active Shade. Some of its core rendering information is only available by right-clicking its information field and enabling its visibility in the pop-up menu list. The Clear button allows you to clear the text statistics log (Fig.54).

When not using the automatic BSP2 and tweaking with the manual BSP values, you should focus on the Render Message Production statistics related to the max leaf size **55** and average leaf size (triangles) of the BSP tree (Fig.55 – 56).

High depth values often equal slower pre-processing times, as mental ray will take longer to travel (casting/hitting rays onto the triangles) through the tree depth. This will also equate to fatter leafnodes and bspsize (kb). Most production companies prefer to have a good balance (low numbers) between the average leaf size, leafnodes and bspsize (kb). The reason behind this is that over a number of frames there will be minor losses of memory during **56** rendering time, which will contribute to better overall rendering time. You can tweak the BSP values when the Material Override is enabled.

The V-Ray System Rollout

The V-Ray:: System rollout also has similar
BSP parameters. However it's rarely needed.
The one value you should pay attention to
is the Dynamic memory limit function. Its
default value is set to 400 MB, which is often
not enough for big projects or when using
displacement materials. Professionals often
set it to 1500 MB or higher to speed up slow
renders caused by memory issues. The rule of
thumb is to look closely at the V-Ray messages
dialog box for possible memory error messages
(Fig.57 – 58).

Another useful tool to reduce memory usage is
the Bitmap Performance and Memory Options
group. It works for both mental ray and V-Ray,
and can be accessed from the Common tab of
the Render Setup dialog box. Its functions were
primarily designed to help 3ds Max handle/
display large textures in the viewport. However,
it can also be used for renders.

To open its dialog box (Global Settings and
Defaults for Bitmap Proxies) simply click on
its Setup toggle. As the dialog box's name
suggests, it affects all textures in the scene. To
turn it on, simply tick the Enable Proxy System
function (Fig.59).

If the Render Mode is set to Render with Full
Resolution Images and Keep them In Memory,
the Proxy Resolution group affects only the
texture displayed in the viewport. The pull-
down list called Downscale map to determines
the resolution (quality) of the textures. There
are four different sizes for the full texture to be
downscaled to: Half, Third, Quarter and Eighth.
The Full option retains the texture's original size
(Fig.60).

Proxy System Group

The Proxy System group affects the processing of textures at render time only. The option called Use proxy only if the original map's largest dimension is greater than allows you to instruct 3ds Max when (and at which pixel size) to proxy the textures in the scene. This tool can be quite useful to exclude/include specific textures from the global process of proxying textures. When rendering, this function only works in conjunction with the Render with Proxies (High Performance, Low Memory) render mode.

The Render Mode pull-down list determines the manner in which you would like 3ds Max to use its memory when processing textures. The default render mode pre-set uses a lot of memory as it doesn't use the proxy texture and its parameters. To use proxies when rendering textures, simply choose the Render with Proxies (High Performance, Low Memory) render mode (Fig.61).

The proxy cache folder sets the location of the cached proxy texture. The default location path is in the C drive. To change this, simply click on the Customize button from the main toolbar, followed by choosing the Configure User Paths option from its drop-down list (Fig.62).

In the Configure User Paths dialog box, open the File I/O tab. In the Project Folder name field, select the BitmapProxies option and click on the Modify toggle to set a different location path. Once the path location has been set, click on the Use Path button and OK to close the main dialog box (Fig.63).

The Page Large Images to Disk (Saves Memory) function should always be enabled. Most

rendering engines and graphics applications use this methodology to save memory. For more in-depth information about how it works, simply check this page of my website: http://jamiecardoso-mentalray.blogspot.co.uk/2009/11/out-of-memory-issues_14.html. The Page File Location function sets the location of the paging files. The OK, Generate Proxies Now button creates the proxy texture and the OK, Generate Proxies Later button saves the current parameters without saving them.

In mental ray, once all the geometry has been added to the scene, professionals cache it by turning on the Enable function to speed up the rendering process. If new geometry changes occur, you can simply click on the Clear Geometry Cache button, unlock the padlock button and allow new geometry caching to take place by re-rendering the scene (Fig.64). Mental ray may also crash when working on extremely complex exterior scenes with millions of triangles.

To help override this you should enable Use Fast Rasterizer (Rapid Motion Blur). This function may help overcome geometry issues, especially when working on exterior scenes (Fig.65). It's worth mentioning that this function, although powerful, disables render elements.

In order to include the render elements, you will need to set the render output as an exr. File format, and enable the relevant rendering passes (Fig.66). If the scene has numerous reflective/refractive elements, it's common practice to reduce the global reflective/refractive values with caution (test render

each value changed, to prevent unexpected artifacts) (Fig.67).

The global shadows and glossy precision should only be tweaked when absolutely necessary. Increasing these values will subsequently increase the rendering times slightly (Fig.68).

Sample Quality

When rendering, it's strongly advised that you are conversant with the Sampling Quality of the rendering engines, as it will prove crucial towards the end of your process. You should only increase the sampling quality when fine-tuning final region/crop renders and when sending the final render (Fig.69 – 70).

If the computer is struggling to cope with excessive amounts of geometry generated from displacement materials in mental ray, you should simply reduce the default value of the Global Max. Subdiv to 1k or less (Fig.71 – 72).

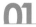
08//Rendering in mental ray

Rendered Frame Window

The Rendered Frame window is not unique to mental ray. However, when its Toggle UI button is enabled, a number of mental ray specific global parameters will be displayed.

While it's quicker and easier to use these Toggle UI parameters, most production companies find it more efficient to manually control these settings through the Render Setup dialog box (i.e., typing in its values).

Furthermore, by sliding any of the Toggle UI parameters, users will automatically change specific global parameters of Final Gather, Glossy Reflections/Refraction Precision, Soft Shadows Precision, Max. Reflections, Max. Refractions, etc.

It's worth mentioning that users should never freeze and reuse the FG when tweaking/sliding the Final Gather and Soft Shadows precision parameters (Fig.01).

Image Precision (Antialiasing): This slider controls the antialiasing of the image. As the value of the slider is reduced you will notice jagged edges along diagonal lines in the image and some artifacts. Higher values produce better images, but will increase render times. This slider automatically adjusts the Samples per Pixel values found in the Render Setup dialog box, under the Sampling Quality rollout seen in Fig.01 (Fig.02 – 03).

Soft Shadows Precision: Controls the quality of soft shadows globally and whether they

01

02

Image Precision (Antialiasing):
Low: Min 1/4 – Max:1
(Draft image quality)

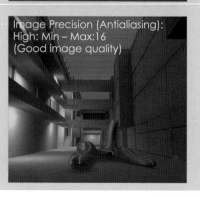

03

Image Precision (Antialiasing):
High: Min – Max:16
(Good image quality)

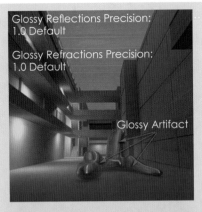

Glossy Reflections Precision:
1.0 Default

Glossy Refractions Precision:
1.0 Default

Glossy Artifact

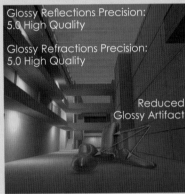

Glossy Reflections Precision:
5.0 High Quality

Glossy Refractions Precision:
5.0 High Quality

Reduced
Glossy Artifact

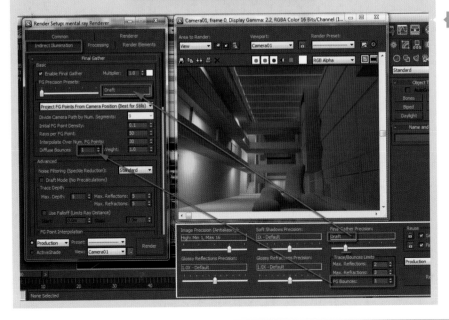

04 are on or not. Soft shadows are produced when light is being emitted from an object that is something other than just a point. The feathered effect of the shadows produced from these lights can be improved with this value. While you are performing test renders you may decide to turn off this slider completely to save on render time. Soft Shadows Precision can also be adjusted in the Render Setup dialog box, under the Renderer tab, in the Global Tuning Parameters (see Fig.01).

05 **Glossy Reflections/Refractions Precision**: These two sliders control the precision of reflections globally or refractions, in reflective or refractive objects. Lower values lead to artifacts and jagged edges, while higher values lead to better images but longer render times (Fig.04 – 05).

Final Gather Precision: This slider controls the accuracy of Final Gather settings to one of six default settings (Off to Very High) found in the Render Setup dialog box. The usefulness of **06** this slider is mostly limited to the lower levels (Off, Draft and Low) as the higher settings will increase render times considerably. Refining Final Gather beyond Draft is best done through settings found in the Render Setup dialog box, under the Indirect Illumination tab, in the Final Gather rollout (Fig.06).

Trace/Bounces Limits > FG Bounces: Controls the number of times mental ray will calculate diffuse light bounces in the scene. Switching from 0 bounces to 1 will have a dramatic effect on the scene, whereas increasing the value past 3 will have a minimal effect on the scene (Fig.07 – 08).

Max. Reflections: This value controls the number of reflections that can occur in a scene. For scenes that have numerous reflective objects, the default value of 4 may be ideal or not high enough. For scenes that have objects with low reflectivity, rendering time can be saved by reducing this value.

Max. Refractions: This value controls the refractions that occur through transparent objects in a scene. Light gets refracted at each surface of a transparent object. When there are transparent objects in the scene you need to calculate the number of refractions based on the maximum number of surfaces the light will pass through. For a thick glass window, this value would be 2; for a glass vase it would be 4, etc. If the value is too low, the transparent object will render opaque (Fig.09).

Reuse > Geometry: This lock is useful for renders after the geometry in the scene no longer changes. The mental ray renderer will be quicker to compute the geometry translation process (Fig.10).

Final Gather: This lock is useful for test renders when geometry, lighting and major material changes (e.g., displacement and self illumination (glow) using FG) are finalized. You can save the FG at a lower resolution (e.g., 300 x...) and reuse it for larger final renders (e.g., 5000 x...), provided the camera angle and the

07

Final Gather Precision: Draft (Draft FG quality)

08

Final Gather Precision: Medium (Good FG quality)

09
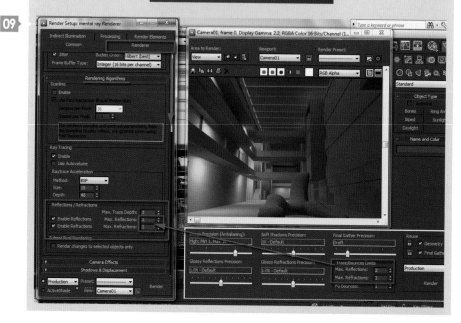

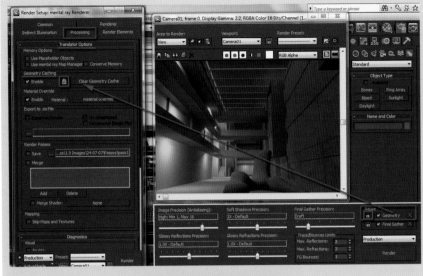

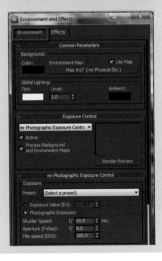

10 image ratio remains intact. The initial final gather is computed on one computer only, to avoid artifacts. Later the FG Map file can be used with the Reuse Final Gather function, on multiple machines, if available.

Render Setup Dialog Box

The Render Setup dialog box is an alternative to the Rendered Frame window for establishing mental ray settings, but also offers many more settings that the user can control. The following discussion will focus on some of its most important settings, in addition to what has been highlighted earlier.

Caustics and Global Illumination (GI) >

11 **Caustics**: In the Indirect Illumination tab, under the Caustics and Global Illumination (GI) rollout, you can enable and control the reflective or refractive caustic effects in your scene. It is advisable to avoid using caustics in external scenes, as this can take too long to compute (Fig.11).

Environment and Effects > Exposure Control:
This is a tool that allows you to adjust your image brightness, contrast, and color without

12 adjusting the lighting. It is used once you have finalized your lighting setup and wish to make some final adjustments to the image. When you work in 3ds Max and use either a Daylight System or photometric lights, if Exposure Control is not on then it will prompt you to turn it on. When mental ray is active, the mr Photographic Exposure Control is used.

Once you activate Exposure Control, or it is activated for you, you will see the mr Photographic Exposure Control rollout displayed in the Environment tab of the Environment and Effects dialog box (Fig.12).

Exposure > Preset: This list allows you to select from several preset values for exterior and interior conditions. Each preset will adjust the Exposure Value (EV) and Photographic Exposure.

Exposure Value (EV): The Exposure Value is a numerical value used to represent the exposure in the scene. Exterior daylight scenes typically have an EV of 15.0, whereas an interior scene lit by artificial lights will have an EV of 2.0. The lower the value, the greater the exposure and the brighter the scene will appear.

Photographic Exposure: The three controls of Shutter Speed, Aperture (f-stop) and Film Speed (ISO) combine to adjust exposure of the image. The lower the shutter speed (e.g., 1/64 is slower than 1/512), the more light is let into the camera and therefore the brighter the image will be (Fig.13).

The smaller the Aperture value, the more open the shutter of the camera will be, thereby letting in more light and making the image brighter. Film Speed refers to the speed that a film will absorb light, 100 typically being the slowest. Doubling the value of the ISO setting will increase the EV value by 1.0

Image Control: Highlights (Burn), Midtones, and Shadows can be controlled here to adjust the contrast of the image. Increasing the Highlights value makes the bright areas brighter (the default is 25). Midtones can be made brighter or darker by raising or lowering the value (the default is 1.0). Increasing the Shadows value will make the shadows darker (the default is 0.2). This tool is also very useful to increase the contrast of a scene (Fig.14 – 15).

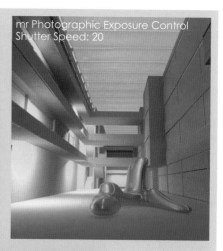

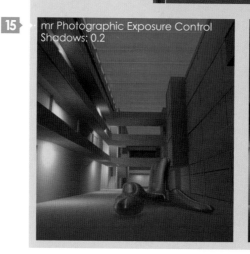

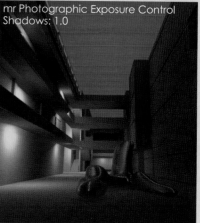

Color Saturation: Allows you to increase or decrease the color saturation of the image, much in the same way you do in a color selector (Hue, Luminance and Saturation).

Whitepoint: Defines the temperature value of white light in an image, similar to color adjusted film or white balance controls on digital cameras. Typically exterior scenes with a Daylight System would be set to 6500. If you wish to correct the yellow/orange quality of an interior image that is lit with primarily incandescent lights, a value of 3700 would be more appropriate.

Vignetting: Controls the darkness at the corners of the image and helps balance the brightness of a scene (Fig.16).

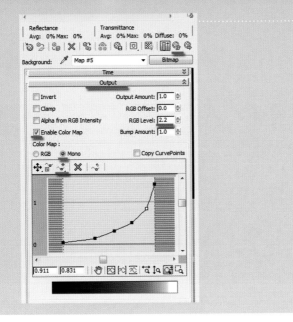

Physical scale > Physical Units: (cd / m²): This function outputs physically accurate, high dynamic range pixels, using the candelas per square meter units (i.e., cd/m²). It is useful when key elements in the scene such as the light model and its values are in cd/m² (e.g., photometric).

This also means that, images that are not of a high dynamic range nature (e.g., standard JPEG) will not be displayed correctly, unless calibrated to candelas per square meter units. To calibrate, users often tweak with the image's Output rollout parameters, such as the RGB Level value and its curve points (Fig.17).

Unitless: This function allows users to manually input values that will help mental ray interpret the illumination in the scene, when they are not physically based. Values of 80000 or above (e.g., 120000) will help correct most environment lighting and self-illumination artifacts (see Fig.15).

This value comes from approximate direct illuminance data of a real sky model. Most physically accurate rendering engines incorporate this available data into their system to emulate a real sky model. This real data will also help blend real footage with CG lighting. It's worth mentioning that, for best results, users are advised to mainly use photometric lights.

Gamma/LUT Settings: Its Setup toggle allows users to set up the gamma values (see Fig.15).

Note: Some of the parameters not mentioned here are covered in the tutorials and other sections of the book.

09//Rendering in V-Ray

V-Ray:: Frame Buffer Rollout

Enable built-in Frame Buffer: This function enables the renders to take place in the V-Ray frame buffer. Also, if using render passes, the render channels/elements will be embedded in the frame buffer channel's menu pull-down list (Fig.01 – 02).

Some of the best features of the V-Ray frame buffer are:

Track mouse while rendering: When enabled, this button allows users to determine with the mouse pointer which areas rendering buckets should be concentrating on.

Depending on the scene's complexity and the computer's specs, it may take a few seconds to see the rendering buckets moving across the frame buffer. This tool is really useful to test render specific areas of the frame buffer. To enable it, users need to click on its button first, followed by clicking/moving the mouse to the relevant part of the frame buffer (Fig.03).

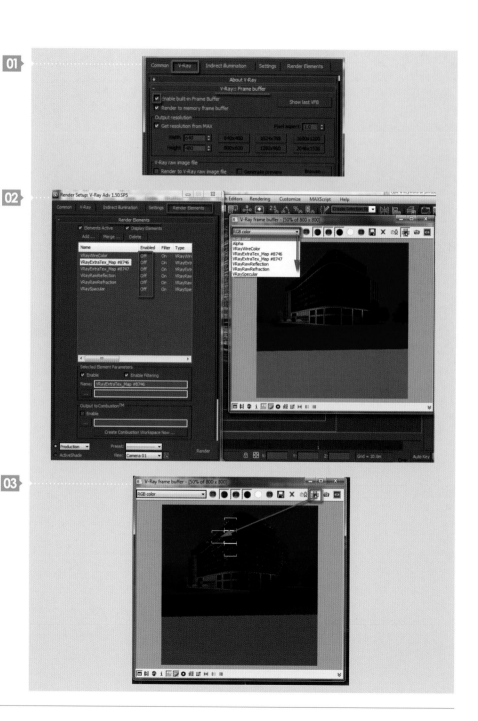

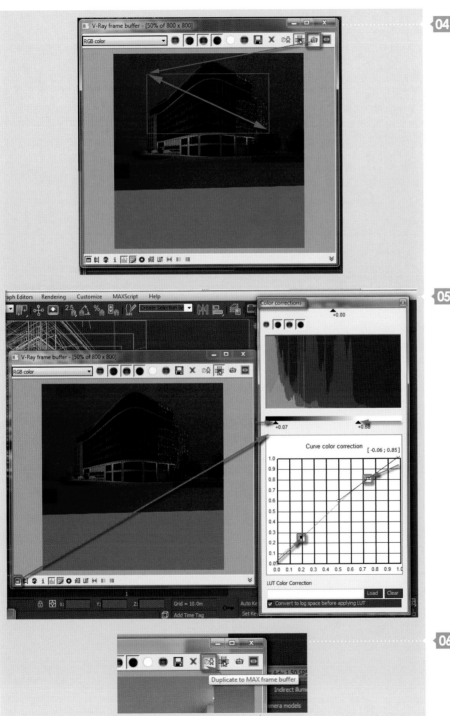

04

Region render: When enabled, this button allows users to draw a square/rectangular region with a mouse point on the area they want to render. To enable it, simply click on its button first, followed by clicking, holding down the left key and drawing across the frame buffer (Fig.04).

Show corrections control: This button opens the Color corrections dialog box, which subsequently allows users to tweak its settings with the sliders and curve points. The curve points need to be dragged inwards towards the center of the grid in order to be editable (Fig.05).

05

Use colors curve correction: When enabled, this button allows users to see the effect of the Color corrections dialog box in the frame buffer.

Use exposure correction: When enabled, it displays the exposure brightness in the frame buffer.

Duplicate to MAX frame buffer: This function duplicates the frame buffer. It's quite useful if you want to cross-reference render changes (Fig.06).

06

Show last VFB: This button displays the last image rendered in the V-Ray frame buffer (Fig.07).

Depending on the graphics card being used, users may be required to either enable or disable the Adaptive Degradation button to prevent the frame buffer from being sluggish. Alternatively, you can open its dialog box to change specific settings by simply right-clicking on its button (Fig.08 – 09).

Render to memory frame buffer: Having this function enabled will use the V-Ray frame buffer memory to process the render. If you are computing very large output size renders, and experiencing memory issues, simply disable this function (as seen in Fig.07).

Output resolution > Get resolution from MAX: This function uses the Common tab output size dimensions to determine the final render size. If disabled, users can type in the relevant frame size dimensions (as seen in Fig.07).

V-Ray raw image file: This group is quite useful to save memory when rendering huge output size renders. When the Render to V-Ray raw image file option is enabled, V-Ray will render the raw image file directly to its specified location as a .vrimg format, without using the frame buffer, unless the Generate preview function is enabled (as seen in Fig.07).

Split render channels: When enabled, this group allows users to specify the location to save the render channels/elements, by enabling the Save separate render channels function. If the location path is not set, the render elements will only be embedded in the frame buffer's Channel menu pull-down list (Fig.10).

V-Ray:: Global Switches Rollout

Lighting > Hidden lights: When enabled, this function allows hidden lights in the scene to be also taken into consideration during the rendering time.

Shadows: Enables or disables the shadows globally

Materials > Reflection/refraction: This function enables or disables the reflections/refractions globally.

Indirect illumination > Don't render final image: This function allows the pre-rendering process to take place, without having to render the final image. This is quite useful when users intend to save the indirect illumination parameters only.

Compatibility > Use 3ds Max photometric scale: When enabled, this function makes V-Ray light units compliant with the 3ds Max photometric scale. Otherwise, V-Ray results may differ (Fig.11).

V-Ray:: Image Sampler (Antialiasing) Rollout

This group determines the quality of the renders. Users can choose a number of available image samplers from the Type pull-down list. Adaptive DMC is one of the most popular ones, as it produces clean, detailed and noise-free renders (Fig.12).

The Antialiasing filter group provides users with a variety of different filters to choose from (Fig.13 – 16).

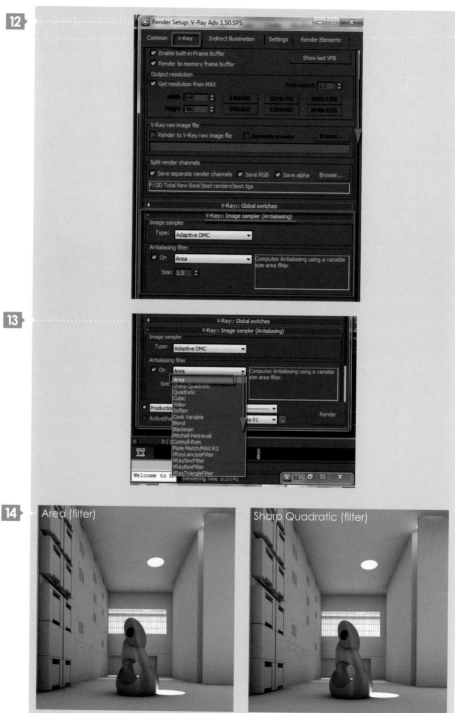

Area (filter)

Sharp Quadratic (filter)

Mitchell-Netravali (filter)

Catmull-Rom (filter)
(Pronounced edges)

Blackman (filter)
(Sharp)

Soften (filter)
(Blurry)

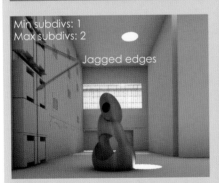

Min subdivs: 1
Max subdivs: 2

Jagged edges

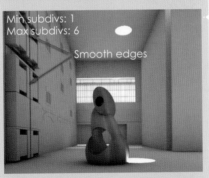

Min subdivs: 1
Max subdivs: 6

Smooth edges

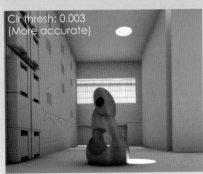

Clr thresh: 0.003
(More accurate)

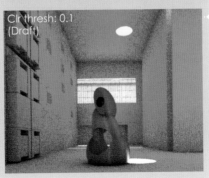

Clr thresh: 0.1
(Draft)

V-Ray:: Adaptive DMC Image Sampler Rollout

15

Min subdivs: This sets the minimum number of samples taken for each pixel. A value of 1 should be sufficient to capture most details in the distance. In extreme cases, some professionals may increase it to 2 or higher in order to capture very tiny details.

16

Max subdivs: This function sets the maximum number of samples taken for each pixel. The default value of 4 would be equal to 16 pixels per square, which is very detailed. Higher values will result in slower rendering times (Fig.17).

17

Clr thresh: This function is disabled by default as the Color Threshold is being controlled by the Noise Threshold values of the Settings tab. To enable it you need to disable the DMC sampler thresh function. Small values yield more accurate and better results, and higher values produce less accurate/draft results (Fig.18).

18

Use DMC sampler thresh: When enabled, the DMC sampler is controlled by the Noise Threshold values of the Settings tab. Small values yield more accurate and better results, and higher values produce less accurate/draft results (i.e., noisy render) (Fig.19).

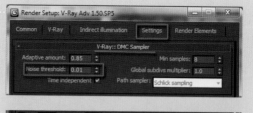

V-Ray:: Color Mapping Rollout

Color mapping is widely used to apply color transformations on the final renders. There a number of color mapping modes from the pull-down list. One of the most popular ones is the Exponential type (Fig.20).

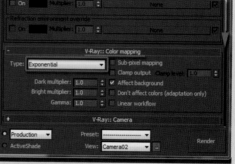

Type > Exponential: This color mapping mode saturates the render colors depending on its brightness. Professionals often use it to correct overexposed areas of an image and to give a photo-like feel to an image (Fig.21).

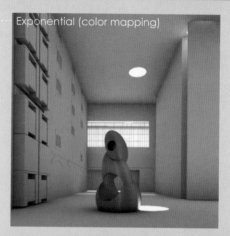
Exponential (color mapping)

Clamp output: This function is quite useful to correct/clamp tiny bright spots of an image (e.g., artifacts).

Dark multiplier: Sets the brightness of dark colors in the scene.

Bright multiplier: Sets the brightness of bright colors in the scene.

Gamma: This function sets the gamma correction, in spite of the color mapping mode. A value of 2.2 is often used.

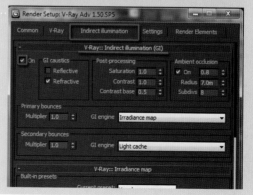

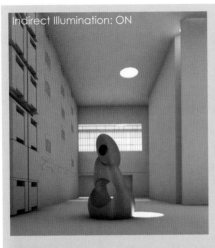

Indirect Illumination: ON

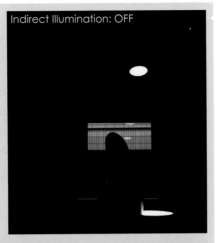

Indirect Illumination: OFF

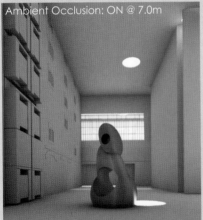

Ambient Occlusion: ON @ 7.0m

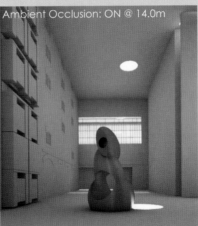

Ambient Occlusion: ON @ 14.0m

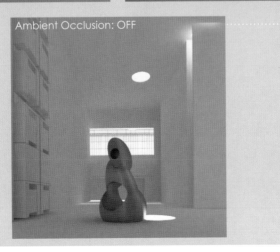

Ambient Occlusion: OFF

V-Ray:: Indirect Illumination (GI) Rollout

23

On: This function enables or disables the indirect illumination parameters (Fig.22 – 23).

Ambient occlusion: This group sets the AO parameters globally. It only affects indirectly lit areas of the scene. When enabled, the Amount sets the amount of AO (e.g., 0.0 = no AO). The Radius function sets the radius of the connecting shadows. The Subdivs function sets the amount of samples necessary to compute the AO. The default is rarely increased (Fig.24 – 25).

24

25

Primary bounces: The indirect illumination takes into consideration the first set of ray bounces from surfaces visible to the camera. Users can choose from a number of GI engine modes from the pull-down list to compute the primary bounces. This function is often used to help brighten up the scene. One of the most popular ones is the Irradiance map approximation (Fig.26 – 27).

Secondary bounces: Indirect illumination takes into consideration the second set of ray bounces from surfaces used in the GI calculation. Users can choose a number of GI engine modes from the pull-down list to compute the secondary bounces. One of the most popular ones is the Light cache approximation. Fewer users implement Brute Force as it is unbiased (e.g., more time consuming, but more accurate). The Brute Force parameters are self-explanatory.

V-Ray:: Irradiance Map Rollout

In a nutshell, irradiance map is the process of efficiently computing the diffuse irradiance of object surfaces in the scene. It does it efficiently by adding more global illumination detail only in areas where surfaces are close to each other, and on non-uniformly lit areas.

Built-in presets > Current preset: This pull-down list allows users to load a number of presets to help calculate the irradiance map. For test renders users often choose the Low preset, and for final renders users pick the Medium or High preset. Specific lights and materials that depend on irradiance values will benefit a great deal from higher settings (Fig.28 – 29).

Basic paramenters > HSph. subdivs: This function determines the quality of the samples.

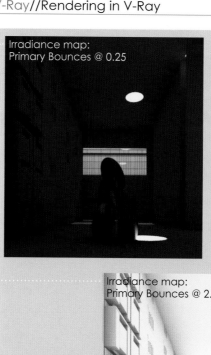

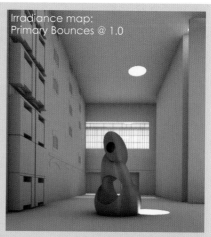

Irradiance map: Primary Bounces @ 0.25

Irradiance map: Primary Bounces @ 1.0

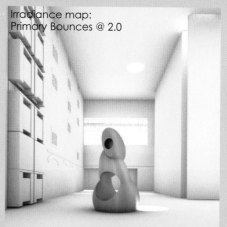

Irradiance map: Primary Bounces @ 2.0

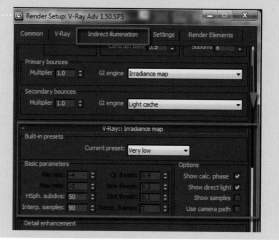

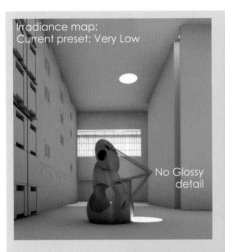

Irradiance map:
Current preset: Very Low

No Glossy
detail

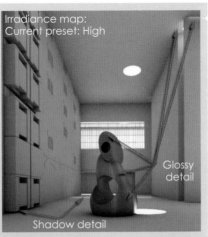

Irradiance map:
Current preset: High

Glossy
detail

Shadow detail

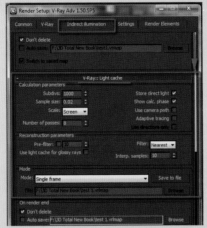

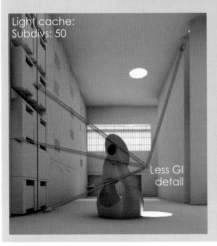

Light cache:
Subdivs: 50

Less GI
detail

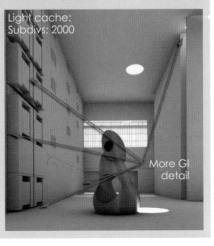

Light cache:
Subdivs: 2000

More GI
detail

29 Smaller values yield faster renders (e.g., less accurate). The default value is often okay.

Interp. samples: This function sets the number of samples to be interpolated. Larger values often smooth out/blur artifacts.

Options > Show calc. phase: This function allows users to see the irradiance map calculation phase in the render buffer.

Show direct light: This function allows users to view the direct light during pre-calculation.

30 ## V-Ray:: Light Cache Rollout

Light cache is a V-Ray specific technique to achieve the global illumination in a scene. Furthermore, this GI approach is very similar to photon mapping (Fig.30).

Calculation parameters > Subdivs: This function determines the accuracy of the light cache. Values of 1000 or above are recommended for final high resolution renders (Fig.31).

Reconstruction parameters > Pre-filter:

31 When enabled, it filters the light cache samples during the pre-calculation time, which can be quite useful when saving the light cache file. Higher values yield blurrier results (at times necessary to correct noisy samples)(see Fig.32).

Use light cache for glossy rays: This function uses the light cache for glossy rays. This option is immensely useful to help reduce the rendering process of glossy surfaces. However, the glossy surfaces may not look as attractive.

Note: Some of the parameters not mentioned here are covered in the tutorials.

10//Proxies in mental ray

Proxies often help you handle large amounts
of data in a scene and reduce the rendering
times dramatically. It's recommended that you
seriously consider creating proxies once the
3ds Max scene has reached about 90 MB in size.
Trees, grass and furniture often contribute a
great deal to increasing the scene file size. The
following tutorial will highlight the process of
quickly creating mental ray proxies.

Collapsing Groups

1: Ensure you isolate the set/group in
question. To do this simply select the
relevant objects and right-click them,
followed by selecting the Isolate Selection
option from the quad menu pop-up
(Fig.01).

2: The next step is to open the group (if
applicable) and collapse any potential
instanced geometry. 3ds Max cannot
attach instanced geometry, therefore
it's necessary to collapse them first. The
quickest way of doing this is to select
the entire group and convert it into an
editable mesh or editable poly. Select the
relevant objects and right-click, followed
by choosing the Convert to Editable Poly
option from the quad menu pop-up.
Editable Poly was chosen because it gives
you the option to attach multiple objects
at once (Fig.02).

3: Next, select any of the objects and open the Modify command panel. Under the Edit Geometry rollout, click on the Attach List toggle and attach multiple objects from its dialog box list (Fig.03).

4: The material Attach Options dialog box should be prompted. Choose Match Material IDS to Material and to Condense Material and IDs, followed by clicking OK to close the dialog box (Fig.04). All the geometry should be attached and a new Multi/Sub-Object material created (Fig.05).

5: Next, ensure that you have the Pivot point of the object at the base. This will prove crucial when planting/positioning proxies (Fig.06).

Creating a Proxy

1: In the Command panel, open the Geometry command and choose mental ray from its drop-down list (Fig.07).

2: Open all four viewports and click on the mr Proxy button. Click and drag it along the Top viewport to begin creating the proxy gizmo (Fig.08).

3: Open the Modify panel and choose the Source Object by first clicking on its button and selecting the relevant object in the scene (Fig.09).

4: Next, click on the Write Object to File toggle to name and save the file in its dialog box. Ensure that you save the file in a shared and accessible drive in the network (Fig.10).

5: The mr Proxy Creation should be prompted. There are a number of available options; choose Current Frame and click OK to close it. The location of the created proxy should be listed in the Proxy File group (Fig.11). It's worth noting that, depending on your scene setup, having the Preview Generation group enabled may cause slow rendering times when creating the preview. For this reason some users tend to disable this.

6: Once the proxy has been created, if it's not in the correct position, simply move it accordingly. The Show Bounding Box function should also help position the proxy, especially due to its previously adjusted pivot point. There may be few cases when you need to tweak the Scale value to ensure it matches with the original mesh it was generated from. The Viewport Verts function allows you to preview the point cloud. Having more vertices displayed in the viewport will make the proxy heavier in size (Fig.12).

7: The final step is to assign the previously created Multi/Sub-Object material onto the proxy object. In addition, you also save out the original mesh for reference purposes and keep the proxies in the main scene (Fig.13).

It's worth mentioning that when copying proxies you should copy them as an Instance, as opposed to Copy, in addition to enabling the BSP2 Raytrace Acceleration method. This will reduce the rendering times dramatically. You should only copy proxies when absolutely necessary. Instanced proxy objects and BSP2 means less memory consumption, whereas copied proxy objects and BSP2 means higher memory consumption.

The ideal situation would be to have mental ray load up proxies only once (multiple instanced proxies or one big proxy with different sets of plants, trees, etc., attached together as one mesh).

To scale individual instanced proxies to create randomness in the scene, simply use the Scale tool from the main toolbar as opposed to using the proxy Scale function from the Modify command.

Chapter 02

06//Pre-Production

Client Brief

The pre-production process begins with a brief from the client describing their concept, ideas and vision, while also showcasing physical samples of things like textures, finishes, sketches and photo references. At the same time, they will also send you information about deadlines, etc.

Photo References

The next step after receiving the brief is to find the best photo references to use as a source for art direction, lighting, design possibilities and finishes, etc. This process is one of the most important stages of the entire project! It's crucial to liaise directly with the client about subjects such as the individual features of the project and the design, etc.

01

Camera/Lighting/Effects First Choices

Ideal lighting, camera and colors

Similar lighting with blue tones

Alternative Choices

Close-up and angled camera

Depth of field for close-up shots

Wider camera view looking up

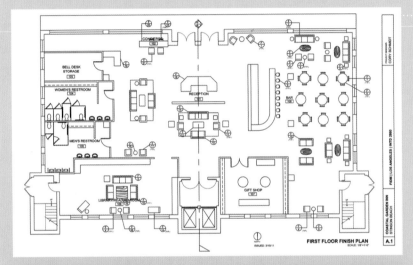

FIRST FLOOR FINISH PLAN
SCALE: 1/8"=1'-0"

02 Since the final image in this case will be used as marketing on billboards and magazines, etc., you will need to source photo references that are sympathetic to this kind of work. They will have an impact on the decisions you make about the render output size, alternative camera angles, colors, 3D content and composition.

03 Having the above information will help you have a better understanding of the project, in order to make key decisions about the final composition, lighting, types of people to be added in post-production and how they interact with the space and camera angle.

Mood Board

One you have done this you can create a mood board containing images that will influence the project's direction and final presentation. These images can be sourced from the internet, magazines or even your own catalog of reference images (Fig.01 – 02).

Draft 3D Model

04 Before working on the materials and other individual features of the scene we need to first establish the composition by creating a draft 3D model of the space. This draft model should consist of the main shapes and the key components of the scene, as these are what will have an impact on the composition of the final image. You will be provided with sketches and drawings by the client to help you create your draft 3D model. Some clients may even provide a draft model (Fig.03 – 04).

Camera Position

Once you have created your draft model you can set up the camera position (or positions) that shows off the relevant areas of the design.

By doing this you can quickly generate some options for your client. Once the client has seen some options they should be able to mark their chosen camera angles on the sketches or drawings they provided you with at the start of the process (Fig.05).

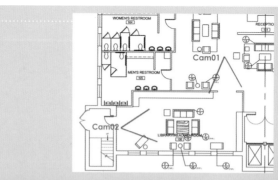

Setting the Camera

1: Open the Create panel and in the camera group, choose the Target type.

2: Click and drag the cursor to create and set its target direction. Use the top viewport to get a better view of the results (Fig.06).

3: Open the Modify command panel.

4: In the Parameters rollout, choose Free Camera. This will give you more flexibility to move the camera around.

5: While the camera is selected, move it down to eye level (e.g., 1.58m, 1.60m from the floor). Make sure that you move it along the Z axis and that you have set the Display Unit Scale to Metric. At times even accurate scenes may look disproportionate in scale as the result of not having the camera at eye level. This practice will also prove vital when integrating people and other objects in post-production (Fig.07).

Field of View

1: The photo references and the client's feedback should be used as a guide to capture the correct field of view (FOV). To ensure that the exact camera frame is being displayed in the viewport, enable the Show Safe Frames function (Shift + F) while in Camera View mode.

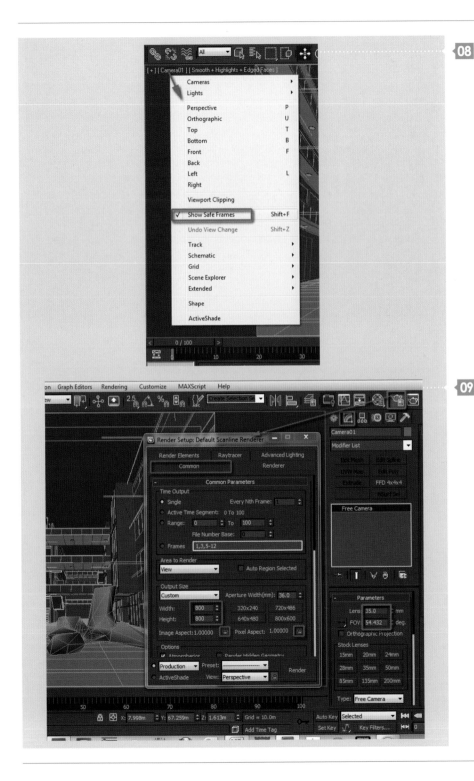

2: While the camera is still selected, go to the Modify command panel and set the camera lens to about 35mm.

3: To capture more of the frame, open the Render Setup dialog box (F10).

4: In the Common tab, under the Render Output Size group, set the Width and Height to about 800 pixels (i.e., portrait). Also lock the Image Aspect and the Pixel Aspect. This will ensure that the frame type remains when the output size values are changed later (Fig.08 – 09).

If the camera view captures all the design features that the client intended, they will sign it off and give you the go-ahead. Once you have their approval of the camera angle and your mood boards you will have a good idea of the overall art direction. This entire process is designed to help the client quickly understand and preview the impact of their design choices and the artistic direction, before entering the production phase.

Conclusion

The pre-production phase is one of the most important stages of the entire project. As such it's vital to discuss and liaise with the client about the art direction, important design features, camera views, technical constraints, budget and material finishes.

Mood boards are one of many effective ways of getting ideas across and brainstorming. This production stage will also help the client consider or reconsider various aspects of the original project direction, before entering the production phase.

12//Creating Materials

Introduction

With the art direction and the materials agreed upon, the process of creating the materials should be quite straightforward. The following tutorial will talk you through the intricacies of creating key scene materials, while focusing primarily on the fine-tuning of the main shader parameters for the subsequent process of creating the lights and rendering.

Camera Height

Let's start by opening the file under the name of Interior Daylight_Start.max. When a window pops up with Adopt the files Gamma and LUT Settings in it, select OK. It's worth mentioning that the camera and the render size have been chosen already during the pre-production process. After some trial and error the camera height was set to about 1.58/1.60 meters, which is about the standard eye level of most cameras (Fig.01 – 02). Some users or clients, however, might prefer a slightly lower or higher camera height depending on the effect intended.

Unit Setup

The first parameter to adjust is the Units Setup display function. This will prove crucial when creating real scale objects accurately, measuring distances in the scene and entering bitmap values, etc. To do so, simply go to the main toolbar and click on the Customize tab, followed by choosing the Units Setup function from the drop-down list (Fig.03).

Its dialog box should appear. By default its Display Unit Scale is set to Generic Units. Change it to Metric and choose the Meters

High quality fair faced insitu concrete

04 unit type. I normally work between meters and millimeters depending on the size of the object I am creating and the length of the numeric value I am entering or measuring. However, you can choose the metric unit if you feel more comfortable working with.

Although it was previously mentioned that the camera was set to meters, for the purpose of this exercise the Max file is set to Generic to provide you with the opportunity to adjust the metric units to your liking.

05 It's worth noting that this action does not affect the scale of the geometry in any way, shape or form. It is only a guideline for metric display purposes.

To ensure that objects merged/imported into this scene retain their original scale/size, we are going to open the System Unit Setup dialog box (Fig.04).

Once opened, ensure that the Respect System Units in Files function is enabled. Please note **06** that the original System Unit Scale function should never be changed unless there's an exceptional reason to do so (Fig.05).

Measuring Objects in the Scene

Prior to beginning work on the file it is common practice to quickly measure objects in the scene, to check if they have the correct scale. To do so simply create a Tape helper and begin measuring objects such as chair seats (0.4m), the door height (2.2m) and the floor to ceiling height, etc (Fig.06). If the measurements are not what they would be in the real world, then it is worth re-importing/merging or re-modeling certain objects, or even the entire scene.

Our eyes easily detect scale discrepancies, therefore if they exist in your scene it will be perceived as unrealistic. These precautionary measures will prove vital when creating textures and making the scene look believable.

Opening mental ray

The next step is to load the mental ray rendering engine.

1: Open the Render Setup dialog box by pressing the F10 key.

2: In the Common tab parameters, scroll down to the Assign Renderer rollout and click on the Production toggle. The Choose Renderer dialog box should pop up.

3: Choose the mental ray renderer from the list and press OK to close the dialog box. The mental ray renderer should load up (Fig.07 – 08). If you have a newer version of 3ds Max you may need to choose NVIDIA Mental Ray from the list.

The next phase is to begin applying textures.

Metal Surfaces

The first material to begin working on is the metal surfaces.

1: Open the Material Editor by pressing the M key or by clicking on its icon.

2: Next select an empty material slot and click on its Standard shader toggle to load up the Arch & Design shader (Fig.09).

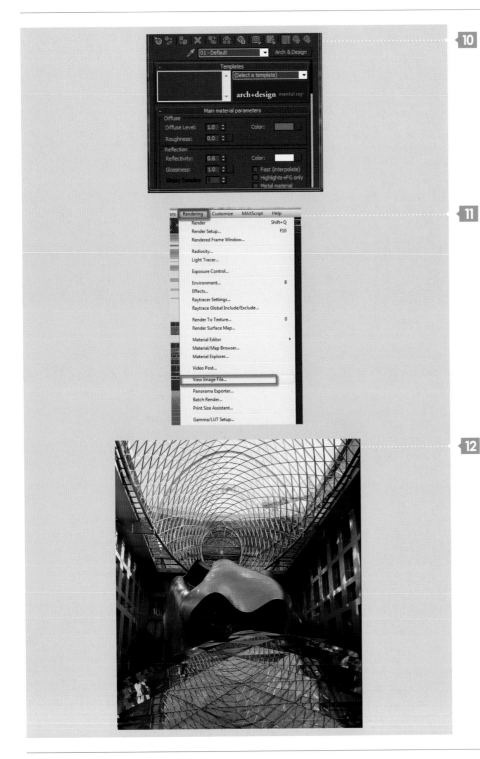

3: The Material/Map Browser dialog box should pop up. Under the mental ray rollout, choose the Arch & Design shader from the list (Fig.10).

Reference Observation

Prior to commencing the work on the material, open and locate the photo reference called render_reference1.jpg. To do so, simply click on the Rendering main toolbar and choose the View Image File option from the drop-down list (Fig.11).

It's common to hear scientists and researchers using the phrase "part of good science is good observation". To be a good scientist you need to observe things carefully, the same is true when working on a realistic scene.

Looking closely at the tall metallic sculpture at the center of the atrium, one can see that it is quite reflective and captures the blue hue from the skylight and the environment. Also, it is quite glossy (Fig.12).

Loading the Material

Let's start by loading the metal pre-set template under the name of Satined Metal. In the Template rollout, pick the Satined Metal pre-set from its drop-down list (Fig.13). Once loaded, its core properties text should be displayed. Also note how its physical properties have changed (Fig.14).

Adjusting Materials

By default, some of mental ray default parameters are too high and others are too low or disabled. The next task is to fine-tune these parameters for optimal results.

1: Scroll down to the Special Effects rollout and enable the Ambient Occlusion function. This function will add detail and depth to objects. Set its Max distance value to about 3.0m (Fig.15). This value worked okay for this scene's scale. However, you may try different values to see what works best.

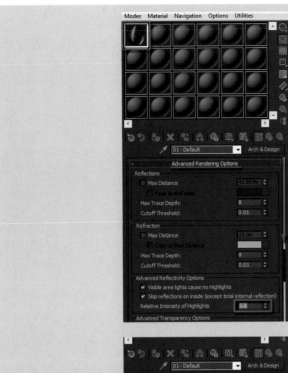

16

2: Some of the core attributes of a metallic surface are the shine and reflections. To boost its shine, scroll down to the Advanced Rendering Options rollout. Under the Advanced Reflectivity Options group, increase its Relative Intensity of Highlights to about 3.0. Note in the material thumbnail how its shine has changed. You can try different values if desired (Fig.16).

3: Its glossy grid density is set to default. To change it, scroll down to the Fast Glossy Interpolation rollout and change its default Interpolation Grid Density to 1 (Fig.17).

17

4: Finally, name this material accordingly so you can remember the original shader pre-set that you adjusted (e.g., "Metal Panel (satined metal)"). Also, assign this material to all the relevant objects in the scene (Metal Panel, etc.,) and test render the results (Shift + Q) (Fig.18). This stage is mainly to tweak key parameters; you will fine-tune it later when the lights have been added.

A simple method of searching for and selecting objects is to press the H key and type the object's name in the Find field.

18

Due to the long list of objects that require this material, it's recommended that you use the scene file called Interior Daylight_Finished.max as a reference.

The Roof Light

The next material to concentrate on is the roof light material (e.g., the etfe cushion roof). Using the same steps as were described earlier, locate and open the photo reference image under the name of Translucent.jpg. At first glance you can see that its surface is transparent with a slightly blurry effect. It's worth mentioning that in this case the client wanted this material to be more reflective than depicted in the photo reference. As mentioned earlier, this stage is mainly to tweak key parameters; again it will be fine-tuned later when the lights have been added.

1: Select a new empty material slot and choose the Arch & Design shader. Load the material pre-set template under the name of Translucent Plastic Film. Choose and load the second material, which is under the name of Translucent Plastic Film Opalescent Strong Blur. It is worth mentioning that this material was originally chosen by the client to emulate a translucent roof light material (Fig.19).

2: As you did previously, scroll down to the Fast Glossy Interpolation rollout and change the Interpolation Grid Density to 1 (same as rendering). Also, under the Advanced Rendering Options rollout, ensure you have the Transparency Propagates Alpha Channel function enabled (Fig.20).

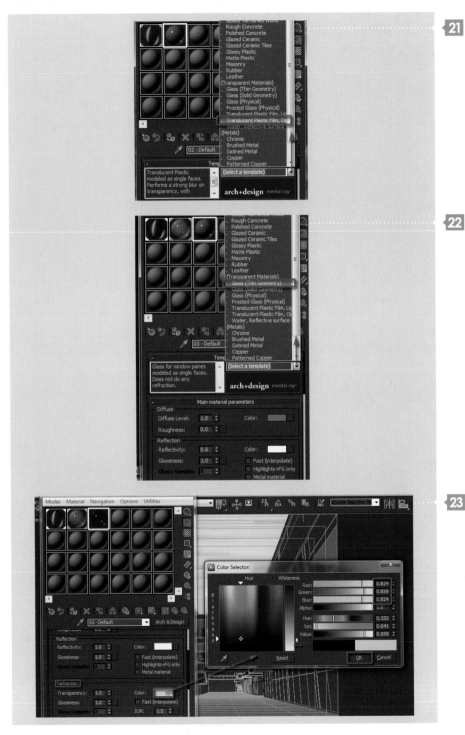

21

This function will be handy when editing the environment alpha channel against this translucent material and its reflections.

3: Finally, name this material accordingly (e.g., "etfe cushion roof (Translucent Plastic Film, Op)") and assign it to the etfe cushion roof object in the scene. Test render (Shift + Q) the results (Fig.21).

22

It is worth mentioning that a similar material was assigned to the main translucent sculpture in the scene. It is currently hidden for the purpose of this specific tutorial. However you can unhide it and assign the same material to it if desired.

The Glass Surface

The next material to focus on is the glass.

1: Select a new empty material slot and choose the Arch & Design shader. Load the Glass (Thin Geometry) material template from the list. This shader is quite good at emulating a standard office glass material (Fig.22).

23

2: Office glass often has a slight green tint to it. To emulate this, simply scroll down to its Refraction group and click on its color swatch to bring up the Color Selector dialog box.

3: Choose a light green tone (R: 0.824; G: 0.859; B: 0.824) and hit OK to close the dialog box. You may choose a different hue of green if desired (Fig.23).

4: Next change the Fast Glossy Interpolation density to 1(same as rendering). Also name this material accordingly and assign it to all the glass objects in the scene (e.g., doubled-glazed curtain walling, etc). Test render (Shift + Q) and look at the results (Fig.24). Due to the long list of objects that require this material, it's recommended that you use the Interior Daylight_Finished.max file, for reference purposes.

The Floor Surface

Next we will focus on the floor material. It is worth mentioning that the client had already supplied the floor texture (extensive photos of the relevant surface and physical/object samples to be scanned in).

1: Load up a new Pearl finish material template using the steps highlighted earlier (Fig.25).

2: Next apply a bitmap chosen by the client. Click on the Color diffuse toggle to bring up the Material/Map Browser dialog box (Fig.26).

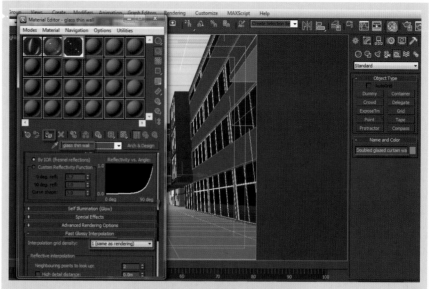

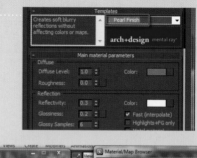

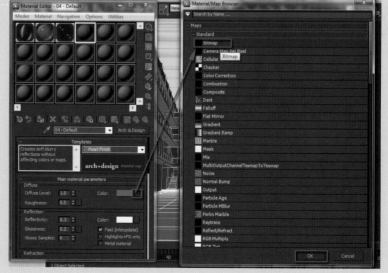

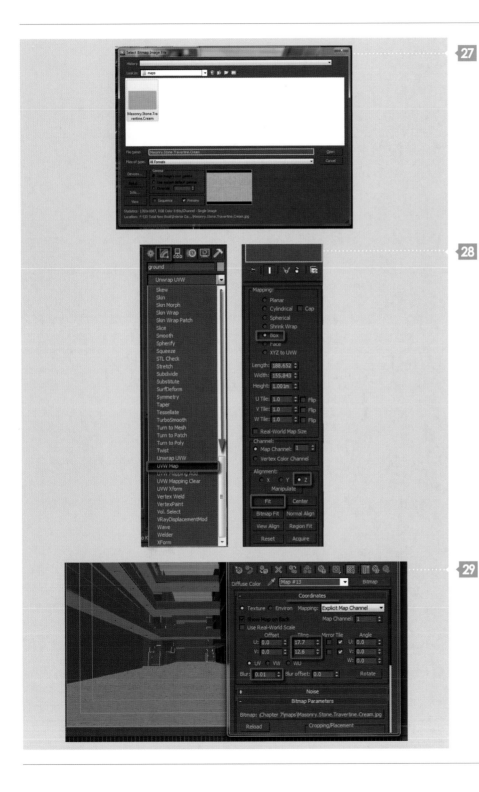

3: Choose the Bitmap option from the Standard rollout list and pick the bitmap under the name of Masonry.Stone. Travertine.Cream (Fig.27).

4: Its default coordinates should load. Assign it to the object called ground. With the bitmap applied, the next step is to adjust it so it looks realistic and part of the scene.

5: Open the Modify command and apply the UVW Map modifier from its dropdown list.

6: Choose the Box Mapping type with the Z alignment axis, and click the Fit button to automatically adjust the texture (Fig.28). The mapping type was chosen as it wraps well around the relevant surface.

7: Back in the Material Editor bitmap Coordinates, decrease the Blur value to 0.01 to make the texture sharp. Note that this action may increase the rendering time of this texture slightly.

8: To make the texture tiling scale realistic, increase the U tiling value to about 17.7 and the V tiling to about 12.6. You might want to try different values if desired (Fig.29).

Floor Reflections

The next step is to begin adding a slight diffused shine to the surface.

1: Back in the Main Material Parameters, in the Reflection group, decrease the Reflectivity value to about 0.3 and the Glossiness to 0.2. Note how the shine is being affected by these values in the Material Editor slot thumbnail (Fig.30).

2: Disable the Fast (interpolate) function. This action will prevent the material from yielding artifacts.

3: To widen the glossy highlight depicted on the material slot thumbnail, we are going to increase its BRDF 0 deg. refl value to about 0.41. You can try different values, if desired. It's worth noting that, while the glossy highlight is being widened, the reflection is also going to be increased automatically (Fig.31). However, since the Glossiness value is low the reflections and the glossiness are going to be diffused. Also, change the Fast Glossy Interpolation density to 1(same as rendering) and enable its Ambient Occlusion function.

The intended effect is looking okay. However, most surfaces in the real world are uneven. To emulate this effect we are going to apply a Noise Procedural map in the Bump toggle to break up the surface.

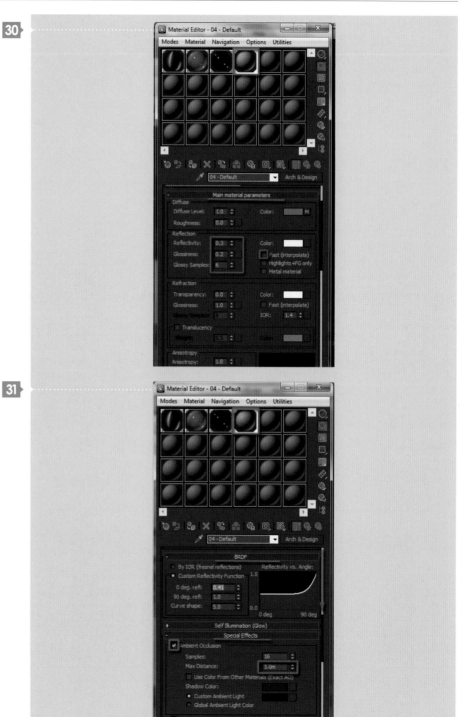

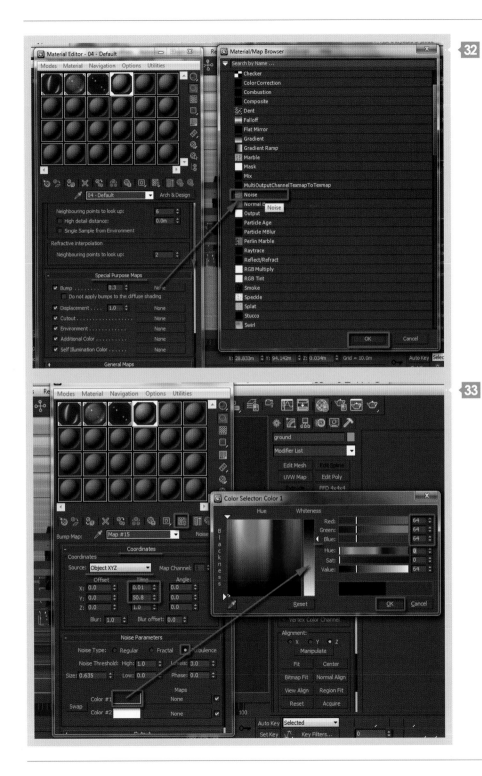

1: Scroll down to the Special Purpose Maps rollout and click on its Bump toggle.

2: In the Material/Map Browser dialog box, choose the Noise procedural map from the list (Fig.32).

3: Its parameters should load up. Click on the Show Standard Map button to see the procedural map displayed in the viewport.

4: The Noise seems too spread out on the floor's surface. To break it up, change the Noise parameters to Turbulence, and increase its X tiling to 0.01 and Y tiling to 50.8.

5: To soften its bump appearance, change its default Color swatch to light gray and test render the results (Fig.33).

The surface should look good now, but if you are not completely satisfied with the current bump results, decrease its amount to about 0.07. It's worth mentioning that once the lights are added most of these parameters will be tweaked further.

With the correct bitmap tiling and the basic shader parameters inputted, the subsequent test renders, which will include the lights, will be limited to fine-tuning minor settings only. This workflow will save users a considerable amount of time when test rendering.

Concrete Surface

The next material to concentrate on is the concrete surface. It's also worth mentioning that the client had already supplied the appropriate texture for the concrete (e.g., extensive photos of the relevant surface and physical/object samples to be scanned in).

1: In the scene, select the object under the name of High quality fair faced insutu concrete04.

2: Create a new material slot and load up the Rough Concrete material template using the steps highlighted earlier. Also assign it to the selected object and name it accordingly (e.g., "High quality fair faced insutu concrete rough concrete").

3: The concrete default shine seems a bit too shiny. To adjust this, simply reduce its Reflectivity and Glossiness to 0.28 (Fig.34).

4: Most concrete surfaces have a slight diffused shine to them. To achieve this, simply scroll down to the BDRF rollout and increase its 0 deg. refl value to about 0.91. You can clearly see the changes taking place in the Material Editor thumbnail. This value worked okay, however you can use different values if desired.

5: Also enable the Ambient Occlusion function (Fig.35).

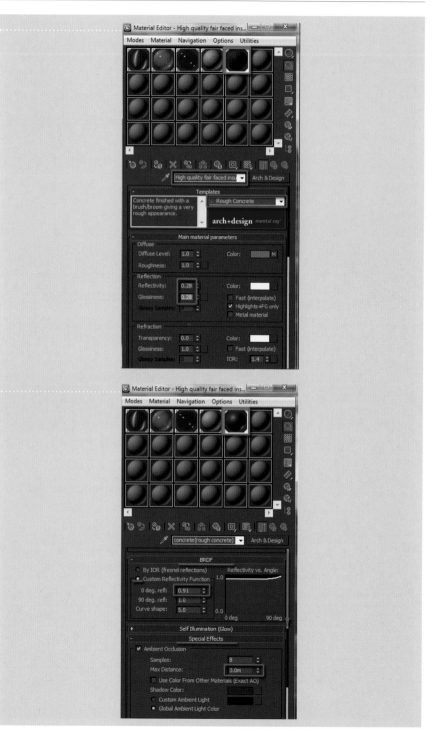

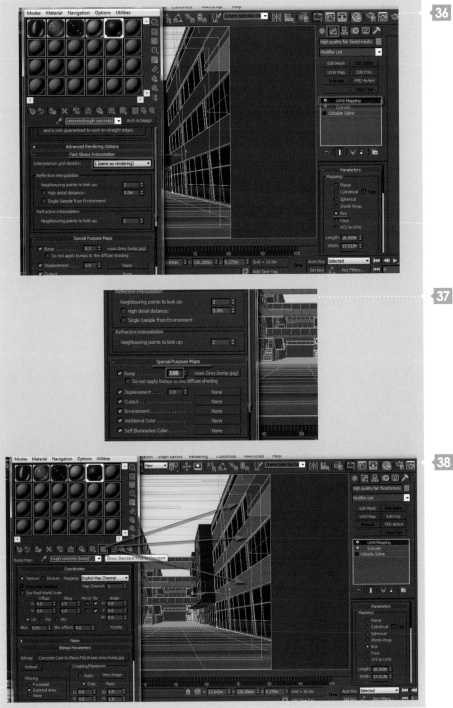

Concrete Maps

You will then need to apply the UVW Map modifier using the techniques we covered earlier.

1: Set its Fast Glossy Interpolation function to 1 (same as rendering) and do a test render (Shift + Q) (Fig.36).

2: The bump value on the concrete texture looks a bit too high in the render. To rectify this scroll down to the Special Purpose Maps rollout and decrease the Bump value to about 0.06 (Fig.37).

3: To preview the texture tiling in the viewport, enable the Show Standard Map in the Viewport button, inside its bitmap coordinates (Fig.38). It's worth noting that once the lights have been added to the scene you may be required to tweak certain values further.

Chamfered Edges

To chamfer the edges of an object without
having to manually add extra geometry to the
surface, we are going to enable the Round
Corners function, under the Special Effects
rollout. Due to the fact that the results of
this effect are only visible in the render, we
are going to create a dummy object (e.g.,
chamferbox) in the viewport in order to find
the adequate value to input. This technique will
help save time by reducing the number of test
renders considerably.

1: Select and isolate the relevant object (Alt
+ Q).

2: In the Create command panel, change
the default Standard Primitives to
Extended Primitives (Fig.39) and choose
the Chamferbox object type (Fig.40).

3: Create a chamferbox with similar
dimensions to the main object in the
scene.

4: Since the Fillet value of the chamferbox
is going to be relatively minuscule, we
need to change the Display Unit Scale to
millimeters in order to input the correct
value. It's worth noting that this action
will only affect the units' display, not the
scale. It is quite common for professionals
to switch between metric displays
depending on the size of the numerical
value (Fig.41).

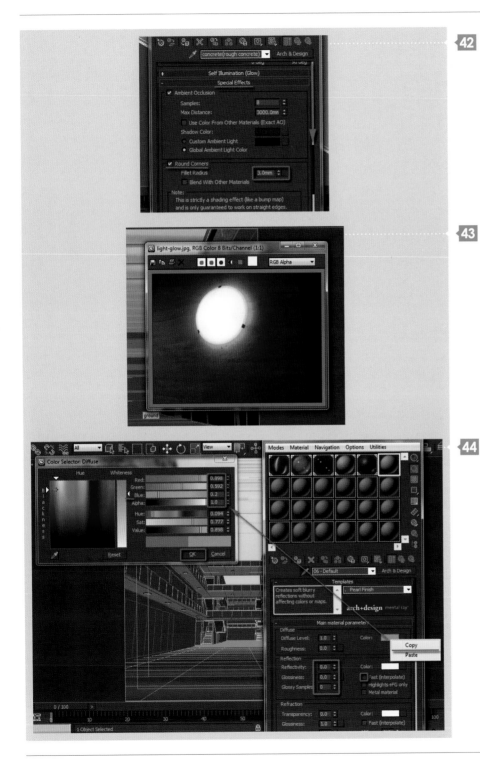

5: After a few tweaks to the Fillet values, 3mm seems to have worked best.

6: Next go the Special Effects rollout and input a value of 3mm to the Fillet Radius value. You can delete the chamferbox dummy object, or set it to not render. Also you may want to apply this effect to some of the other materials in the scene (Fig.42).

Glowing Light

The final material to focus on is the glowing light. Locate and open the photo reference image under the name of light-glow.jpg. As you can see, the lights glow brightly from the center and are surrounded with a colored ring around the edges (Fig.43). As I mentioned earlier, this stage is mainly to tweak the key parameters; they will be fine-tuned later when lights are added.

1: Select another empty material slot and create a new Pearl Finish material template using the steps described earlier.

2: In the scene, select the object named light 12.

3: Change its color swatch to an orange (R: 0.898; G: 0.592; B: 0.2). Also copy its diffuse color swatch by right-clicking and choosing Copy (Fig.44).

4: Since there are no reflections we are going to set all Reflection values to 0.0 and disable the Fast (interpolate) function.

5: Scroll down to the Self Illumination
(Glow) rollout and enable it (Fig.45).

6: Select the Filter color swatch, right-click
and paste the previously copied color.

7: Assign the material to the selected object.
Also set the luminance to Physical Units:
(cd/m2), and test render (Shift+ Q).

8: The glow seems a bit too high in the
render. Reduce it to about 500 and test
render again (Fig.46).

The glow now looks much better. However, the
colored ring is only apparent when there is a
texture assigned to it. Note that this approach
is often implemented by reputable companies.

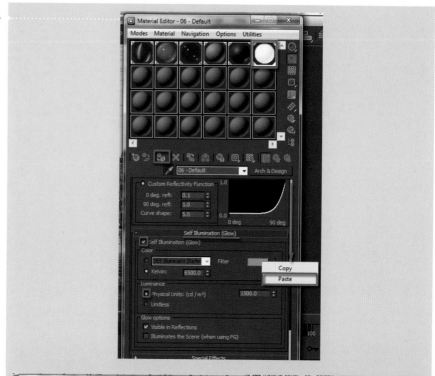

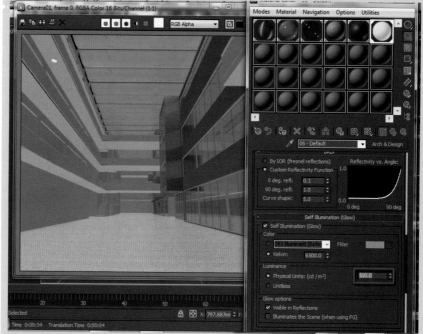

1: In the Main Material Parameters rollout, assign the bitmap light-glowMain.jpg to the Diffuse toggle. Also, isolate (Alt + Q) the light 12 object (Fig.47).

2: To ensure that the bitmap accommodates the object's circular shape, apply the UVW Map modifier to it and make the bitmap visible in the viewport.

3: Click on the UVW Mapping modifier from its list to be able to manually move the gizmo in the viewport (Fig.48).

4: Choose the box mapping type and tweak its Length and Width values to make the colored ring fit within the boundaries of the surface. Also move the UVW Mapping gizmo to help fit the bitmap.

5: Copy the bitmap from the Color diffuse toggle of the Main Material Parameters rollout (right-click + Copy) and Paste Instance it in the Filter toggle of the Self Illumination (glow) rollout.

6: Finally, apply this material to all other relevant objects in the scene using the steps covered earlier.

Conclusion

It is imperative to create materials and shaders using real photos as reference. Due to the fact that global illumination (GI) and lights take a considerable amount of time to compute, the initial task of applying shaders and textures should be carried out in order to speed up the process. Using this approach from the start, the user will be left with minor adjustments to address when the global illumination and the lights are created at a later stage.

13//Lighting

Introduction

With all the materials created, the next step is to bring the scene to life. This exercise will take you through the intricacies of setting up the scene to begin lighting in the most efficient and realistic manner. During this process you will learn how to:

- Use a striking photo reference similar to the 3D space to create CG photorealism.
- Create a daylight system and photometric lights.
- Use the Material Override to quickly test render the scene with the lights and Global Illumination.
- Position the lights strategically to achieve the perfect depth.
- Fine-tune the lights and the materials to complement each other and match key elements of the photo reference closely.

It is worth noting that this exercise is not about recreating an exact replica of a photo reference. It is about choosing key elements to integrate into a proposed design space, while following the client's original brief and material specifications. As mentioned earlier, part of good science and artistry is good observation.

Material Override

Let's start by first enabling the Material Override for fast rendering turnarounds.

1: Open the Render Setup dialog box (F10). In the Processing tab, under the Translator Options rollout, enable the Material Override function (Fig.01).

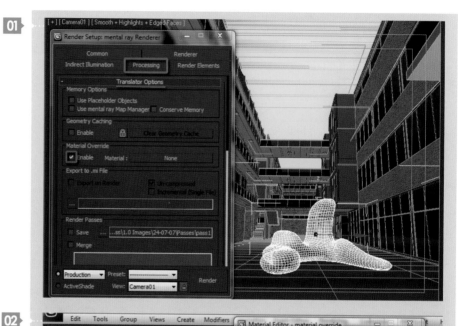

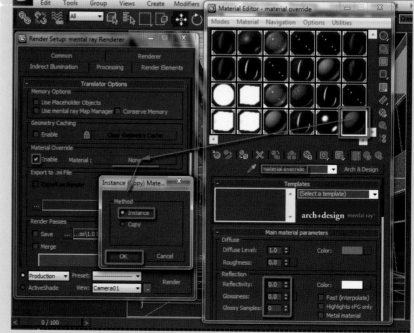

Creating the Basic Override Material

Next we are going to create a basic white, non-reflective material to be used as the Material Override.

1: Open the Material Editor (M), select an empty slot and name it "Material Override".

2: Load the Arch & Design shader as described in the previous chapter.

3: In the Main Material parameters rollout, under the Reflection group, set all its values to 0.0. This will disable all the reflectivity and glossy highlights.

4: Next drag this slot from the Material Editor into the toggle of the Material Override function.

5: The Instance (Copy) Material dialog box should be prompted (Fig.02). Choose the Instance method function. Both parameters should now be linked. Test render the results (Shift + Q).

Creating the First Light

Next we are going to create the first light in scene using the Daylight System.

1: Click on the Maximize Viewport toggle (Ctrl + W) to have all four viewports displayed (top, front, left and the camera viewport). This will facilitate the creation of the Daylight System object.

2: Click on Create in the main toolbar (Fig.03).

3: On the drop-down list, choose Lights followed by clicking on the Daylight System option. Alternatively, if using newer versions of 3ds Max, the Daylight System can be accessed in the Systems main toolbar.

4: Hit the cursor in the Top viewport to begin the creation. The Daylight System Creation dialog box should be prompted; choose Yes to automatically create the mr Photographic Exposure Control (Fig.04).

5: Click and drag to create the daylight compass first. Once you have done this, release and move the mouse to create the Daylight System object. Click again to end the creation once you are satisfied with its distance from the ground (Fig.05).

Adjusting the Light

Next we are going to change some of the light's key parameters to ensure that everything renders accurately.

1: While the Daylight System object is still selected, open the Modify command.

2: In the Daylight Parameters rollout, change the Sunlight type from Standard to mr Sun (Fig.06).

3: Change the Skylight type to mr Sky. The mental ray Sky dialog box should be prompted. Click Yes to automatically create the mr Physical Sky environment map (Fig.07). Test render the results (Shift + Q).

156

08

09

10

Sunlight Shadows

The render looks a bit too dark due to the override material. For the time being though we are going to concentrate on setting the direction of the sunlight shadows.

1: In the Modify parameters of the Daylight System object, go to the Position group and enable the Manual function to begin moving the direction of the sunlight object.

2: To interactively preview the position of the shadows in the viewport you need to turn on the Smooth + Highlights + HW function in the viewport (if you are using a new version of 3ds Max this function may not be available, in which case you can simply enable Shaded mode). To do this click on the text and in the drop-down menu choose Lighting and Shadows, then Illuminate with Scene Lights (Fig.08).

3: Repeat the same action to enable other viewport functions, such as Hardware Shading, Exposure Control in Viewport and Shadows.

4: With the Move tool, begin moving the daylight object to a position where the direct shadows fall on the right side of the internal building façade (X: -71.666m; Y: 259.389m; Z: 138.074m) and test render the results (Fig.09). The sunlight shadow direction is looking more appealing now (Fig.10).

Ensure the Compass helper is at the following position: X: 9.747; Y: 115.257m; Z: 0.0m to get accurate results.

Increasing the Brightness

The next step is to increase the brightness of the scene.

1: First enable the Gamma/LUT Setup function. To do so, simply go to the main toolbar and click on the Rendering tab. In the drop-down list, choose the Gamma/LUT Setup option (Fig.11).

2: Set the Gamma value to about 2.2 and accept all the other default values (e.g., Input Gamma: 2.2, Output Gamma: 2.2, Materials and Colors enabled. A value of 2.2 should work for most scenes).

3: Open the Render Setup dialog box (F10). In the Indirect Illumination tab, under the Final Gather rollout, set the Rays per FG Point to about 150. This will increase the number of rays emitted, thus increasing the brightness and smoothing indirectly lit areas.

4: Open the Environment and Effects dialog box (8). In the Environment tab scroll down to the Exposure Control rollout and change the exposure preset to mr Photographic Exposure control. This exposure control preset will yield more realistic exposure effects (Fig.12 – 13).

5: Enable the Process Background and Environment Maps function. It's good practice to always enable this specific function as it will help correct environment-related artifacts in the scene (bitmaps, HDRI, etc).

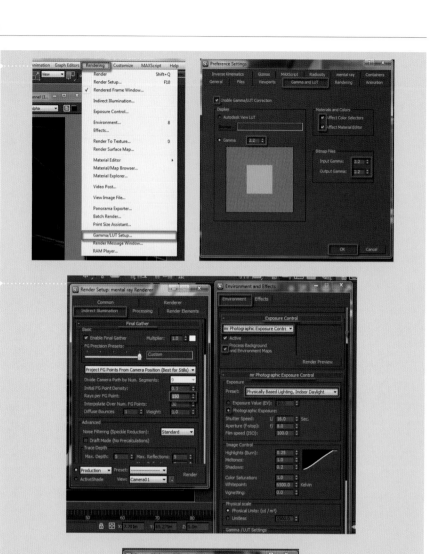

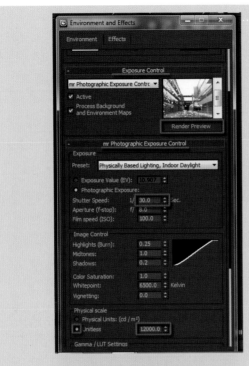

6: In the mr Photographic Exposure Control rollout, change the exposure preset to Physical Based Lighting, Indoor Daylight and enable the Photographic Exposure function. This will ensure that indoor areas receive more light.

7: For a more accurate assessment of the sunlight coming through the roof light into the atrium, it's best to disable the Material Override function. Test render the results (Shift + Q). S

Correcting Scorch Marks

It is worth noting that you don't need to render the entire frame to assess the effect of the sunlight in the atrium. While the render is looking okay, there are certain areas in the scene that are slightly scorched.

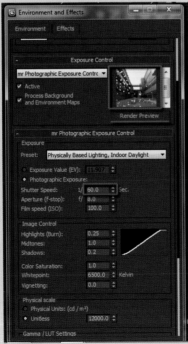

1: To correct this increase the Shutter Speed value to about 30.0.

2: In the Physical Scale group enable the Unitless function and set it to about 120000.0. This value will help blend the exposure control with the environment physical sky. It will also help rectify artifacts related to the environment (Fig.14).

Please note that if you are using a newer version of Max and the physical scale value is set to 80000 you may not have scorching problems. However, setting the physical scale value to 120000 will help rectify most environment artifacts. This value comes from approximate direct luminance data from a real sky model. Most physically accurate rendering engines incorporate this available data into their system to emulate a real sky model.

3: To speed up the test renders without the Material Override enabled, select the viewport and click the Render Preview button in the Exposure Control rollout thumbnail.

Correcting Bleached Out Areas

Although this is a great improvement, the roof light is still bleached out. To correct this, simply increase the Shutter Speed value to about 60.0 and click the Render Preview button again. The roof light should look much better now (Fig.15).

Using the Photo Reference

Next we are going to use the photo references as a guide to make the scene more realistic.

1: Open the photo reference under the name of render_reference1.jpg, the same way as you did in the previous chapter (Fig.16).

2: Note how the blue skylight color is affecting the reflective surfaces and the scene in general. To emulate this we are going to increase the skylight influence in the scene. While the daylight object is still selected, go to the Modify command and expand the mr Sun Basic Parameters rollout.

3: Disable the Inherit from mr Sky function. This will break the inherent link between the mr Sun and mr Sky parameters.

4: In the mr Sky Parameters rollout increase its Multiplier to about 2.0. This will increase the skylight influence in the scene (more blue tones) (Fig.17).

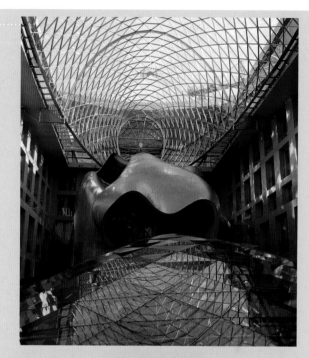

5: To make the blue tint more prominent and similar to the photo reference, scroll down to the mr Sky Advanced Parameters rollout and decrease its Red/Blue Tint value to about -0.4 (Fig.18).

6: With the mr Sky Multiplier set to 2.0 it will automatically make the mr Physical Sky too bright. To prevent this, go back to the Environment and Effects dialog box (8). Also open the Material Editor (M).

7: Back in the Environment and Effects dialog box, under the Common Parameters rollout, drag the mr Physical Sky from the Environment map toggle and drop it in the Material Editor slot. The Instanced (Copy) dialog box should pop up. Choose the Instance method and OK to close it.

8: The mr Physical Sky parameters should load up. First disable the Inherit from mr Sky function. The link between the sky from the Environment toggle (i.e., mr Physical Sky) and the sky object is now disconnected.

9: In the Inherit from mr Sky group, decrease the Multiplier function to about 0.25.

10: Scroll down to the Non-Physical Tuning group and set the Red/Blue Tint to -0.3. Preview another thumbnail render to see the results (Fig.19).

Adding Artificial Lights

Next we are going to start adding some warm artificial lights in the scene to make the image more appealing and similar to the photo reference.

1: In the scene, select the light model group under the name of Light fitting and isolate it (Alt + Q).

2: To create the first artificial light, expand the Create command list and select the Lights group.

3: In the Object type rollout select the Target Light type and click the cursor in the viewport (front viewport preferably) to create the light object (Fig.20).

4: Drag down the cursor to create the direction of its target.

5: Once the direction of the artificial light is set, open the Modify command. In the General Parameters rollout, disable the Targeted function. This will provide the user with more flexibility to move the light around without any constraints to its target.

6: The shadows are disabled be default. This is ideal when carrying out preliminary test renders without a huge increase in the render times. Even though the shadows are disabled, it is always good practice to change the shadows' group type to Ray Traced Shadows in case you decide to enable the shadows at a later stage.

7: In real life most recessed lights are projected down in a cone shape. To emulate this effect change the Light Distribution (Type) to Spotlight (Fig.21).

8: Also, in the Distribution (Spotlight) rollout increase the Falloff/Field value to about 106.0 to start with.

9: Exit Isolation Mode.

10: In the main toolbar change the Selection Filter type to Lights. This will ensure that only the lights in the scene are selected, as opposed to all types of objects.

11: Select and move the light to a position where it sits slightly beneath the first bottom-left recessed light object within the camera view (X: 0.789m; Y: 84.455m; Z: 4.676m). Test render this to see how the light is affecting the scene (Fig.22).

Light Intensity

The current light intensity doesn't seem to have affected the scene much.

1: To correct this scroll down to the Intensity/Color/Attenuation rollout. In the Dimming group enable the Resulting Intensity function and increase its value to about 50.000.

2: To add some warmth to the scene and to make it similar to the photo reference, change its Filter Color to a yellow/bright orange tone (R: 246; G:157; B: 62) and test render the scene again (Fig.23).

3: Finally, in the Distribution (Spotlight) rollout, increase the Hotspot/Beam value to about 42.0, and reduce the Falloff/Field value to 98.0.

Creating a Second Light

The light intensity should now be visible in the scene, which means that the next step is to create a second light.

1: Create the second light (Ctrl +V) and choose the Instance copy method in the Clone Options dialog box (Fig.24).

2: Move it next to the recessed light object directly above in the next floor. Also rotate the light towards the adjacent wall so it washes it down. Its XYZ position should be: X: 0.789m; Y: 84.897m; Z: 9.282m. The rotational position should be around: X: 0.0; Y: 37.2; Z: 0.0 (Fig.25).

3: To speed up the test renders, enable the Material Override function and test render (Alt + Q) (Fig.26). Feel free to choose different position values, if desired.

Creating Multiple Lights

The following step will be to create around 19 more lights. I suggest doing a test render after you create each new light. This is to prevent the scene from becoming overexposed, and it also ensures there is a clear difference between the light and dark areas (which adds depth).

1: All lights should be copy instanced with the following Modify parameters. In the Distribution (Spotlight) rollout, increase the Hotspot/Beam to about 146.0 and the Falloff/Field to about 179.5. These values are changed to increase the hotspot spread. The slight increase of the falloff value will feather/smooth the hotspot edges. Also note that the shadows remained unchecked, to speed up the rendering times.

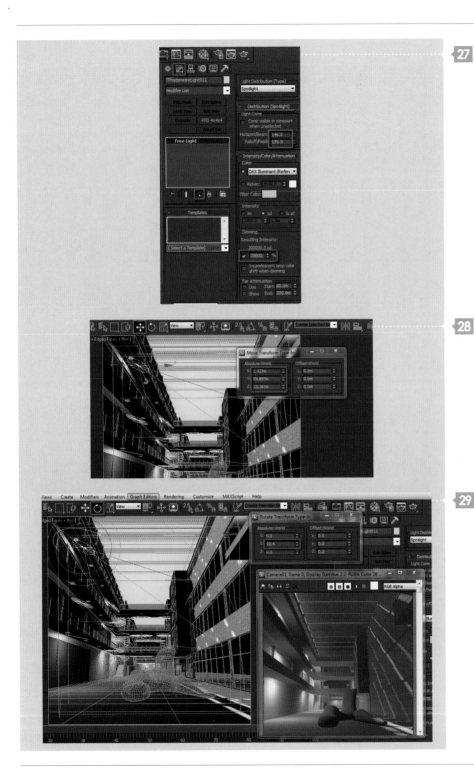

2: For this specific scene the ambient occlusion should make up for the spotlight shadows. Even if the shadows of the artificial lights were on, they wouldn't be very apparent due to the nature of the scene and the position of its contents. Yet the rendering times would be astronomical because of the number of lights casting soft shadows.

3: In the Dimming group, reduce the Resulting Intensity value to about 20.000. This value should subtle the brightness of the light hotspot (Fig.27).

4: The first spotlight created has been moved and rotated slightly. The position of the third light created should be X: 1.427m; Y: 84.897m; Z: 13.261m (Fig.28). Its X rotational value should be 19.4 (Fig.29). The remaining lights were created using some of the steps covered earlier. Test render the results (Shift + Q).

Making Amendments

The next stage is to disable the Material Override function and test render the scene to assess it. At first glance the render is looking okay. However, it could benefit from having more scene highlights, especially from the glow intensity of the recessed lights. Also note that these numerous glow highlights can potentially be reflected onto other objects in the scene, thus creating a more appealing and realistic render. Furthermore, the metal panel reflections look slightly too blurry and don't have enough edge highlights.

1: To fix this open the Material Editor and select the mr Physical Sky Parameters slot. In the Sun Disk Appearance group, increase the Disk Intensity and the Glow Intensity to about 25.0. This action will increase the sun disk intensity appearance on the sky and on other reflective objects in the scene (Fig.30).

2: Select the light glow material in the Material Editor. Scroll down to the Self Illumination (Glow) rollout.

3: In the Luminance group increase the Physical Units value to about 90.000. This action will increase the recessed light glow intensity substantially (Fig.31).

Reducing the Blur

To reduce the reflection blurriness of the metal panels, first select its material slot Metal Panel (satined metal).

1: In the Reflection group increase the Glossiness value to about 0.75 (Fig.32).

2: To bevel its sharp edges, scroll down to the Special Effects rollout and enable the Round Corners group. The Fillet Radius results are only available at render time.

3: To preview its result in the viewport we are going to use a very common trick. First select the Metal Panel object in the scene and isolate it (Alt + Q).

4: Next, create a ChamferBox extended primitive. It should have similar dimensions to the Metal Panel object in the scene. Tweak its Fillet value to preview its results in the viewport. This

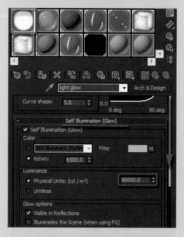

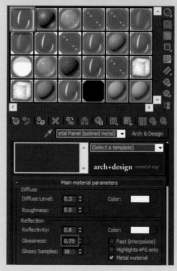

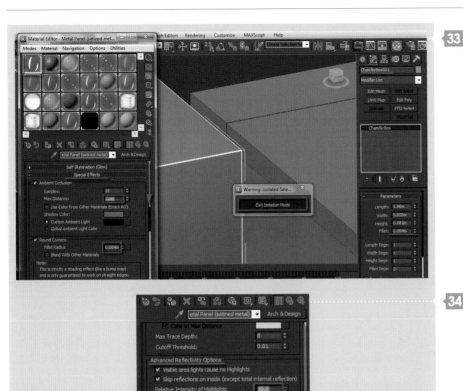

 33

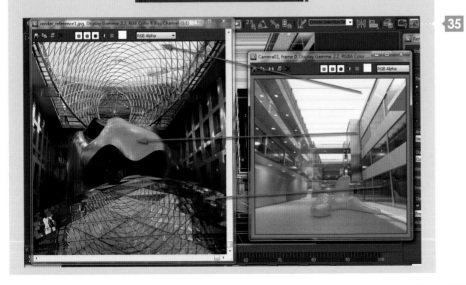

will determine which Round Corners value will work best with the Metal Panel object.

5: The value of 0.004m seemed to work best. Feel free to input a value that you find most suitable (Fig.33). It is also worth noting that to input micro values you should change the Metric Display Unit Scale to millimeters or another lower metric system.

6: Back in the Material Editor, set the Round Corners Fillet Radius value to about 0.004m. Also delete or hide the ChamferBox extended primitive.

7: In addition increase its Ambient Occlusion Max Distance to about 3.0m. This value will ensure that the AO will still be visible even when this object is far away from the camera.

8: In order for this metallic surface to pick up the glint from its corner radius (bevel/ chamfer) or other bright objects, you should increase its Relative Intensity of Highlights function to about 10.0 or higher (Fig.34). This function can be found in the Advanced Rendering Options rollout, under the Advanced Reflectivity Options group. Test render the results.

9: The blue tones, highlights, overall depth and lighting are now much closer to the photo reference. Tweak the remaining materials by using some of the steps covered earlier (Fig.35).

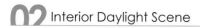
14//Rendering

Rendering

This final stage of the production will focus on:

- Saving the Final Gather map
- Test rendering regions of the scene for quality control.
- Adding elements and testing render effects
- Fine-tuning the global parameters
- Setting the final render output size to high resolution
- Creating the final render.

The Final Gather Map

Let us start by saving the Final Gather (FG) file.

1: Open the Render Setup dialog box (F10) and expand the Indirect Illumination tab.

2: In the Final Gather rollout, set the Initial FG Point Density value to about 5.0. This value will help increase the indirect shadows in the scene (which adds an appearance of depth). However, it will also increase the final gather processing time dramatically (Fig.01).

Rendering Size

Since the FG map will be saved at a small resolution (e.g., 800 x 800 or smaller), the FG processing time should be quicker than your standard renders. Later this pre-saved FG file will be frozen and reused to render at a higher resolution.

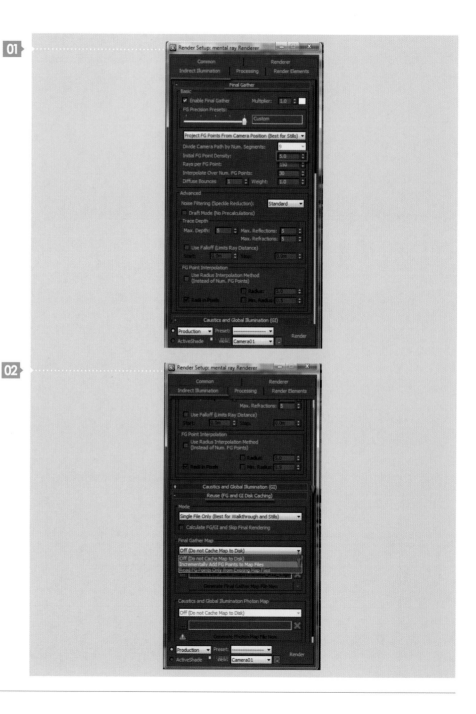

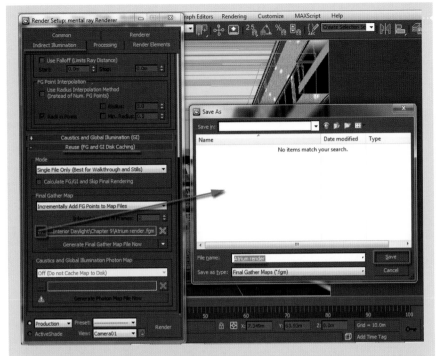

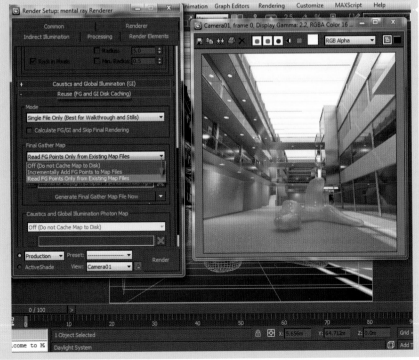

If you're rendering on a relatively low spec computer it would be worth inputting a smaller Initial FG Point Density value (e.g., 3.0) for faster results.

Creating the FG

1: Scroll down to the Reuse (FG and GI Disk Caching) rollout. In the Final Gather Map group, choose the Incrementally Add FG Points Map Files option from its drop-down list (Fig.02).

2: Click on the Save As toggle (…) to choose a location and name the FG map file.

3: A dialog box should appear. Name the file "Atrium render" and Save it to close the dialog box (Fig.03).

Some users simply enable the Calculate FG/GI and Skip Final Rendering functions and click Render to save, if they already know what the result will look like. However, for this exercise we are going to save and render the results so we can assess the image/scene. Click on the Generate Final Gather Map File Now button or simply press Shift + Q to render a preview.

The overall lighting and depth of the test render looks acceptable with the new FG settings. Back in the Final Gather Map group, change the current FG map type to Read FG Points Only from Existing Map files. This new chosen method will bypass the FG process and jump straight to the rendering phase (Fig.04).

Render Elements

The next step is to start setting up the scene to render elements such as Z Depth and Material IDs. It's always best to set up the render elements before increasing the render output size. Also, it's worth noting that as with most rendering engines, rendered elements will increase the rendering times slightly.

1: Go to the Processing tab and enable the Material Override function as you did previously. This is to speed up the test rendering of the render element (Fig.05).

2: Open the Render Elements tab and expand the Render Elements rollout.

3: Click on the Add toggle to open its Render Elements dialog box.

4: First select Material ID from the list. Hold down the Ctrl key and choose the Z Depth element, which will mean that both elements are selected. Z Depth will be at the end of the list (Fig.06).

5: Click OK to close the dialog box. Both elements should now be listed (Fig.07). Turn on the Enable Filtering function of both elements. This will help smooth the jagged edges often visible in the rendered elements.

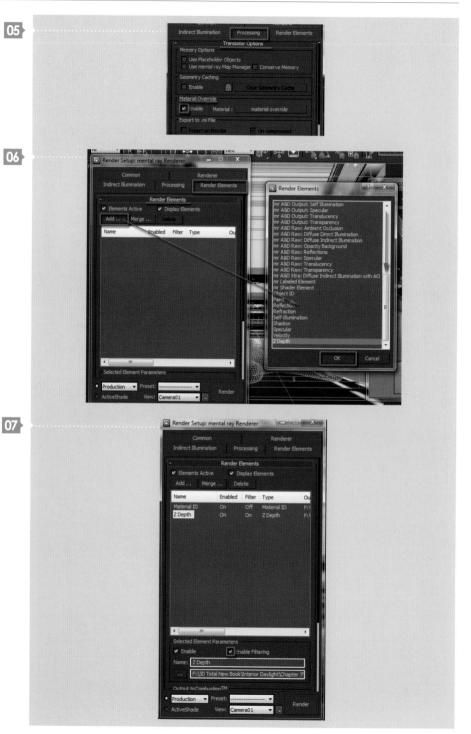

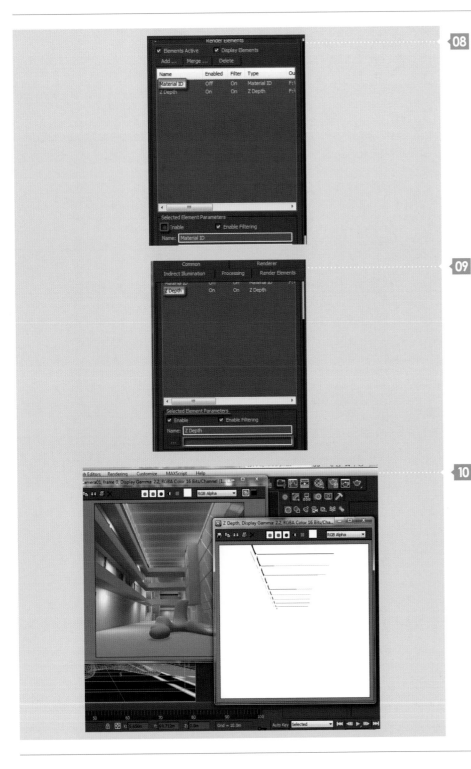

Fine-tuning Z Depth

08

Let's start by fine-tuning the Z Depth parameters.

1: Disable the Material ID element (Fig.08).

2: Select the Z Depth element. In the Selected Element Parameters group, select and delete the current location path of the Save As toggle. This will ensure that the following test renders are not automatically saved in the default location. Click Render (Shift + Q) **09** to preview the current Z Depth results (Fig.09 – 10).

Accessing Z Depth

While the frame rendered relatively quick (i.e., saved FG and Material Override), the results are currently far from satisfactory. Often a Z Depth render is only considered good when there is a clear monochromatic gradient between bright and dark areas. This information will be vital later when used in post to add the depth of field effect. To ensure that we have **10** good Z Depth results we need to tweak some parameters.

1: In the Z Depth Element Parameters rollout, set the Z Min function value to 0.0m. This value will ensure that bright areas start from the foreground.

2: In the Z Max function, set its value to about 16.5m. After several quick test renders this value worked best with the current metric system (meters). However, feel free to try different values if desired (Fig.11 – 12).

Material IDs

The next task is to go to the Material Editor and add different numbers to each of the materials we want added into the Material ID frame buffer.

1: Open the Material Editor dialog box (M).

2: Once the material slot is selected, click and hold the Material ID Channel button.

3: From its numbers list, choose any number other than 0 by sliding the cursor and selecting a number.

4: Select other material slots that you might want to tweak in post (e.g., metal, glass, floor) and repeat the described steps. Assign a different number to every new material slot (Fig.13).

For this exercise it wasn't necessary to add more render elements. However, at times production companies use elements such as mr A&D Raw: Reflections or mr A&D Raw: Specular, etc.

Corrections and Tuning

Next you are going to fine-tune key settings and region-render specific areas of the scene prior to creating the final render. Before you do so, first disable all render elements to speed up the subsequent test renders.

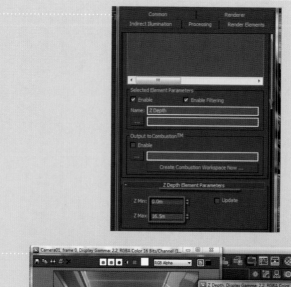

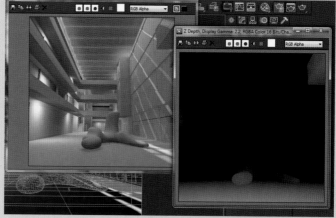

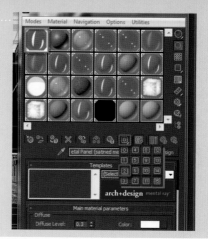

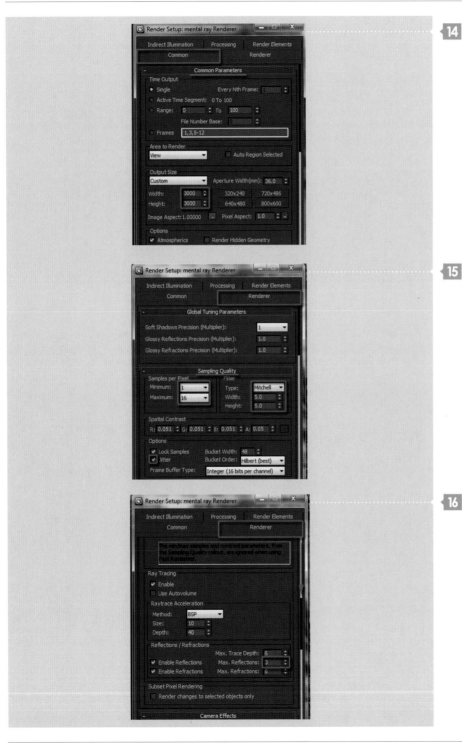

14

1: Open the Common tab. In the Output Size group increase the Width and Height sizes to 3000 pixels. This value should be sufficient to achieve high resolution renders, however feel free to input higher values if desired (Fig.14).

2: To change the image sampling quality to high resolution, open the Renderer tab and extend the Sampling Quality rollout.

15

3: In the Samples per Pixel group, change the Minimum value to 1 and the Maximum value to 16. These values are the minimum required to achieve high resolution images without compromising the rendering speed much.

4: In addition, change the Filter Type to Mitchell and the Width/Height value to about 5.0 (Fig.15).

5: In the Options group, enable the Jitter function. This function will correct renders with jagged edges. As mentioned earlier you can also try different values and settings if you like.

16

Reflective Surfaces

Due to the number of reflective surfaces in the scene the image may take slightly longer than usual to render.

1: To help rectify this scroll down to the Reflections/Refractions group and reduce the global Max. Reflections value to about 3. It's worth mentioning that lower values may result in reflection-related artifacts such as black blotches, etc (Fig.16). It isn't necessary to tweak these with BSP ray trace acceleration because the scene is

relatively small (e.g., 12 MB). Once you have done this, turn off the Material Override function.

2: Next, open the Common tab. In the Area to Render menu choose Region. A marquee should appear in the viewport. With the help of the cursor, tweak the corner handles and make it fit a small rectangle in the far-left side of the viewport (Fig.17). Test render that area to assess the quality of the final image. While the latest render is looking reasonably okay, there are some apparent glossy artifacts being generated from underneath the metallic balcony on the left side. Generally these artifacts shouldn't be visible with the settings/ parameters used earlier.

3: To fix this, select the relevant material slot. In the Arch & Design Reflection group, increase the Glossy Samples value to about 45. While this high value will help correct the glossy graininess it will also increase rendering times (Fig.18).

4: In the Render Setup dialog box, under the Global Tuning Parameters, increase the Glossy Reflections Precision (Multiplier) and the Glossy Refractions Precision (Multiplier) to about 5.0 (Fig.19). This high value is necessary to completely correct the glossy artifact. However, values between 2 and 4 are usually sufficient. Only through region test renders can a user determine which value is best for each situation.

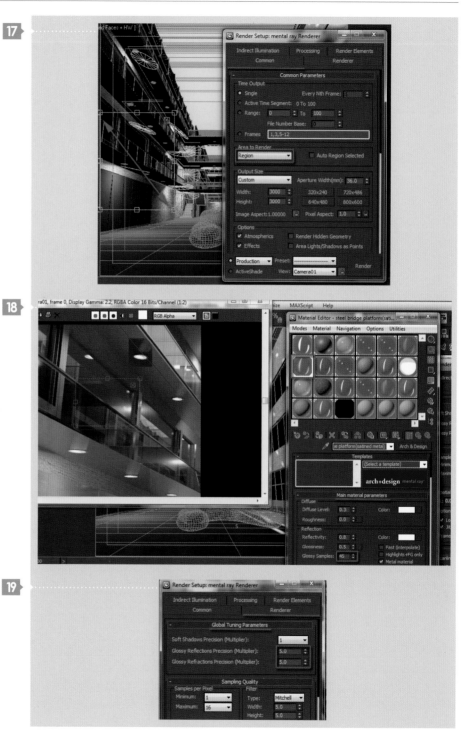

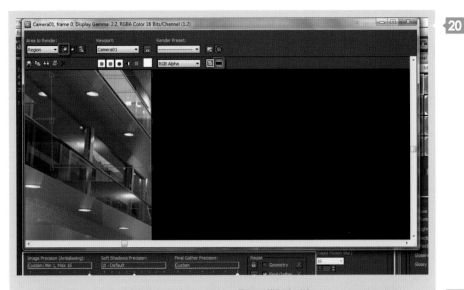

5: Before carrying out another region render, click on the Toggle UI button of the frame buffer. This action should bring up other frame buffer functionalities.

6: Next click on the Region Render button and position its frame buffer marquee on the relevant area and test render again (Fig.20).

The Render Output File

The render is now looking good to go. The next and final step is to name the Render Output file, change a few settings and send the scene to render.

1: Scroll down to the Render Output group and enable the Save File function.

2: Next click on the Files toggle to bring up the Render Output file dialog box.

3: Name it "Atrium" and change the Save as type setting to Targa Image File. Click the Save toggle (Fig.21).

4: The Targa Image Control dialog box should pop up. In the Image Attributes group, enable the 32 Bits-Per-Pixel function. Also choose the Compress and the Pre-Multiplied Alpha functions, followed by OK to close the dialog box. Click Save again to close the other dialog box (Fig.22).

It's worth mentioning that for the purpose of this exercise a Targa Image File format was chosen mainly due to the limited amount of post-work required. Most production companies tend to use the Open EXR Image File format, due to its compatibility with well-known post-production applications such as Nuke, etc. Also the Open EXR Image File file format can include a host of very useful render data, which is crucial for very complex shots.

5: Go back to the Render Elements tab to enable all elements again and set the path location of the Z Depth (Fig.23).

6: Finally, in the Common tab, change the Area to Render type to View, and create the final render (Fig.24 – 26).

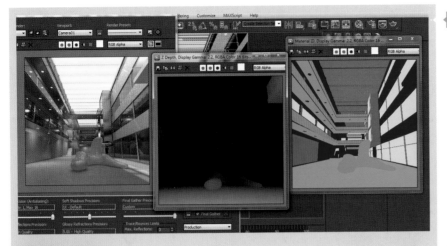

25 If you have multiple machines set up and connected to a network, you can either choose to render the frame as a Distributed Bucket Rendering (DBR) or as a Net Strip Render.

Some of you may be asking why the Global Illumination (GI) was not used. One of many reasons is the fact that since the introduction of 3ds Max 2009, the Final Gather parameters have become so diverse and powerful on their own that the GI parameters are rarely needed now. In fact, from my humble experience, enabling the GI often doesn't add value to the render quality. In addition, the time spent

26 tweaking its parameters could be better spent on other more relevant aspects of the production phase. However, feel free to use the GI to see what benefits it will be bring to this scene.

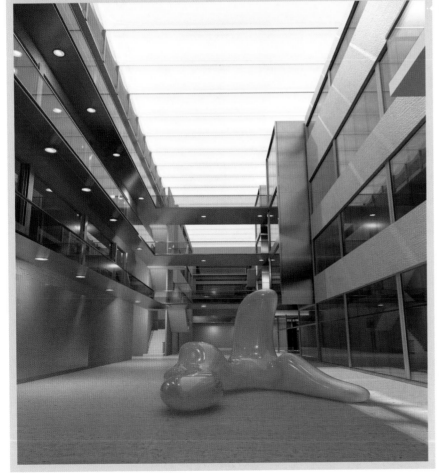

15//Post-Production

Post-Production

Post-production is one of the most important stages of the entire process. Users often take this opportunity to quickly and interactively fine-tune numerous vital aspects of the render such as color correction, levels, etc. In real production this process also allows the client to have more flexibility to make basic changes to the visuals while receiving quicker feedback from the artist creating the work.

Duplicating Your Render

Without further ado let's fire up Photoshop and start by opening (Ctrl + O) the pre-rendered image under the name of Atrium.tga (Fig.01). Also open the image under the name of render_reference1.jpg to use as reference (Fig.02).

1: First let's duplicate the background layer to ensure that we don't permanently damage the original layer.

2: While in the Layer tab select and right-click on the background layer.

3: In the list choose the Duplicate Layer option (Fig.03).

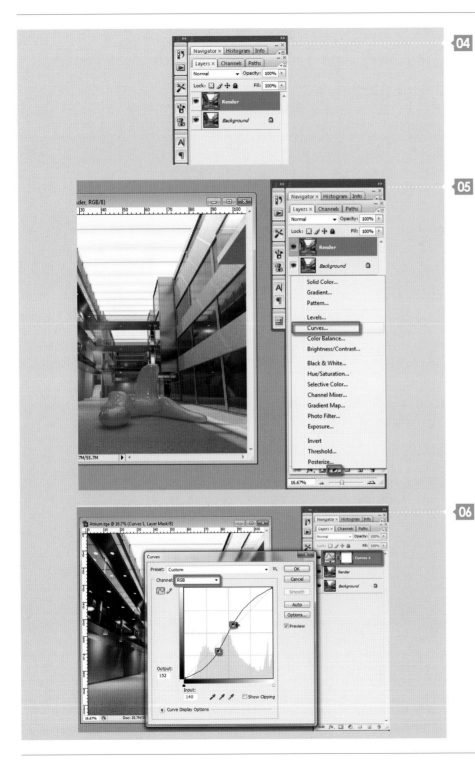

04: In the Duplicate Layer dialog box, rename the duplicated layer to "render" and click OK (Fig.04).

Coloring Layers

It's good practice to color key layers of the PSD document according to their relevance. To do so, right-click on the render layer and select the Layer Properties dialog box from the pop-up list. Choose the orange color from the drop-down list and click OK to close the dialog box.

Curves Adjustments

Next we are going to adjust the levels of the image using a Curves adjustment layer.

1: While the render layer is selected, click on the Adjustment Layer button to bring up its pop-up list (Fig.05).

2: Choose the Curves adjustment layer from the list. Its dialog box should pop up automatically.

3: To begin with, tweak the curves with the Channel set to RGB.

4: Start by adding a point on the curve line by left-clicking on it with the cursor (cross/target).

5: Add another point (second) on the upper part of the curve line (Fig.06).

6: To darken the less bright parts of the image, select the first point (lower down point) and move it downwards gradually.

7: Next select the second point (the upper-most point) and move it upwards gradually to brighten the less dark parts of the image. The final result should be an S-shaped curve. Note how the contrast in the image has increased.

Accentuating the Blue

The next step is to accentuate some of the existing colors to try to make the colors match those in the reference.

1: Open the Channel function and select the Blue channel from its drop-down list (Fig.07).

2: Next use the technique highlighted earlier to boost the blue tones in the relevant areas of the image. Values (points) above the curve line change the color towards a blue tone and values below the curve move them towards yellow tones.

Depending on the curve point location it will affect different parts of the image. As mentioned earlier, upper areas of the curve line represent the brighter areas of the image and lower parts of the curve represent the darker areas. For this exercise we are going to add the first point on the middle of the curve line and move it upwards slightly. Note in Fig.12 how the blue tones have been boosted.

3: Add the second point lower down the curve line and move it down slightly to boost the yellow tones in areas of the image.

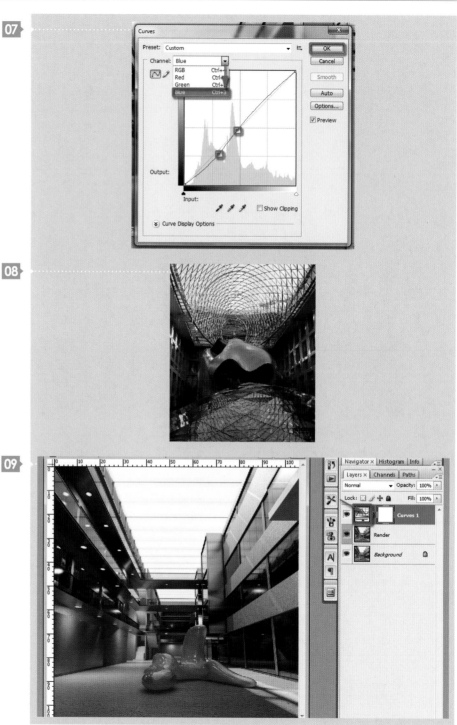

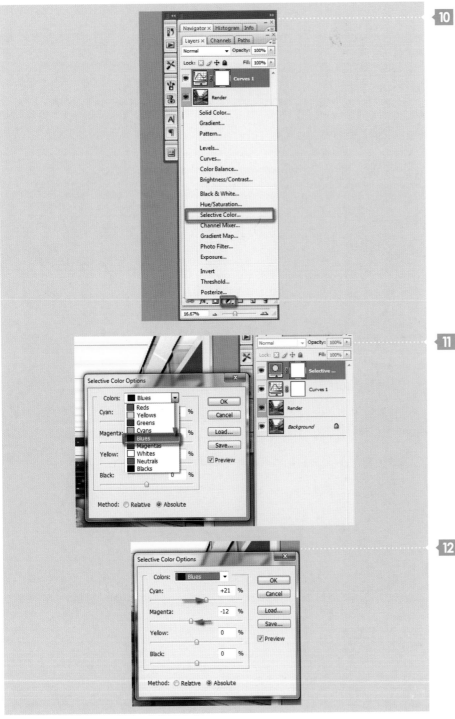

4: Close the dialog box by clicking OK. The image tones are now looking closer to the photo reference.

It's common practice to continuously compare the image against the photo reference for best results (Fig.08 – 09).

Also note that we are using adjustment layers due to their unique flexibility to edit any of their specific settings at any stage without compromising the main image. To edit the curves simply double-click on the curve thumbnail in the Layer list. This applies to any adjustment layer.

Selective Color Adjustment Layers – Blue

Now we are going to apply a selective color adjustment layer to further refine the image.

1: As previously done, click on the Adjustment Layer button to bring up its list and choose the selective color (Fig.10).

2: Its dialog box should pop up. Choose the Blues color from its drop-down list (Fig.11).

3: Move the Cyan slider slightly to the right (+21).

4: Move the Magenta slider to the left (-12). Note in your file how these actions are affecting the image in comparison to the photo reference. Feel free to try different values, if desired (Fig.12).

Selective Color Adjustment
Layers – Yellow

While in the Selective Color dialog box, choose
Yellow from its drop-down list.

1: Move the Cyan slider to the left to about
-24% (Fig.13).

2: Move the Magenta slider to the right to
about +13%. Note in your image how the
yellow tones are much closer to the photo
reference. Click OK to close the dialog
box (Fig.14 – 15). Save the file as "Atrium.
psd".

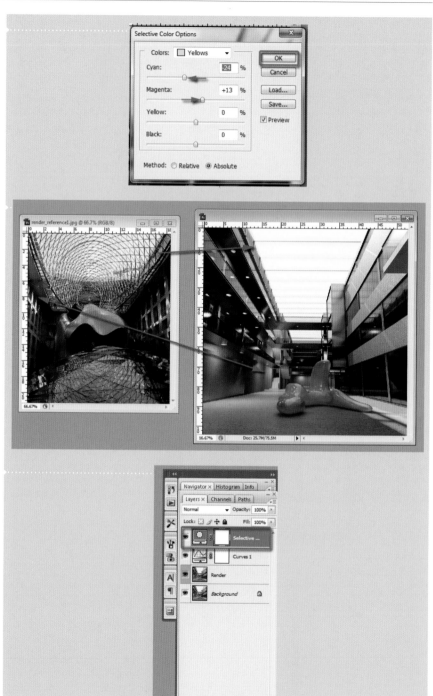

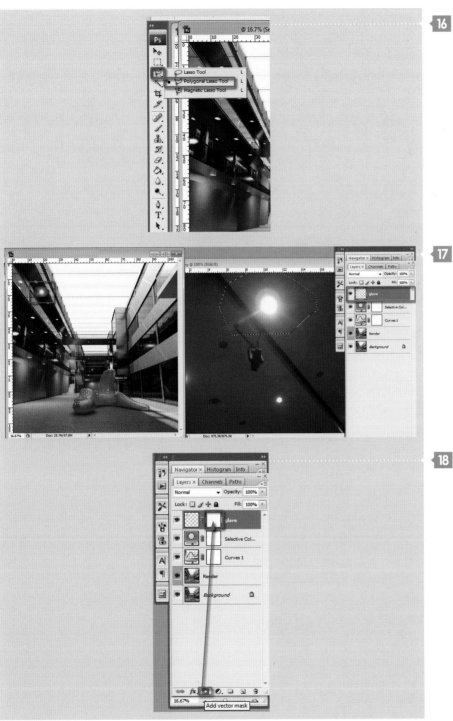

Adding Glare

16 The next step is to add the glare effect commonly seen on recessed lights.

1: Open the image named glare.jpg.

2: On the side toolbar, select and hold the L key to choose the Polygonal Lasso tool from its list and draw around the glare bright spot (Fig.16 – 17).

3: Copy the selection (Ctrl + C) from the layer document. Select the Atrium. psd document and paste (Ctrl + V) the selection onto the document.

4: Name the layer "glare" by following the steps described earlier.

Layer Masks

Next, we are going to use a layer mask and the Brush tool to delete undesired areas of the glare layer. In addition we will use layer blending modes to help blend the layer with the main image.

18

1: While the glare layer is selected, click the Add Vector Mask button (Fig.18). This option is helpful when editing images with the Brush tool while retaining the option to make changes to the original image.

2: Select the Brush tool (B) from the side toolbar (Fig.19). On the main toolbar select and hold on the Brush button to display its brush size options.

3: There are a number of brush types, shapes and sizes. For this exercise we are going to choose a feathered (soft-looking) brush type. These types of brushes will help control the brush impact on the image (Fig.20).

4: In the side toolbar choose the black and white color swatch for the Foreground and Background colors. Black omits areas with the Brush tool and white does the opposite. To edit the set Foreground and Background colors simply click and hold on either of the color swatches. To switch between the two, press the X key (Fig.21).

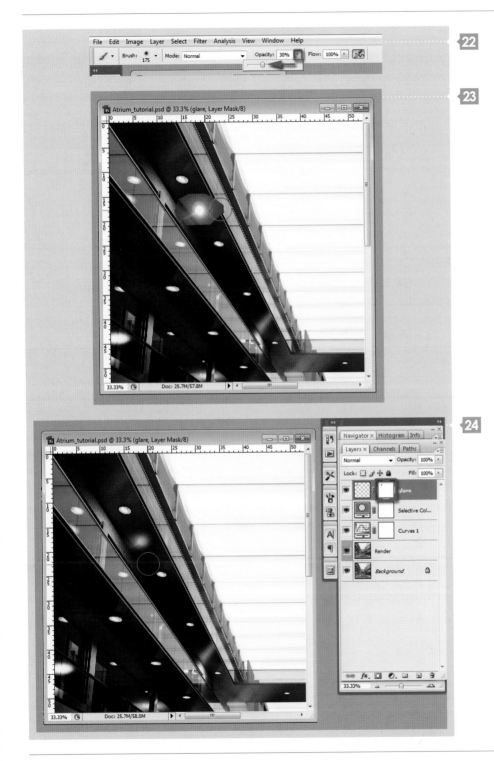

5: By the default the opacity of a brush will be set to 100%. For better control set it to 30%. Feel free to use different values if desired (Fig.22).

6: Before applying brush strokes ensure you have the layer mask selected as you don't want to paint on the image accidentally. Click and brush around the less bright areas of the glare layer. Note that in the image areas of the layer are being omitted (Fig.23 – 24). The beauty of this tool is that it provides users with the flexibility to bring back the omitted areas by using the white color of the background. To increase the brush size simply use the] key and use the [key to reduce it.

7: To help blend the glare layer further, click and choose the Hard Light layer blending mode from its drop-down list (Fig.25). You may use a different layer blending mode, if desired.

The Transform Tool

The next step is to use the Free Transform tool to make the glare fit in the shape of the recessed lights.

1: Select the layer itself (not its mask) and press Ctrl + T to enable the Free Transform tool. Its marquee should appear.

2: Right-click on its center and choose the Distort tool from the drop-down list. This tool will give users more flexibility to push and pull the layer (Fig.26).

3: Hover and click on its corner handles to begin adjusting the glare layer to fit the recessed light.

4: Once satisfied, hit the Enter key to exit. Duplicate the layer and repeat the previous steps to create similar results for all the other recessed lights in the image.

5: To keep all these new layers organized in one folder, create a group folder by clicking on the button identified in Fig.27.

Photographic Effects

Next we are going to enhance the image using effects such as a vignette and chromatic aberration. These photographic effects will help make the visual more photorealistic. There are two different methods of creating these effects: manually and through a Photoshop filter.

To apply these effects with a Photoshop filter simply go to the main toolbar and click on the Filter tab. In the drop-down list choose the Distort option followed by selecting the Lens Correction tool. Most of its settings are self-explanatory.

To have the ultimate control over these effects we are going to create them manually. First we are going to start with the vignette effect.

1: On the side toolbar click and hold the Marquee button to choose the Elliptical Marquee tool option from the pop-up list (Fig.28).

2: On the Atrium.psd document, click and drag the tool from the top left-most part of the document to the bottom right (Fig.29).

3: Once created, feather the selection using the Ctrl + Alt + D keys. Its dialog box should pop up.

4: Set its Feather Radius to about 200 pixels. It's worth noting that this value worked well for the size of this document. However, feel free to try different values if required (Fig.30).

5: The next step is to inverse the selection by pressing the Shift + Ctrl + I keys. This is to ensure that the vignette only affects the edges of the document.

6: Next we are going to use the Levels adjustment layer to create the effect. While the marquee selection is still on, add a Levels adjustment layer (Fig.34).

7: In the Output Levels box drag its slider to the far left to darken the selected area and subsequently create the intended effect. Because this effect is in a layer, users will be able to edit it on demand without having to recreate everything again (Fig.31).

8: By using the Brush tool and selecting the mask of the Levels adjustment layer, you can partially omit undesired areas or, alternatively, extend areas using some of the techniques discussed earlier. Name the layer "vignetting" (Fig.32).

Chromatic Aberration

Next we are going to finalize the image by applying chromatic aberration. It's worth mentioning that prior to applying this effect the document has to be flattened first.

1: Click on the top edge of the document and right-click on it.

2: In the pop-up menu choose Duplicate from the list (Fig.33).

3: Name the new document "CA" (as in "chromatic aberration") and click OK to close the dialog box (Fig.34). Now we have a completely new document.

4: In the new document (CA), select the right-most part of the vignetting layer and right-click on it. A list should appear. Choose to flatten the document (Fig.35 – 36).

5: To create the chromatic aberration effect select the document's Channels tab and choose the Red channel first (Fig.37).

6: Press the V key to enable the Move tool. Also ensure you have the document at 100% size. While the Red channel is still selected, nudge it upwards with the Move tool (Fig.38).

7: Select the Green channel and nudge it downwards once.

8: Finally select the Blue channel and nudge it to the left once. Now select the top channel (RGB) to see the final results. We essentially shifted the RGB channels in different directions to emulate a chromatic aberration effect.

Adjusting the Chromatic Aberration

To have ultimate control over the prominence of this layer (CA), add it to the main Atrium Photoshop document as a new layer in order to tweak its mask and opacity levels.

1: Select the background layer and duplicate it (Fig.39).

2: In the duplicate layer dialog box choose the Atrium.psd destination document name and call it "CA". Close the dialog box by clicking OK (Fig.40).

3: The CA layer is now in the Atrium.psd document. Move it to the top of the layer list.

4: Create a layer mask and use the Brush tool to reduce the appearance of this effect in certain parts of the image by using the techniques highlighted earlier (Fig.41).

It's worth mentioning that this effect (CA) should be used with subtlety. You may also use other adjustment layers, if desired.

Once you are satisfied with the final result save the PSD file as a TIFF for printing purposes. Reputable companies often choose this file extension because of its capacity to retain the full quality of the visual (Fig.42).

Chapter 03

16//Pre-Production

Introduction

Since most photo references for potential camera positions, effects and finishes have already been agreed upon and signed off during the pre-production process described in a previous chapter, we will be focusing mainly on sourcing ideal photo references. These will be of interior night scenes which will be presented to the client for possible approval.

Light Colors

The majority of striking photos of night interior scenes contain strong yellow colors, mostly originating from artificial lights. In addition, it's also common to see strong dark blue colors washing in from the skylight outside (Fig.01). The skylight color is mostly noticeable around and beyond the windows/entrances in direct contact with the outside environment.

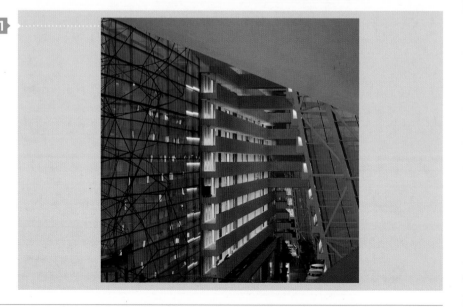

01

Generally, clients and art directors pick photos that contain these two colors in abundance.

Light Effects

Most appealing photos of interior night scenes contain very bright spots of light with a glare effect. These glare effects often appear in the shape of a star, or a ring with a yellowish/red rim on the edges, depending on the camera filter being used. It's very rare to find nice photos of a night scene without these light effects (Fig.02).

Shadows

Photos of interior night scenes often contain soft shadows throughout. These soft shadows are mostly generated from the artificial lights, or indirectly lit by artificial bounce light and/or the blue skylight from outside. It's also common to find traces of the light color in direct or indirect (e.g., diffused) shadows (Fig.03).

Highlights

Highlights are one of many contributors to an appealing photo. The most striking photos contain clear definitions between bright and dark areas (e.g., depth). These highlighted areas are often created by the light in direct contact with the surface containing the highlight (Fig.04).

Material Highlights

Glints generated by glossy surfaces often add a lot to a photo. It's very rare to find a nice photo without any surface glints (Fig.05).

Overall Mood

In addition to all the aforementioned ingredients of a great photo, the overall contrast and depth are two of the most important contributors when it comes to having a nice, dramatic photo.

Selection Process

The selection process for the best photo/s to be used as reference/s can take between a few hours and days, depending on the client and/ or the deadline. Some clients may have a good idea of what they want which makes the entire selection process very quick and easy. Such quick decision-making clients often possess numerous photos of other similar spaces that they have built in the past; therefore, they know the exact look and feel of what they are after.

Sometimes the selection process can take quite a bit of time for reasons such as too many people having input (clients), the user not presenting the adequate type of photos, etc. It is, however, crucial to sign off the photo reference/s prior to embarking on the production phase (e.g., during pre-production).

Signing off at this stage will provide the user and the client with a clear view of the direction of the final output, and prevent too many last minute changes towards the end of the deadline. This workflow will later prove vital to finishing the project within the agreed time and budget.

Finally, it's good practice to source good photo references from books about architectural photography, Google, Flickr, etc. Fig.06 was chosen as the main point of reference by the client.

17//Lighting

Lighting

This chapter will take you through some of the best approaches for lighting an interior night scene using mental ray. While most of the rendering parameters are set to default in this scene, the interior artificial lights and most of the materials have been kept intact from the daytime scene.

We will be introducing a skylight to set the overall tone of the scene. To help you do this you can look at the nighttime reference selected at the pre-production stage. This photo will be used to match the overall color of the light and the mood of the scene.

Without further ado let's start by opening the Max file with the name Interior Night_Start. max. As mentioned earlier, most rendering parameters are set to default and the materials have been kept intact from the previous daylight scene. As well as this, all the interior artificial lights are still in the scene. To start, do a test render (Shift + Q) so you can quickly assess the overall scene (Fig.01).

Using Your Reference

Due to the absence of the Daylight System in the scene, mental ray immediately assumes it's a night scene, hence the dark blue mr Physical Sky in the environment. The first step is to open the photo reference and tweak the lights to match it.

> **1:** Go to the Rendering tab in the main toolbar and choose View Image File from its drop-down list (Fig.02).

2: Locate and open the file under the name of InteriorNightPhoreference.jpg. Note in the photo reference how the yellow artificial lights inside the building are complementing the dark blue tones of the clear sky outside (Fig.03).

Using Reference Colors

The following step will demonstrate how to capture these colors in the 3D scene.

1: Go to the Command panel and open the Create tab.

2: In the Create tab click on the Lights button and choose Standard from its drop-down list (Fig.04).

3: Under the Object Type group select the Skylight button and click its target/cursor in the Top viewport to create the skylight object (Fig.05).

4: With the skylight object created the next step is to capture its true color as depicted in the photo reference. Open the Modify command and scroll down to the Skylight Parameters rollout.

5: In the Sky Color group click and hold the Sky Color swatch to open its dialog box.

6: In its Color Selector dialog box, click the Color Picker button and pick the sky's true color by clicking the Color Picker on the top left part of the photo (Fig.06). Its values should be automatically captured in the Color Selector parameters. Alternatively, simply type in the following values: Red: 0; Green: 30; Blue: 254.

Once finished, click OK to close the dialog box. This is one of many methodologies used by top professionals to capture the true colors of a photo or footage. Test render the changes (Fig.07).

Adjusting the Sky Color

The color of the skylight is now closer to the one in the photo. However its multiplier intensity value requires increasing slightly. In the Skylight Parameters rollout increase the Multiplier value from 1.0 to 5.0 and create another test render to assess the results (Fig.08).

Adjusting the Artificial Lights' Colors

The skylight color and its intensity now match the photo reference. Next, we are going to use a similar approach to match the colors of the artificial lights in the scene.

1: In the camera viewport set the Selection Filter to Lights by simply clicking on its main toolbar icon and selecting it from the drop-down list (Fig.09). This will make it easier to select lights in the scene. Select any of the artificial lights in the scene as they are mostly instances.

2: Open the Modify command and scroll down to its Intensity/Color/Attenuation parameters rollout.

3: In the Color group click and hold the Filter Color swatch to open its dialog box.

4: In the Color Selector dialog box select the Sample Screen Color button and pick the dark yellow tone in the middle right part of the photo. The selected colors should be automatically captured in the Color Selector parameters (Fig.10). Alternatively type in the following values: Red: 246; Green: 133; Blue: 0.

Once satisfied click OK to close the dialog box and test render the results (Fig.11). The overall color of the render and the mood are now very similar to the photo reference.

It is worth noting that you can always adjust the colors and the overall contrast of the render in post-production. Since most post-effects can easily be implemented in sequenced frames, it makes perfect sense to always bear this in mind when rendering the final shots.

This production approach will ultimately help users be more flexible with the client's ever-changing designs and briefs. The scene is now at a point where you can safely begin making preparations for the final render.

18//Rendering

Rendering

This chapter will conclude the production stage by talking you through the process of setting up the best rendering parameters to ensure a smooth, detailed, fast and high quality render. You will also be introduced to new state of the art render elements to help improve the overall look and feel of the final visual.

During this process we will proceed with preliminary test renders and draft settings to preview the overall results. Finally, crucial region test renders will be carried out to assess the overall quality of the visual prior to submitting the final high resolution render.

Render Elements

Start by adding key render elements for post-production.

1: Open the Render Setup dialog box (F10) and go to the Render Elements tab.

2: We currently have the Material ID and the Z Depth elements from the previous tutorial selected. Before we begin adding new render elements, first select the Z Depth element to ensure that all the layers to be added sit below it.

3: Click on the Add toggle to bring up its dialog box (Fig.01 – 02). In the Render Elements dialog box add the following elements:

mr A&D Output: Beauty – This render element is quite similar to the main

render, only with more depth and contrast (this is mostly attributed to the mr exposure controls being subtracted from the render elements output). This is ideal for composing in post. Keep the Multiplier and the Apply shadows functions as default (Fig.03).

mr A&D Raw: Ambient Occlusion – This render element will add extra connecting shadows to areas where the light doesn't reach. This is ideal to add extra depth to the image. Keep the Multiplier and the Apply Shadows functions as default (Fig.04).

mr A&D Raw: Reflections – This render element renders the reflections at full intensity. This is ideal to control the amount of reflectivity in post. Keep the Multiplier and the Apply Shadows functions as default.

mr A&D Raw: Specular – This element renders the specular components. This is ideal when reinvigorating the specular levels in post. Keep the Multiplier and the Apply Shadows functions as default (Fig.05).

Once the elements have been added, test render (Shift + Q) the results (Fig.06).

The Final Gather Setup

The render elements' default values work well. The next step is to disable the render elements for the time being by turning off the Elements Active function. This will help speed up the test renders. Next we are going to start setting up the Final Gather parameters for the final render.

1: Go to the Indirect Illumination tab and open the Final Gather (FG) parameters rollout.

2: In the Initial FG Point Density function set its value to about 1.0. This value is high, however, it will add a lot of depth to the scene. Furthermore this function is capable of correcting most FG artifacts, depending on the value being used. High values will result in slow rendering times. Alternatively if your computer has less than 4GB of RAM, a value of 0.5 would be okay without having to compromise the overall quality.

3: In the Rays per FG Point function, set its value to about 300. Values between 150 and 300 are often sufficient for most complex scenes. Higher values will increase the rendering times drastically (Fig.07).

Preparing mental ray

The following steps are to prepare mental ray to save the FG files prior to sending the final renders.

1: In the Indirect Illumination tab scroll down to the Reuse (FG and GI Disk

06

07

Caching) parameters rollout. In the Mode group, enable the Calculate FG/GI and Skip Final Rendering function. This function will save the FG files during the pre-calculation process and stop at rendering time. Always remember to disable it when sending the final render.

2: In the Final Gather Map group, change the FG to Incrementally Add FG Points to Map Files and click on the Save As (…) toggle.

3: Its dialog box should pop up. Name it "Atrium render_Night.fgm" and close the dialog box by clicking the Save button (Fig.08).

4: Open the Common parameters and go to the Output Size group. Set its Width and Height value to about 500 pixels (Fig.09). Mental ray allows the FG map to be saved at a small size, to be reused later at a much higher render size without compromising the render quality (e.g., 3000 pixels or higher).

5: Finally, to cache the geometry open the Processing tab.

6: Under the Translator Options rollout turn on the Enable function from the Geometry Caching group. Once cached this function will help speed up the translation process that occurs during the pre-calculation time (Fig.10). This technique is more effective and noticeable in complex scenes. Press Shift + Q to begin saving the FG map.

The Final Gather

1: Once the pre-calculation process is finished and the FG map is saved, go back to the Indirect Illumination tab. Open the Reuse (FG and GI Disk Caching) rollout and disable the Calculate FG/GI and Skip Final Rendering function.

2: In the Final Gather Map group, change it to Read FG Points Only from Existing Map Files and load the pre-saved FG map from its location. This will enable mental ray to kick-start the rendering and skip the pre-calculation process (Fig.11). This also means that you can render this file using the Strip Render option from the Net Render dialog box. A similar technique can be used for animations.

Setting up the Render

Next we are going to set up the render parameters for the high resolution visuals.

1: Open the Renderer tab and expand the Global Tuning Parameters rollout.

2: In the Glossy Reflections Precision (Multiplier) function, increase its value to about 5.0. It's worth noting that this value was set this high to correct a few glossy reflection artifacts in the scene. However, try lower values if you are experiencing slow rendering times.

3: Increase the Glossy Refractions Precision (Multiplier) value to about 5.0.

4: In the Sampling Quality rollout, go to the Samples per Pixel group and set the Minimum value to 1. In addition, set

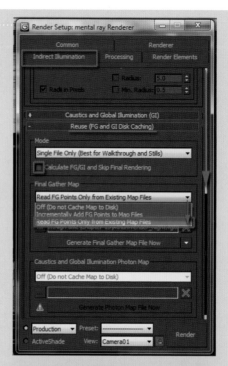

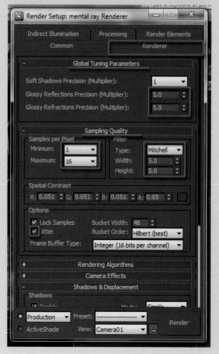

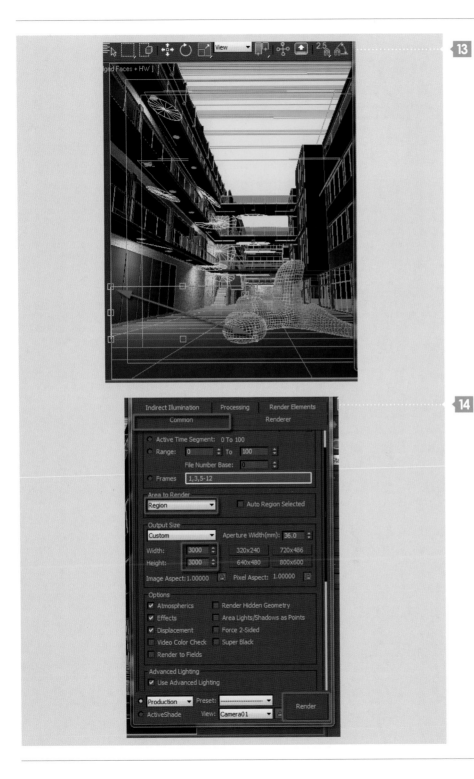

the Maximum value to 16. These values are the minimum required to achieve satisfactory render results.

5: In the Filter group set its Type to Mitchell, followed by increasing the Width and Height values to 5.0. The Mitchell filter often yields much superior render results when compared with other render filters.

6: Finally, ensure that the Jitter option is enabled, to prevent jagged edges in the renders (Fig.12).

Testing Key Areas

1: Before we begin test rendering key areas of the scene for quality assessment, go to the Common parameters tab and scroll down to the Area to Render group.

2: Change it to Region type and adjust the transform marquee corner handles to fit specific areas of the scene where artifacts would be more apparent (e.g., glossy/reflective areas and darker areas of the scene).

3: Finally, set the Width and the Height of the Output Size to about 3000 pixels, followed by rendering the chosen region area (Fig.13 – 14). It's crucial to carry out high resolution region renders to avoid unpleasant surprises once the final render is created. With the exception of geometry and self-illuminated materials using FG/GI, most material parameters are tweakable without having to recalculate the FG map.

The Final Render

1: Once you are satisfied with the high resolution region renders, change the Area to Render option to View.

2: In the Render Output group enable the Save File function and click on the Files toggle. The Render Output File dialog box should pop up.

3: Set the Save As type to a TGA file format.

4: Name the file "AtriumNight.tga" and set up the TGA file options as previously done. Click Save to close the dialog box.

While this file format worked perfectly for the purpose of this exercise, feel free to choose a different file format, such as EXR, if desired (Fig.15).

Prior to creating the final render, open the Render Elements parameters and enable the Elements Active and Display Elements functions. Their path should automatically match with the main render file. If not, it's worth setting it up. Furthermore, in the Selected Element Parameters group, turn on the Enable and the Enable Filtering functions. This will ensure the render elements are not jagged (Fig.16).

Click Render (Shift + Q) to create the final image (Fig.17).

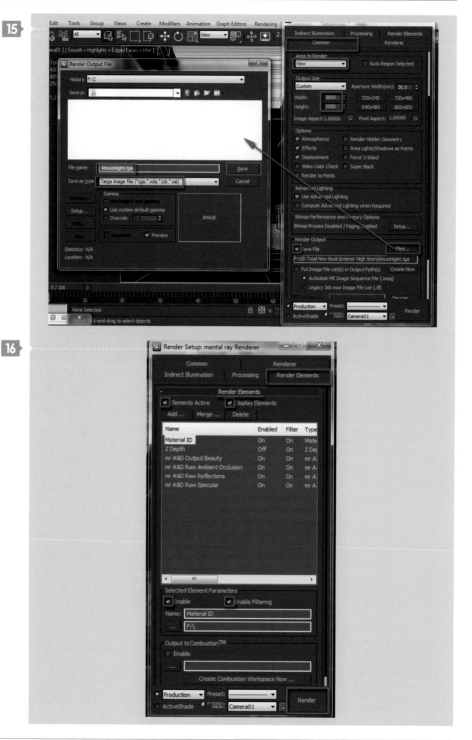

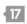

19//Post-Production

Introduction

This chapter will conclude the interior nighttime tutorials by talking you through unique workflows to assemble the pre-rendered elements in post-production. This will be done while using the photo reference as a guide to tweak the overall contrast, colors, specular and reflections of the render. We will also be using some of the layers we used in the daylight scene in Chapter 10 to help speed up and finalize the nighttime scene.

Most post effects will be kept in separate layers to provide you with more flexibility to edit the document at any given time. Clients are the biggest beneficiary of this methodology as it allows them to receive faster feedback from users when tackling ever-changing briefs and concepts. Keeping documents in layers is a widely used and efficient approach adopted by numerous production companies across a variety of CG sectors.

Let us start by opening the following pre-rendered files from Chapter 13:

- AtriumNight_mr A&D, Raw Specular.tga
- AtriumNight.tga, AtriumNight_MaterialID. tga
- AtriumNight_mr A&D Output Beauty.tga
- AtriumNight_mr A&D Raw Ambient] Occlusion.tga
- AtriumNight_mr A&D Raw Reflections.tga.

Also, open the files under the name of InteriorNightPhoreference.jpg and Atrium.psd (Fig.01 – 02).

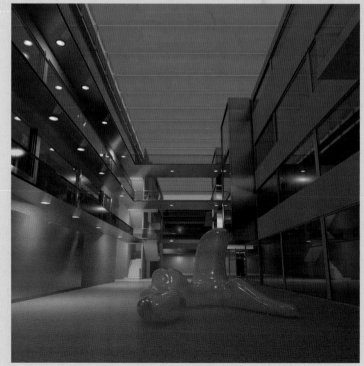

1: Minimize all documents apart from InteriorNightPhoreference.jpg and AtriumNight.tga.

2: Select the AtriumNight.tga document. In its Layers tab, duplicate the background layer by right-clicking and choosing the Duplicate Layer option from the pop-up list (Fig.03).

3: Right-click on the duplicated layer and choose the Layer Properties option from its pop-up list.

4: Rename the layer "render" and change its color to red (Fig.04). It's always good practice to duplicate layers, as it will prevent users from accidentally altering the original one irreversibly.

5: Save the document as a PSD file: "AtriumNight.psd".

Combining Elements

The next step is to begin merging the render elements into the AtriumNight.psd document.

1: Select the file called AtriumNight_mrA&D Output Beauty.tga. Duplicate it using some of the techniques covered earlier.

2: The Duplicate Layer dialog box should pop-up. In its Destination group, choose the Atrium.psd file from the Document drop-down list.

3: Rename it "beauty pass" (Fig.05). The layer should now be part of the AtriumNight. psd document.

4: Ensure that it's on top of the render layer. The order in which each layer is positioned plays an important role in achieving the correct effect.

5: To fully blend in the beauty pass layer, choose the Lighten blending mode, from its drop-down list (Fig.07). While this blending mode has worked perfectly for the intended effect, you can always try different layer blending modes if desired. Also, try turning on and off its Layer Visibility icon to see the before and after effects.

Reflections

Next you will be merging the AtriumNight_mrA&D Raw Reflections.tga file with the AtriumNight.psd document, using some of the techniques covered earlier.

1: Select the AtriumNight_mrA&D Raw Reflections.tga file and merge it into the AtriumNight.psd document. Ensure that this layer sits above the beauty pass layer.

2: Rename it "reflections" and choose the Lighten layer blending mode to integrate the layer (Fig.07).

3: While the integration looks good, its prominence seems slightly excessive. Being able to judge whether or not an effect is overly used is part of being a good observer, but you can also use a photo reference to ensure that the effect is as it should be.

06

07

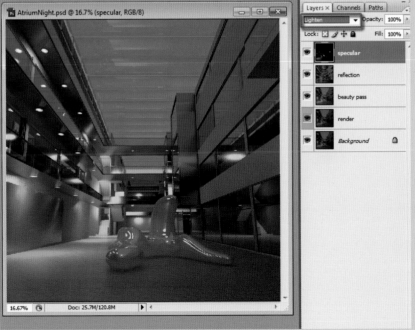

4: Go to the layer Opacity and decrease its value to about 27%. This value worked well. However, try different values if desired (Fig.08).

Specular Highlights

The penultimate render element to be merged into the AtriumNight.psd document is the AtriumNight_mrA&D Raw Specular.tga file.

1: Select and merge the AtriumNight_ mrA&D Raw Specular.tga file into the AtriumNight.psd document, using the steps described earlier. Rename the layer "specular". Ensure this layer sits above the reflection layer.

2: Use the Lighten blending mode to integrate the file. Note how the render elements are gradually improving the overall image (Fig.09).

Making Adjustments to the Specular Highlights

While the specular highlights make the overall image more appealing, they look slightly too prominent in areas such as the surface of the translucent sculpture. This means that the next task is to omit the unwanted highlights. What you leave and remove is an artistic decision, so again you will need to use your reference and real world observations.

1: To start making adjustments we need to select the relevant areas. Select the AtriumNight_MaterialID.tga document and click on the Select main toolbar.

2: Choose the Color Range option, from the drop-down list. Its dialog box should appear (Fig.10).

3: In the Color Range dialog box ,use the Eyedropper Tool to select the color ID from the sculpture (e.g., green). A white, masked area should appear automatically in the dialog thumbnail (Fig.11).

4: White areas represent the selected areas, and black areas are left unselected. Use the Fuzziness slider to increase the selected area(s). A value of 87 worked well; however, you might want to try different values.

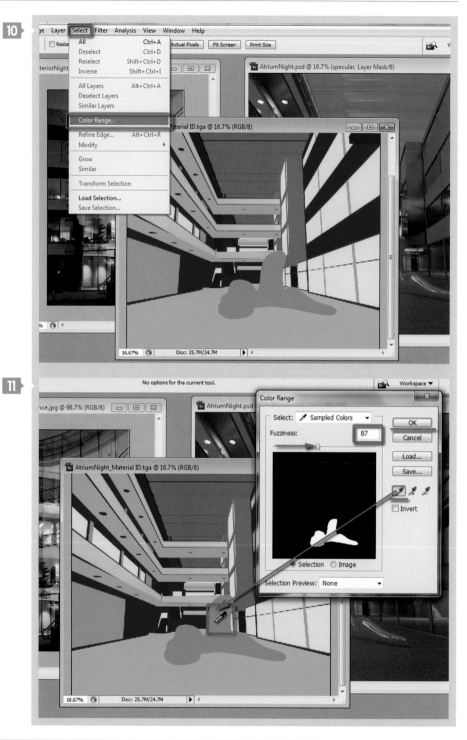

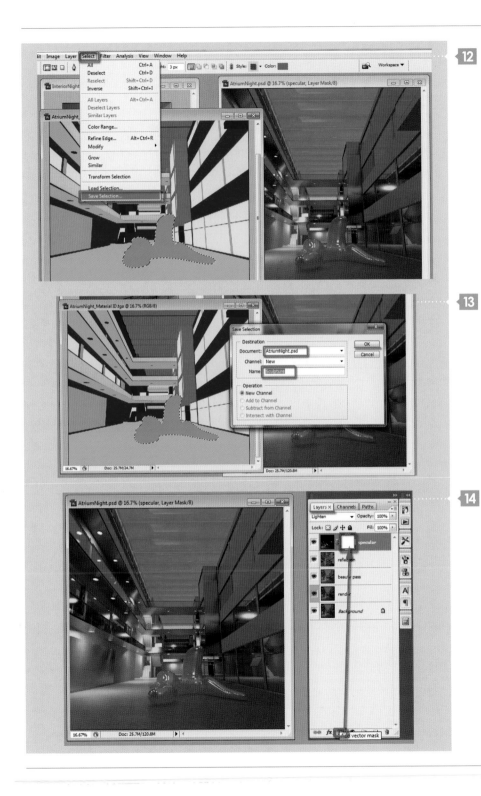

5: Click OK to close the dialog box. An automatic selection should appear around the sculpture.

6: To save the selected area into the AtriumNight.psd document, click on the Select main toolbar and choose the Save Selection option from its drop-down list. Its dialog box should appear (Fig.12).

7: In the Destination group choose AtriumNight.psd from the drop-down list and rename it "sculpture". Click OK to close the dialog box. The selection should now be saved in the AtriumNight.psd channel's tab (Fig.13).

8: Select the AtriumNight.psd document and select the specular layer. Create a layer mask that is attached to it by clicking on the Layer Mask button. A layer mask thumbnail should now be attached to the specular layer (Fig.14).

9: Next, open the Channels tab. To enable the sculpture channel selection simply hold down the Ctrl key and click on the sculpture channel thumbnail. The selection should appear in the document (Fig.15).

Omitting Unwanted Highlights

The next step is to begin omitting the specular highlights in areas where they are not required.

1: Go to the Layers tab and select the layer mask thumbnail to ensure that you don't paint directly onto the layer.

2: Enable the Brush tool by pressing the B key. In addition, ensure that the Default Foreground Color is set to black, and the background color is set to white. The black color omits pixels, and the white color does the opposite. To switch between colors, simply press the X key.

3: Begin brushing away the selected area. Note that the pixels will disappear as you paint. Also note the masked areas appearing on the layer mask thumbnail (Fig.16).

4: Once you are satisfied with the results, simply press Ctrl + D to deselect.

Color Corrections

The next phase is to begin color correcting the overall image.

1: Select the specular render element to ensure the incoming layer sits above it. Click on the Adjustment Layer button and choose the Selective Color option from its pop-up list (Fig.17).

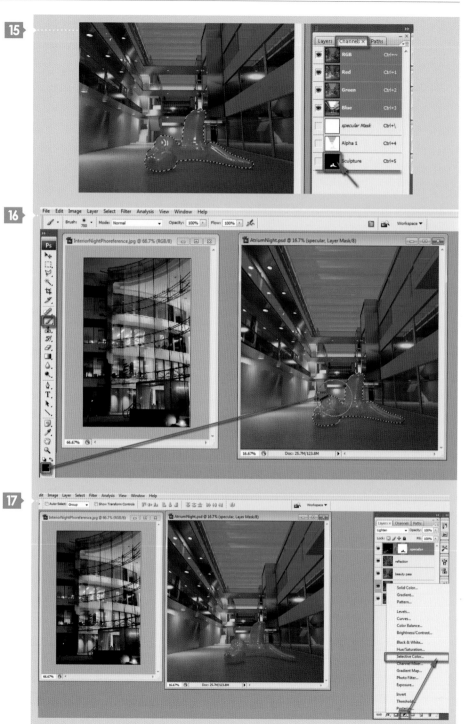

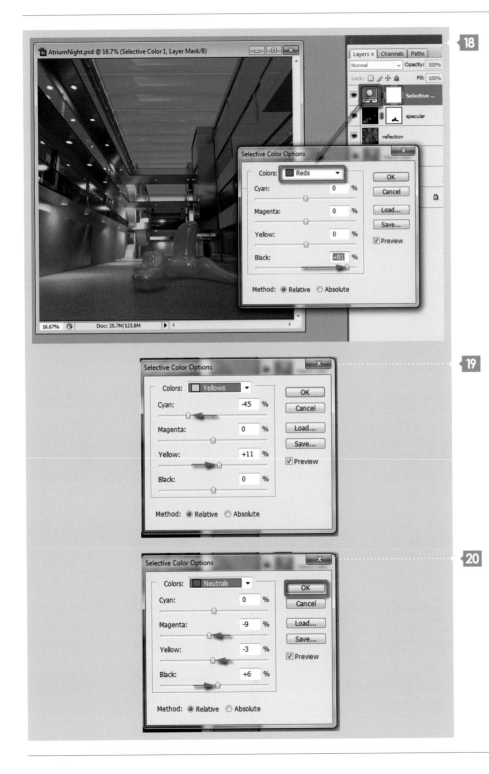

2: The Selective Color Options dialog box should appear. In the Colors option choose Reds and set the Black value to about +81. Note how the red tones darken slightly (Fig.18).

3: Change to Yellows colors and set the Cyan value to about -45, and the Yellow to +11. Note how the red and the yellow tones are looking closer to the photo reference now (Fig.19).

4: Finally change to the Neutrals colors and set the Magenta value to about -9, the Yellow value to about -3 and the Black value to about +6 (Fig.20). Note how most colors in the image now match the photo reference closely.

This adjustment layer is quite unique and powerful in being able to choose the specific colors of an image and fully manipulate them. Once you are satisfied with the results, click OK to close the dialog box (Fig.21 – 22).

Contrast

To match the overall contrast of the photo reference with the render we are going to use the Curves adjustment layer. This layer is useful when controlling the contrast of an image and its respective colors.

1: Add a Curves adjustment layer on top of the Selective Color layer by using the techniques covered earlier. Its dialog box should appear.

2: Go first to the Blue channel to adjust the blue tones (Fig.23).

3: The upper parts of the curve represent the brighter areas of the document. Moving a point upwards in these areas will add a blue tone to the brighter areas of the document. Moving a point downwards in these areas will add a yellow tone to the brighter areas of the document. The lower parts of the curve represent the darker areas of the document. Moving a point upwards in these areas will add a blue tone to the darker areas of the document. Moving a point downwards in these areas will add a yellow tone to the darker areas of the document.

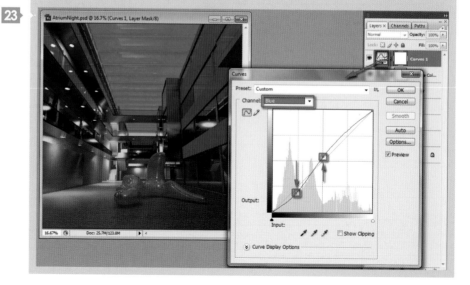

4: Add two curve points to its curve. The first point should go on the brighter areas of the curve and the second point should go on the darker area of the curve.

5: Move the upper curve point upwards to add bluer tones to the brighter parts of the image, and move the lower point downwards to add yellow tones to the darker parts of the image. Note how the yellow and blue tones are matching the photo reference even more closely now.

6: Next go to the RGB channel and add two more points to the RGB curve line (Fig.24). Move the upper point slightly downwards to darken the brighter areas, and move the lower point downwards to further darken the darker areas of the image. We now have an image full of contrast, matching the photo reference seamlessly. Once you are satisfied, click OK to close the dialog box (Fig.25).

Hue and Saturation

The last adjustment layer to add will be the Hue/Saturation one.

1: Add a Hue/Saturation adjustment layer using some of techniques covered previously. Its dialog box should appear. In the Edit group, choose the Blues.

2: Increase its Saturation to about +9 and decrease the Lightness to about -18. Note the changes taking place in the document (Fig.26). Click OK to close the dialog box once you are satisfied with the results. These values generated the intended results; however, you can try different values if desired.

Ambient Occlusion

The last render element to add is the AtriumNight_mrA&D Raw Ambient Occlusion. tga.

1: Add the AtriumNight_mrA&D Raw Ambient Occlusion.tga layer to your AtriumNight.psd and rename it "AO".

2: Choose the Multiply layer blending mode to fully integrate the elements. Note in your document, how the AO layer has added more depth to the overall image (Fig.27).

While the AO layer has blended seamlessly with most of the document, there are some visible geometry artifacts that can be seen in the top left part of the image, by the metal structures and on parts of the glass roof (black blotches). These artifacts are often picked up by the ambient occlusion when the face normals of certain objects are not in the right direction.

3: To rectify this we are first going to add a layer mask thumbnail and use the Brush tool to brush away the relevant areas. Use the previously described techniques to do this. Set the brush Opacity to 100% and begin brushing away the relevant areas (Fig.28 – 29).

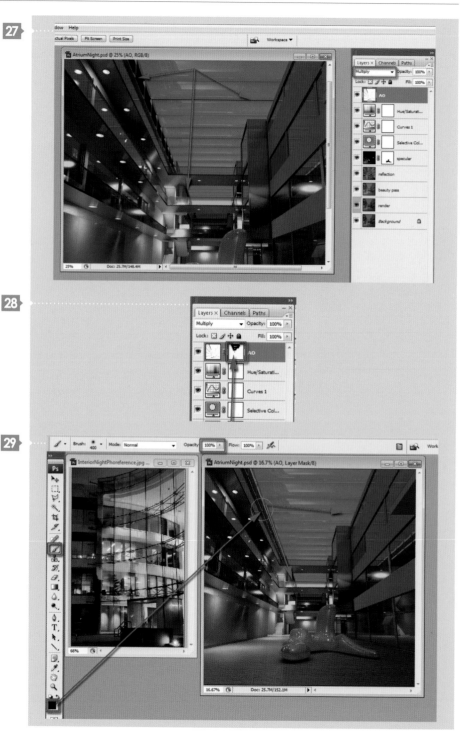

4: Next we are going to gently brush away areas of the image where the AO is too prominent. Set the Opacity of the brush to about 30% and choose a very soft brush (e.g., feathered). Begin brushing away areas where the AO is too prominent. With the brush opacity set to 30% you will have better control of how much of the AO is brushed away (Fig.30).

Reusing Previously Created Layers

The next step is to use some of the layers that were created for the Atrium.psd file and merge them into the AtriumNight.psd document.

1: Select the document named Atrium. psd. Select the Glare folder group and the Vignette layer (Fig.31).

2: Right-click and choose to duplicate both layers. Choose the AtriumNight.psd as the destination document (Fig.32). Both layers should now be part of the AtriumNight. psd. Ensure both merged layers are above the AO layer.

3: Add and/or omit parts of the vignette effect by using some of layer mask techniques described earlier. Set the brush Opacity to about 10% to carefully brush away the relevant parts. The overall colors, contrast and depth of the photo reference should match the render (Fig.33).

Preparing to Apply Depth of Field

The next effect that we will add to image is depth of field.

1: Right-click on the top edge of the document and choose the Duplicate option from its pop-up menu. In the Duplicate Image dialog box, rename the document "DOF" and close it (Fig.34 – 35).

2: You should now have a duplicated version of the document under the name of DOF. It's good practice to work on duplicated documents when applying effects that might be subject to greater scrutiny by the client.

3: Next, we are going to flatten the entire document in order to apply the depth of field effect (DOF). Select the Vignette layer and right-click on it. Choose the Flatten Image option from the pop-up list. The entire document and its layers should now be flattened into one image (Fig.36).

4: Open the document under the name of Atrium0000_Z Depth.tga and go to its Channels tab.

Hold down the Ctrl key and click on the RGB channel thumbnail (Fig.37). The Z Depth selection should become active. The RGB channel was chosen because it contains more pixel information (e.g., the Z Depth grayscale information).

5: While the selection is still active, go to the Select main toolbar and choose the Save Selection option from its drop-down list (Fig.38). The Save Selection dialog box should appear.

6: In the Destination group choose the DOF document and rename the selection "ZDepth". Close the dialog box by clicking OK (Fig.39).

The channel selection should now be part of the DOF.psd document. It's worth mentioning that it's only possible to merge channel selections in this manner if both documents have the same dimensions (e.g., width and height).

Depth of Field

Before adding the camera depth of field filter, first duplicate the layer and rename it "DOF" (Fig.40). This is to ensure it doesn't affect the original layer.

1: Click on the Filter main toolbar. In its drop-down list scroll down to the Blur option and choose the Lens Blur filter (Fig.41). The dialog box should appear. Its parameters are quite self-explanatory.

2: In the Depth Map group, load the pre-saved Z Depth channel Source. Increase the Blur Focal Distance value to about 255 by moving the slider to the right. This function determines the amount of blur. Try different values if desired. The blurring area seems to mainly affect the background parts of the image. Enable the Invert function to rectify this.

3: In the Iris group, choose the Pentagon (5) shape. This is the most commonly used shape (5 angles). Increase its Radius to about 45. Note how the changes are taking place in the preview window.

4: The blade curvature sets the number of angles in the pentagon shape. The higher the curvature numbers, the more circular the curvature. Keep the blade curvature at 5.

5: Set the Rotation value to about 50. Depending on the content of the image you may need to tweak the rotation of the pentagon angle (in 2D space) until the desired effect is achieved.

Again, you should use artistic license and photo references to determine what's correct. Try different values if desired (Fig.42).

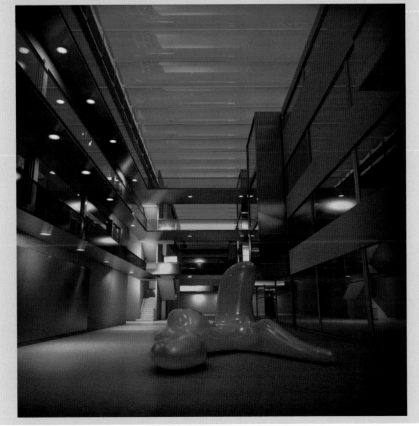

6: Use the zoom in/out buttons and the side sliders to focus on certain areas of the image and make sure you are happy with it. Once you are satisfied, click OK to close the dialog box.

7: Finally, apply a chromatic aberration effect using some of the techniques described for the daylight scene. Save the final document as "AtriumNightDOF.psd" and as a TIFF. Also save the changes to the AtriumNight.psd document (Fig.43).

Chapter 04

20//Pre-Production

The pre-production process starts with a number of concept ideas provided by the client, along with samples of scanned textures/finishes, sketches and photo references, etc. This is also the stage where the client will discuss the budget and the deadline.

Photos and References

The first step is to select relevant photos to be used as references for lighting, finishes and other design concepts, etc. This phase is one of the most important stages of the entire project. You don't only need to find images you like, but you also need to liaise directly with the client, extracting key information such as the story behind the design and key features, and then find suitable references. At this stage it is crucial to resolve the aim of the final visual.

01

Photo References for Finishes and Light

Glass and Asphalt Materials

Lighting and Materials

Pavement and Metal Material

Metal Materials

Camera / Lighting / Effects

First Choice

Alternative Choices

Ideal Camera Angle and
Compostion

Ideal Lights and Colors

Different Camera Angles

The purpose of this project is that the image is to be used for marketing purposes on billboards and magazines. The plan is to begin advertising the building and its space to potential clients, while the construction is still taking place.

The exercise needs to be tackled in a way that allows the client and the user to quickly decide on the final composition, the best camera angles, colors, 3D content and the final render output size for printing. It also helps to understand the project and its background enough to make key decisions about the overall lighting, the types of people to be added in post-production and the manner in which they would interact with the space.

Most of this information needs to be gathered into mood boards depicting all the ideas, concepts and suggestions about the art direction (Fig.01 – 03). This subsequently enables the client to quickly decide on the art direction to pursue. These images were photographed; however, some professionals find it quicker to source them from books, Google and websites such as Flickr, etc.

Camera Position

Following this you will need to start to think about the camera position and the final composition. To do this you should quickly create a draft model of the original space and its main contents. The draft 3D model will be based on sketches/drawings and photos supplied by the client (Fig.04).

The next step is to begin setting up the camera to encompass the most relevant areas of the design. By working closely with the client you will be able to rapidly draft suggested camera positions on the 2D drawing (Fig.05).

When setting up the main camera to decide on the composition, it's common practice to do the following:

1: Open the Create panel. In the cameras group choose the Target type. Choosing a targeted camera will help you set the direction of the camera quickly (Fig.06).

2: Once the camera direction has been set, you can then turn it into a free camera to make moving it in the scene easier.

3: Click and drag the cursor to create the camera, followed by setting its target direction.

4: Next, open the Modify command panel. In the Parameters rollout choose the Free Camera type from its drop-down list. As mentioned earlier, this action will enable the user to move the camera more freely in the scene (Fig.07).

5: While the camera is still selected, move it down to eye level (e.g., 1.58 or 1.60, from the floor up). It's worth noting that the units are in meters. At times even accurate scenes may look disproportionate in scale as a result of not having the camera at eye level. This practice will later prove vital when integrating people and other objects in post production.

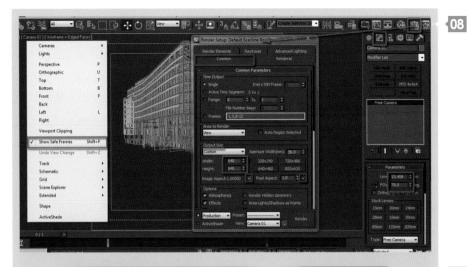

08

09

Field of View

The photo references and the client's feedback help to set up the appropriate field of view (FOV) of the camera. To ensure the exact camera frame is being displayed in the viewport, the Show Safe Frames function (Shift + F) should be enabled. While the camera is still selected, the Modify command should be used to set the camera lens to about 35mm.

To help capture more of the frame, the following should be done:

1: Open the Render Setup dialog box (F10).

2: In the Common tab, under the render Output Size group, the Width and Height should be set to about 640 pixels (portrait). The Image Aspect and the Pixel Aspect functions should also be locked to ensure the frame type remains portrait if/when the output size values are later changed (Fig.08).

3: The chosen camera view will then need to be signed off, which it would be if it has captured the building in its entirety. Also note that the foreground building is not visible to the camera, but is visible in its reflections.

As mentioned earlier, the entire process was designed to help the client understand and preview the impact of their design choices and the art direction, prior to commencing the production phase.

Finally, all the previous steps help the client to choose a photo as the final main point of reference for lighting, mood and materials (Fig.09).

21//Creating Materials

For this exercise we will be using the V-Ray render engine to achieve the results previously discussed and planned during the pre-production process.

1: Open the file under the name of Exterior Daylight Start.max.

2: Load the V-Ray renderer.

3: Open the Render Setup dialog box (F10). In the Common tab, scroll down and open the Assign Renderer rollout parameters.

4: Click on the Production toggle and choose the V-Ray renderer from the Choose Renderer dialog box (Fig.01).

5: Note that the Output Size and the Image Aspect have been chosen and locked during the pre-production stage. In addition, the camera view has also been created and locked (Fig.02).

6: Before we begin applying the shaders and the textures, start maximizing the camera view. Click on the wireframe viewport text. Its pop-up menu should appear. Change the viewport display type to Smooth + Highlights and Edged Faces by clicking on each of the listed options. This will make the selection of objects in the scene slightly easier (Fig.03).

Glass Material

The first material that we will create will be the glass.

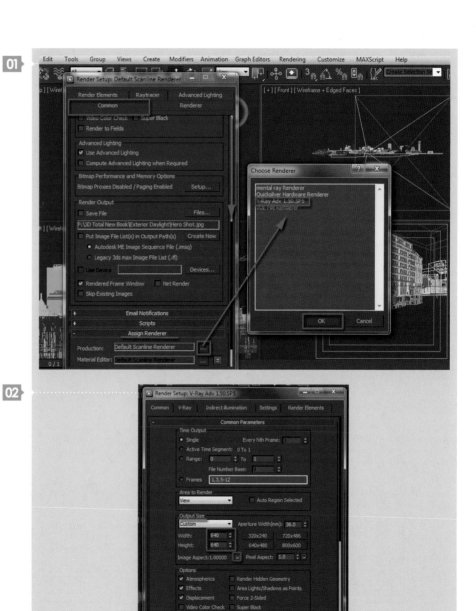

1: Open the Material Editor by pressing the M key or by clicking on its icon.

2: Select a new material slot and name it "glass".

3: Click on the Standard shader toggle. The Material/Map Browser dialog box should pop up.

4: On its list, scroll down to the V-Ray Adv 1.50.SP5 rollout, and choose the VRayMtl shader from its drop-down list. Click OK to close the dialog box. Please note that if you are using a different/newer version of V-Ray, the name list may differ slightly.

5: In the scene select the object with the name _glass-a-single and assign the material slot to it (Fig.04).

Glass Properties

The next step is to begin applying the main glass physical properties: reflection and transparency.

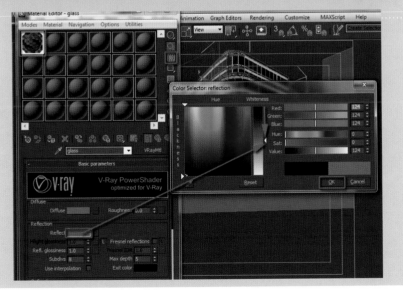

1: Enable the background swatch button to help visualize the appearance of the physical properties mentioned above.

2: Next, in the Reflection group, click on the Reflect color swatch to open the Color Selector dialog box.

3: In the Whiteness color swatch, pull down the slider to a grayer tone (e.g., R: 124; G: 124; B: 124). This will increase the glass reflectivity. Lighter colors yield more reflection, and darker colors have the opposite effect. Click OK to close the dialog box (Fig.05).

4: Change the Refl. glossiness value
to about 0.95. Note in the material slot
thumbnail how a small glint has appeared
on the material. This physical property
will make the glass material glossier,
especially when catching the sunlight's
reflection.

5: To make the glass transparent, pan
down to the Refraction group and click
on the Refract color swatch to open
its Color Selector dialog box. In the
Whiteness color swatch, pull down the
slider to a whiter tone (e.g., R: 211; G: 211;
B: 211). This will ensure that the glass
is almost fully transparent. Click OK to
close the dialog box. Since most glass
panels on curved buildings have a bit of
refraction, we will keep the IOR value at
1.6. In a different situation a value of 1.1
would have been best to emulate a non-
refractive glass (Fig.06).

6: Test render the image to see the results
(Shift + Q). It is worth noting that further
tweaks will be made once the lights and
the GI (global illumination) have been
added in the scene (Fig.07).

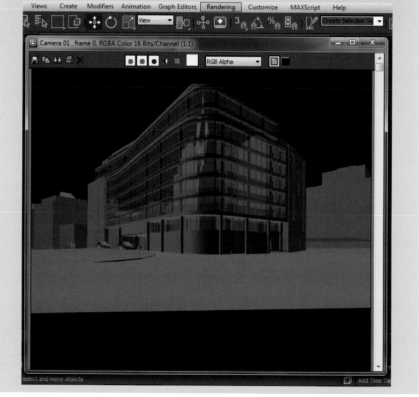

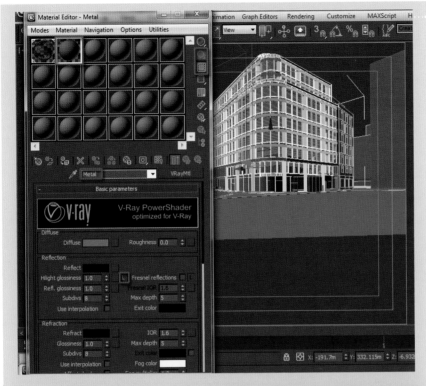

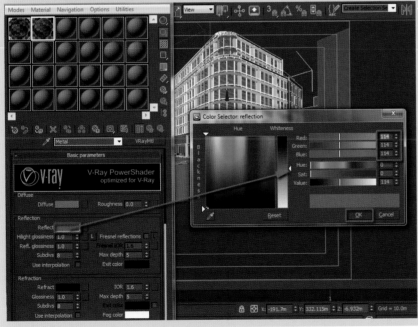

Metal Material

One of the main characteristics of a metallic surface is its shine and diffused reflections. In this exercise you will be primarily applying its basic physical properties. Then, once the lights have been added, you will try to match the photo reference(s) closely.

1: In the scene, select the object with the name _win-frames.

2: In the Material Editor, create a new V-Ray material slot using some of the steps highlighted earlier. Name it "Metal".

3: In the Reflection group, to have better control over the glossiness and its reflections, unlock the Hilight glossiness L toggle. Its editing values should now become available (Fig.08).

4: To increase its reflectivity, open the Reflect color swatch dialog box and pull down the Whiteness slider to a lighter gray color (i.e. R: 114; G: 114; B: 114). Click OK to close the dialog box (Fig.09).

5: To increase the glossy highlights on the metallic surface, decrease its Hilight glossiness value to about 0.61. Note in the material slot thumbnail how the surface's highlight appearance is becoming more spread out. This function only affects the appearance of the glossiness on its surface. You may try different values, if desired.

6: Most metallic finishes have the reflections slightly diffused. To emulate this, simply decrease its Refl. glossiness value to about 0.8. Note in the material slot thumbnail how its checkered surface will look more diffused.

7: Metallic surfaces often have a slight grain to them. The default Subdiv value of 8.0 would yield extremely grainy results. To smooth it simply increase the Subdiv value to about 20. Assign it to all relevant objects in the scene and test render it to see the results (Fig.10).

Ceiling Light

The next material to be worked on is the ceiling light. While we will be using the V-Ray light shader for self-illumination, it will also be important to assign a texture that resembles the light model itself in order to achieve more realism.

1: In the scene, or from the Select From Scene dialog box (H), pick the object called Light fitting big985 (Fig.11).

2: In the Material Editor create a new material using some of the steps covered earlier. Name the new material slot "Ceiling light".

3: While in the Material/Map Browser dialog box, under the Standard rollout, choose the VRayLightMtl shader from its list (Fig.12).

4: Assign this new material to the selected object. Next we are going to locate and apply the relevant texture.

5: Click on its Color toggle to access the Material/Map Browser dialog box.

6: Under the Standard rollout, double-click on the Bitmap option to locate and load the texture under the name of ceiling light.jpg (Fig.13 – 14).

Isolating the Object

For better control of the object in the scene we are going to isolate it.

1: While the object is still selected, right-click on it and choose the Isolate Selection option from the pop-up list (Alt + Q). In the top viewport, change the visual style to Smooth + Highlights.

2: In the Material Editor bitmap parameters, enable the Show Standard Map in Viewport or Show Shaded Material in Viewport button. This tool allows the user to see the texture displayed over the object's surface. Once you have done this you will see that the bitmap doesn't currently fit the proportions of the object (Fig.15).

3: Go to the Command panel and open the Modify command.

4: Open this and choose the UVW Mapping modifier from its drop-down list. Also choose Box Mapping mode and click on the Fit button to make the texture match the surface more accurately (Fig.16).

Please note that if you are using a newer version of 3ds Max, the texture in the VRayLightMtl may not display in the viewport. Professionals often use the standard VRayMtl to

fit the texture properly first, followed by using the VRayLightMtl to achieve the desired effect. If the Smooth + Highlights function is no longer available, choose Shaded mode instead.

Making the Texture Fit

To make the texture fit the surface, do the following:

1: Click once on the UVW Mapping modifier to highlight it and rotate its yellow/orange gizmo to make it perpendicular to the object in question.

2: Click on the Fit button again to adjust the new gizmo position to the boundaries of the object. Note that this modifier will also be applied to all instanced objects in the scene (Fig.17).

3: Change the top viewport visual style back to Wireframe. This is to prevent the viewport's performance slowing down.

4: Apply this material to all the ceiling light objects in the scene and run a quick test render to see the results. As mentioned earlier, these materials will be further tweak once the lights and the global illumination has been added in the scene.

Ceiling Material

This material should be fairly simple to create and apply, especially as it is in the distance.

1: Exit Isolation Mode and select the object named _ceiling-metal3in the scene.

2: Create a new V-Ray material slot using some of the steps mentioned earlier. Name this new material "Ceiling" (Fig.18).

19

3: In the Diffuse color swatch change the default color to creamish.

4: In the Reflection group increase the reflectivity of the ceiling slightly, utilizing some of the steps covered earlier (R: 20; G: 20; B: 20).

5: To diffuse the reflections slightly we are going to decrease the Refl.glossiness value to about 0.54 (Fig.19). Feel free to experiment with different values, if desired. Assign this material to all the relevant objects in the scene. Test render to see the results.

Pavement

20

The next material to create is the pavement material. This exercise will mainly focus on applying the material's basic parameters and its texture. Please note that the following texture to be applied has been created by simply stitching together aerial photos of large portions of a detailed pavement. This technique is used by numerous CG companies in order to achieve realism. As mentioned earlier, further and final tweaks will be made once the lighting and GI have been introduced.

1: Select the object named ground in the scene.

2: Create a new V-Ray material slot and name it "Pavement" (Fig.20).

3: In its Diffuse slot locate and apply a texture under the name of pavement copy.jpg (Fig.21).

4: Once loaded, assign the material to the respective object. In the Bitmap parameters, under the Coordinates rollout, decrease the Blur value to about 0.01. This will make the texture appear sharper; however it may slow the rendering of this texture slightly (Fig.22 – 23).

5: Since the pavement's surface is slightly irregular, we are going to apply the MapScaler modifier, as opposed to UVW Mapping. The MapScaler modifier automatically corrects areas and corners of the surface where the texture may stretch. Simply apply the modifier by scrolling down the Modifier list and selecting it.

6: Under the Parameters rollout, a Scale value of 14.717m worked best. Try different values if desired. Also make the texture visible in the viewport using some of the techniques covered earlier.

Grayscale Texture

Next we are going to apply a grayscale texture to its Bump toggle.

1: While still in the bitmap parameters, click on the Go to Parent button to go back to the main V-Ray material parameters.

2: In the main material parameters, scroll down to the Maps rollout and click on its Bump toggle (Fig.24).

3: Locate and load the texture under the name of pavement copy bump.jpg (Fig.25). Note that the Bump toggle reads grayscale textures more accurately than colored ones. When possible it is always best to control the texture's tiling through the modifier, as opposed to the bitmap itself. This is to prevent you from constantly having to go in and out of the Diffuse and Bump toggles every time you are required to tweak the bitmap's tiling parameters.

The remaining materials were applied using similar or even simpler approaches to the ones described here. The buildings on the far left are real photos (e.g., front, back, left and right) of buildings that were taken and later mapped onto the facades using a simple UVW Mapping modifier to achieve realism. Similar approaches were used on the majority of objects in the scene.

The next chapter will take users through the intricacies of creating the lights to bring the scene to life, and tweaking the materials' physical properties to react harmoniously with the lights and the GI (global Illumination).

22//Lighting

This chapter will explore the intricacies of creating the lights that liven up the scene. Furthermore, we will also cover the importance of tweaking the physical properties of materials in order to make them react harmoniously with the lights and the GI (global illumination).

Open the 3ds Max file with the name Exterior Daylight_TextureFinished.max. For this exercise most materials have already been applied, however, they will require tweaking further once the lights have been applied.

The Sunlight

The first light to be created is the sunlight. This will set the base for all the subsequent lights in the scene. Before beginning to create the light ensure you have all four viewports visible (top, front, left and the camera). Zoom out in all four viewports to facilitate and control the sunlight creation. Due to the amount of geometry in the scene you will need to switch between the Box visual style and the Wireframe in order to increase the performance of your graphics card.

1: Go to the Create command panel and open the lights tab. Choose the VRay light from its roll down list (Fig.01).

2: Next create the sunlight by clicking on the VRaySun button (Fig.02).

3: With the cursor (target/cross), select the top viewport, followed by clicking and dragging the cursor in order to create the sunlight system (Fig.03).

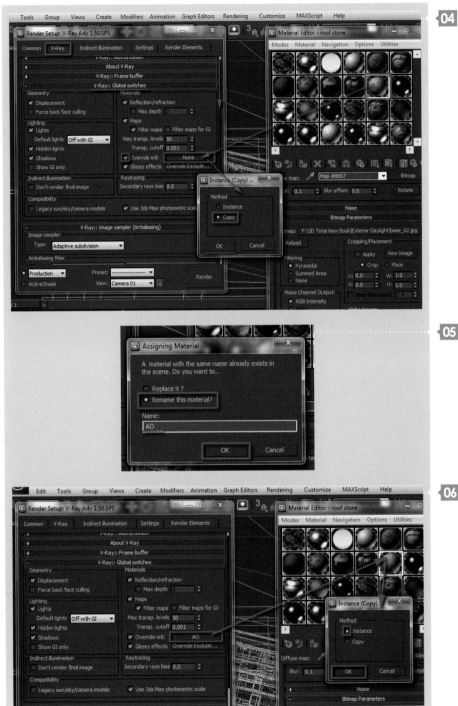

4: The V-Ray Sun dialog box should pop up asking if you would like to automatically add a VRaySky environment map. Click Yes to close the box. The sunlight object and its environment map are now created.

Placing the Sun

The original goal was to get the sun to wash down the entrance, and emulate a bright and sunny day.

To achieve this we will strategically place the sunlight object so it illuminates the scene/ shot in an appealing manner. Before we begin, we are going to first use a white, non-reflective finish as a Material Override. This is to speed up the test renders while setting the direction of the sunlight and its shadows.

1: Open the Render Setup dialog box (F10). Under the V-Ray tab, scroll down and open the V-Ray:: Global switches rollout parameters.

2: In the Materials group, enable the Override mtl function.

3: Open the Material Editor (M) and select the material slot named roof stone (Fig.04).

4: Drag this material slot and drop it onto the Override mtl toggle. The Instance (Copy) dialog box should pop up. Choose the Copy method and OK to accept it. The assigning material dialog box should be prompted.

5: Choose to Rename this material and name it "AO" (Fig.05). A new material has

now been created! This procedure was taken to prevent overriding an existing material assigned to a different object in the scene.

Editing the Material

Next we are going to edit this new override material so it's white and non-reflective.

1: Drag the AO material from the Override mtl toggle onto the Material Editor slot.

2: In the Instance (Copy) dialog box choose the Instance method and click OK (Fig.06).

3: Next, clear the current texture by right-clicking on the Diffuse toggle and choosing the Clear option from its pop-up list (Fig.07).

4: Change the Diffuse color swatch to white (235; 235; 235) and the Reflect color swatch to black (0; 0; 0). Also, change the Refl. glossiness to 1.0 and clear the current bump texture from its toggle (Fig.08).

Positioning the Sun

Next we are going to begin positioning the sunlight object.

1: In the main toolbar set the selection filter from All to Lights only. This is to avoid selecting other objects in the scene accidentally. You can change it back to All or another selection filter when necessary.

2: Select the sunlight head and move it high, so it beams right down to the building: X: -192.325m; Y: 338.129m; Z: 239.505m (Fig.09).

3: Select the camera view and test render (Shift + Q) the results (Fig.10).

Correcting the Sun

The render currently looks overexposed. Using a V-Ray camera or the V-Ray environment exposure controls would help rectify this. However, for the purpose of this exercise and to facilitate the process of importing/exporting cameras – and for better file compatibility with earlier versions of V-Ray – we are going to use the standard 3ds Max camera, while tweaking the sunlight's intensity multiplier values to correct the current problem.

1: While the VRaySun object is still selected, open the Modify command. Under the VRaySun Parameters, reduce its intensity multiplier value to about 0.05m.

2: Also reduce its shadow bias to about 0.001m (Fig.11). This will help the sun's shadows catch the smallest shadow details in the scene. Feel free to try different values. Test render the scene to see the changes (Fig.12).

The Gamma Settings

Next, we are going to set the gamma settings.

1: Click on the Rendering main toolbar.

2: Choose the Gamma/LUT Setup to open its dialog box (Fig.13).

3: Open the Gamma and LUT tab and turn on the Enable Gamma/LUT Correction function. Set it to 2.2 (Fig.14).

4: In the Bitmap Files group, set its Input and Output Gamma values to 2.2 and click OK to close the dialog box. Test render the results.

Setting the Global Illumination

Now that the shadow direction and the gamma settings are in place, the next step is to enable the GI (global illumination) and start tweaking the materials to react realistically with the light(s).

1: Open the Render Setup dialog box (F10). In the Indirect illumination tab, open the V-Ray:: Indirect illumination (GI) rollout and enable it.

2: To speed up the rendering process, under the Secondary bounces group, switch the GI engine from Brute force to Light cache (Fig.15).

16

17

18

3: With the GI engine changed, scroll down to its rollout parameters and set the Current preset to Low. This will speed up the process of irradiance in the preliminary testing phase. Also, in the Options group, enable the Show calc. phase and the Show direct light functions. This will preview the process in the frame buffer (Fig.16).

4: Scroll down, open the V-Ray:: Light cache rollout, and reduce its Subdivs value to about 500. This will speed up the light cache process. Also enable both the Store direct light and the Show calc. phase functions (Fig.17). Test render the scene to see the results (Fig.18).

Adjusting the Global Illumination

The render is looking too bright with the current settings so we need to make some changes.

1: In the Secondary bounces group, decrease the Multiplier value to about 0.25 (Fig.19).

2: Next, go to the V-Ray tab, scroll down to the V-Ray:: Color mapping rollout and change its type to Exponential. Also set it to Affect background only (Fig.20). While it's imperative to have bright and dark areas in the scene, the Exponential color mapping type will help reduce overly bright spots in the scene (e.g., overexposed areas). Test render to see the results.

3: Next, go to the V-Ray:: Global switches rollout and disable the Override mtl function in order to see how the sunlight interacts with the scene materials (Fig.21).

Tweaking the Materials

The overall render is looking okay now. However, there are few tweaks that need addressing. We are going to start by opening the photo reference to help tweak the materials.

1: Click on the Rendering main toolbar and choose the View Image File option from the drop-down list (Fig.22).

2: Locate and open the photo reference under the name of Building Photo Reference.jpg (Fig.23). This photo was chosen to be used as reference during the pre-production phase due to its visual impact and resemblance to the 3D scene (number of reflective glass panes, metallic window frames and the overall color of the photo). In the photo, also note the amount of brightness seen through the office glass and how the shine of the sun is being picked up by the metallic surfaces. The next step is to try to incorporate these effects in the render itself.

3: Open the Material Editor (M). Select the glass material slot.

4: Compare the render to the photo reference. The glass reflections in the render are blurrier and less apparent than the photo reference (Fig.24).

5: To emulate this, in the Reflection group change the Reflect color swatch RGB value from 124 to 100. The reflectivity is slightly reduced now. You will also be able to see a bit more of the office inside. This effect is similar to the photo reference.

6: To reduce its blurriness and make the reflections sharper, increase its Refl. glossiness value to 1.0 (Fig.25).

The Office Lights

Next we are going to make the office ceiling lights a bit yellower and more prominent. Making the ceiling lights more prominent will help make the shot busier. Also, making it yellower will make the overall render more appealing, as yellow tones often go well with blue tones.

1: Select the Ceiling light material slot and increase its Color value to 1.7 to make it more prominent. Also enable the Emit light on back side function. This function allows the back face of the object to be illuminated (Fig.26).

2: To make the bitmap yellower, first click on the Color bitmap toggle. Inside the Light Color parameters, scroll down to the Output rollout settings and turn on the Enable Color Map function.

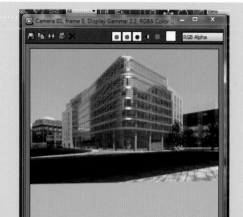

3: To begin tinkering with its colors, enable the RGB function and turn off the G and B buttons by clicking on them.

4: With the Red channel button enabled, click on its upper point curve and set its value to about 1.825. Use its Move tool to help move the curve point, or simply type in the desired value (Fig.27). Utilize its Zoom tool to have a broader view of all the points.

5: To edit the Green channel, simply enable the G button and set its upper point curve value to about 0.875 with the help of its Move tool or by typing the value.

6: To edit the Blue channel simply click on the B button and repeat the previous steps. Set its upper point curve to about 0.358 (Fig.28). Feel free to try different values. Test render the scene to see the changes (Fig.29).

Color Intensity

The ceiling lights are looking much better now. However, their color intensity looks quite uniform throughout the building. To rectify this we will use the Mix procedural map in conjunction with Falloff.

1: Scroll back up to the Light color parameters and click on its Bitmap toggle.

2: In the Material/Map Browser dialog box, open the Standard rollout and choose the Mix procedural map from the list by double-clicking it (Fig.30).

3: The Replace Map dialog box should pop up. Choose the Keep old map as sub-map? button and press OK to close it.

4: In the Mix Parameters rollout under the Maps toggle, click and drag the Color #1 toggle to the Color #2 toggle, to copy it. The Copy (Instance) dialog box should pop up. Choose the Copy method and OK to close it (Fig.31).

5: Next, go to the Color #2 toggle. Scroll down to its Output parameters and turn off the Enable Color Map function. Its yellowish tone has now been turned off (Fig.32).

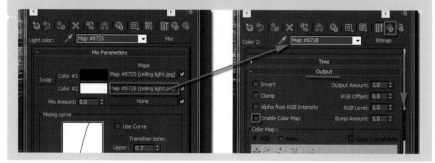

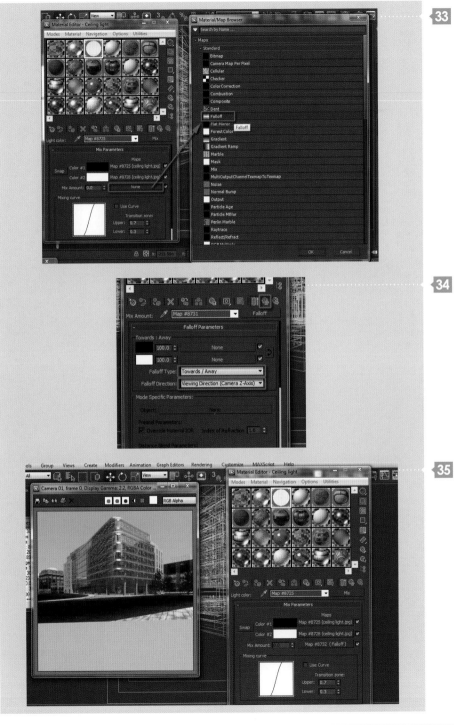

6: We now have the Color #1 toggle with the yellowish tone and the Color #2 toggle without it. Go back to the Mix main parameters (e.g., Go to Parent button) and add the Falloff procedural map.

7: Click on the Mix Amount toggle to access the Material/Map Browser dialog box. In the Standard rollout list, choose the Falloff procedural map (Fig.33).

8: In the Falloff Type choose the Towards / Away option (Fig.34). In the Falloff Direction choose the Viewing Direction (Camera Z-Axis). These options worked best for the intended effect, but feel free to choose different ones if desired. Test render the scene to see the results (Fig.35).

Tweaking the Building's Texture

The following steps are to tweak some of the building's tiled textures.

1: In the scene, select (H) the object named Object19 and isolate it (Alt + Q).

2: There's already a UVW Mapping modifier applied to it. The current window texture seems a bit too big in comparison to other windows in the scene. To correct this, simply increase the U and V Tile values to about 2.0 (Fig.36). The tiling of the window looks more realistic now.

Creating the IES Lights

Next we are going to create a few IES lights in the ground floor area of the building.

1: Select the group of objects named Pizza Express in the scene and isolate them. Due to the complexity of the scene it is often easier to isolate specific areas or objects in order to speed up the process.

2: To begin creating the VRayIES light, open the Create command panel.

3: Under the V-Ray light Object Type, click on the VRayIES button.

4: Click and drag its cursor in the Front viewport, to create the light (Fig.37).

5: If necessary, change the selection filter type to Lights to avoid selecting other objects in the scene. Also, while the light is still selected, go to the Modify panel and turn off the targeted function. This will facilitate moving and placing the lights around the scene.

6: In the Top viewport, move the light next to one of the tables: X: -188.361m; Y: 319.306m; Z: -10.304m (Fig.38).

7: Create the next light by pressing Ctrl + V. In the Clone Options dialog box, choose the Instance option and OK to close the dialog box (Fig.39). All parameter changes to this new light will also affect the previous one and vice versa.

Repeat the steps covered earlier to create more instanced lights and place them close to all the tables on the ground floor. A total of 15 lights should be created (Fig.40). Test render to see the results.

Adjusting IES Lights

The new IES lights are not looking prominent in the render yet. To rectify this, simply do the following:

1: Select one of the lights and open the Modify panel.

2: In the VRayIES Parameters rollout, click on its empty toggle to locate and choose an IES web file. Select the IES web file under the name of 1589835-nice.IES.

3: Reduce the shadows bias value to about 0.001m (Fig.41).

4: Change the color swatch value to: R: 246;
G: 193; B: 146. This will provide a nice
warm tone to the lights (Fig.42).

Region Renders

It's good practice to use the Region Render tool
when test rendering specific areas of the scene,
as it will speed up the work.

1: Go to the main toolbar and click on
Rendering. Choose the Rendered Frame
Window option from its drop-down
list. The frame buffer should now open
(Fig.43).

2: Click on its Toggle UI to enable its other
tool options.

3: In the Area to Render option, choose
the Region tool from the drop-down list.
Its marquee boundaries should appear
(Fig.44).

4: Select and move its corner handles to
encompass the ground floor area in the
frame buffer. Run a test render to see the
results.

Adjusting the Color of the Pavement

When looking at the render it looks like the
street color could do with tweaking. To fix this
the pavement texture will be made a little
darker.

1: In the Material Editor, select the material
slot under the name of Pavement.

2: Go inside its main Diffuse toggle to edit
the bitmap settings.

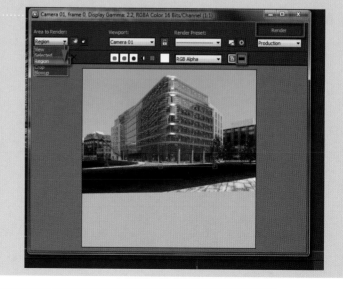

3: Scroll down to its Output rollout parameters and reduce its RGB Level value to about 0.7 (Fig.45).

Note the changes taking place in the material slot thumbnail. You can also use this technique on other relevant materials in the scene.

Adjusting the Color of the Trees

The following step is to color correct the material under the tree foliage to match the photo reference.

1: Select the material slot under the name of Tree. Go inside its main Diffuse toggle and its Diffuse map parameters should load up.

2: Click on its Bitmap toggle to access the Material/Map Browser dialog box. Pick the ColorCorrection procedural map from the Standard rollout list (Fig.46).

3: Choose to Keep old map as sub-map? (Fig.47).

Adjusting the Color of the Foliage

Next we are going to color correct the tree leaves in order to match the photo reference closely. Have the photo reference ready in Max to help you adjust the colors.

1: Scroll down to the Color rollout parameters and move the Saturation slider to the right slightly, in order to accentuate its color (e.g., value: 15.615).

2: To add contrast to the texture, go to the Lightness rollout parameters and enable the Advanced function.

3: Its parameters will open. Under the Gamma / Contrast function, decrease the value to 0.8 and test render to see the results. Use the Region Frame Buffer tool to render the relevant area only (Fig.48).

The darkest and the brightest points of color in the foliage of the trees are now matching the photo reference closely (Fig.49). Feel free to use different values if desired. Once you are satisfied with the results, click on the Go to Parent button to return to the main material parameters. Finally, use the techniques covered earlier to tweak other materials in the scene, if necessary.

Creating Proxies

If you are experiencing problems with the file size it's worth converting heavy objects in the scene into proxies. For example, the tree foliage seems to be one of the heaviest objects, so we will convert it to reduce the file size.

1: To select it, simply click on the Select by Material button on the Tree material slot. The Select Objects dialog box should pop up. Click on the Name bar/tab once to display the highlighted list of objects with this material applied to them.

2: Click on the Select button to select the listed objects in the scene (Fig.50). While the objects are selected, isolate them (Alt + Q) and go to the top viewport. It's good practice to isolate objects when working on complex scenes.

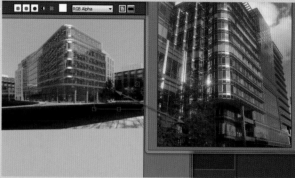

3: Right-click and choose the V-Ray mesh export option from the pop-up list. By default the folder location is chosen by Max. To change it, click on the Browse toggle to find a different location (Fig.51).

Since a number of objects are selected, you should choose the Export each selected object in a single file option. This function is ideal when creating proxies of more than one object simultaneously (e.g., unattached mesh). It is worth mentioning that this function preserves the pivot points of each individual proxy object created.

4: Finally, enable the Automatically create proxies function. This outstanding function automatically creates, replaces and assigns the textures to all proxies created. Press OK to create the proxies (Fig.52). All proxies are now created and placed automatically. The overall file size is substantially smaller now.

Proxy functionalities are identical to X-references. To locate the mesh of each proxy, simply go to the Modify command and check its Mesh file location path under the MeshProxy params rollout (Fig.53). These parameters also provide a range of other self-explanatory options such as scale, display type, animation, etc. One of its best tools is the Import function. This function allows users to bring the original mesh into the scene without the textures.

To reduce the file size further, use some of the techniques covered earlier. It's worth mentioning that for even better optimization of file sizes, simply attach all the relevant objects into one mesh prior to converting them into

proxies. This will enable the proxy in the scene to reference one or fewer meshes.

Before you attach multiple objects into one mesh, ensure that they are not instances of other objects. A quick way of collapsing instanced objects is to first select the objects in question, then right-click on them and choose to convert them into polys or meshes. When done, you can safely attach them to one mesh.

Rendering Glossy Objects

To help reduce the rendering times of some of the glossy objects in the scene, it is necessary to make some material adjustments.

> **1**: In the Material Editor, select the material slot named INTER and scroll down to its Options parameters rollout.

> **2**: While this material's glossiness is important, its reflection is less so due to its irrelevance in the broader context. For this reason we will keep all its current settings enabled, apart from the Trace reflections and the Trace refractions functions (Fig.54).

The rendering of this object will be substantially faster, while its physical glossy properties will remain intact. You can also use this technique on other, less relevant objects in the scene.

The Environment

The final material to be looked at is the environment and clouds that will be seen in the sky and reflections.

> **1**: Go to the top viewport and create a circle by selecting the Circle button from the

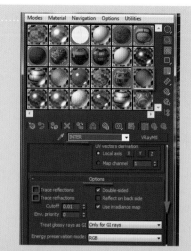

57

58

59

Shapes command list. Drag the cursor in the top viewport to create it.

2: Set its radius to about 164.911m to occupy a bigger part of the scene (Fig.55).

3: Next we are going to give it some width and extrude it. First, name the circle shape "Environment Reflection" and go to the Modify command.

4: From the drop-down Modifier List, choose the Edit Spline modifier to edit it.

5: Scroll down to the Selection parameters rollout of the Edit Spline modifier and enable the Spline button.

6: Scroll further down and open the Geometry parameters rollout. Pan down to the Outline button and type in an amount of about 0.2m. Press Enter to create the outline (Fig.56). Note that the outline has being created in the viewport. Try different values if desired.

7: To extrude the outlined circle simply add the Extrude modifier from the Modifier List. Isolate the outlined circle and extrude it to about 200m (Fig.57). Use the camera viewport to check its proportions. Also, move and center it within the camera position at: X: -170.292m; Y: 306.622m; Z: -22.389m. Feel free to try different values if desired (Fig.58).

The Environment Material

Next we are going to create a new material to assign to the Environment Reflection object. Self-illuminated materials work best when emulating environment reflections.

1: Since the Ceiling light material is a self-illuminated material, we will use its slot as the base to create a similar material. Select its slot and drop it to another material slot.

2: Re-name this new material slot as "Environment Reflection". A new material has now been created.

3: Remove its current Color toggle content by right-clicking on the toggle and choosing the Clear option from the pop-up list (Fig.59).

4: Locate and apply a bitmap under the name of sky019.jpg to the Color toggle content (Fig.60).

5: Assign the material to the object and apply a UVW Mapping modifier to it. Use the cylindrical mapping mode.

6: While the Environment Reflection object is still selected, right-click and go to its Object Properties dialog box. In the Rendering Control group, disable the Receive Shadows and Cast Shadows functions. Click OK to close its dialog box. This will make the object more realistic when emulating the physical properties of the environment (Fig.61). Run a test render to see the results.

Color Intensity

The render is looking okay. However, you can tweak it further by adjusting its Color intensity and UVW tiling.

1: Increase the Color intensity value of the Environment Reflection material to about

5.0. This will make the environment material more visible in the reflections.

2: Make the sky019.jpg texture visible in the camera viewport (e.g., Smooth + Highlights) to help control its coordinates (position) on the object.

3: In the UVW Mapping modifier scroll down to its U, V and W Tile parameters. Change the U Tile value to about 5.0 and the V Tile value to about 1.2. This action will enable the clouds in the bitmap to move closer to the main building. Run a test render to see the results (Fig.62). The overall render is looking much better now.

Environment Reflections

The final step is to make the Environment Reflection object contribute to the alpha channel. This will give the user more flexibility to edit the environment space in post.

1: While the Environment Reflection object is still selected, right-click and choose the V-Ray properties option from the pop-up list (Fig.63).

2: Its dialog box should now appear. To make the Environment Reflection object contribute to the alpha channel, simply go to the Matte properties group and decrease its Alpha contribution value to -1.0. Once this is done, close the dialog box (Fig.64 – 65).

You can also tweak other materials in the scene using some of the techniques highlighted earlier.

23//Rendering

This chapter will talk you through the process of preparing scenes to render in V-Ray.

A lot of emphasis will be put on the V-Ray image sampler parameters and its core settings when rendering high resolution images.

You will be introduced to industry approved indirect illumination settings and approaches that can be used to achieve fast, clean and appealing results.

Finally, key V-Ray render elements will be used to facilitate the post-production process and help address predictable changes that might arise from the client.

Antialiasing

Let's start by adjusting the image sampler (antialiasing) first.

1: Open the Render Setup dialog (F10) and go to the V-Ray tab (Fig.01).

2: Scroll down to the V-Ray:: Image sampler (Antialiasing) parameters rollout. In the Image sampler Type, choose Adaptive DMC from the drop-down list. This type of image sampler is quite good for clean, detailed and noise-free renders. Also, the Adaptive DMC sampler uses less RAM (memory) to process renders.

3: Next, open the V-Ray:: Adaptive DMC image sampler parameters rollout and set the Min subdivs value to 1. This value should be sufficient to capture details

in the distance. In extreme cases some professionals may increase it to 2 or a higher value to capture tiny details.

4: Set the Max subdivs value to about 6. The default value of 4 would be equal to 16 pixels per square, which is very detailed. However, since the final render output size will be 3000 pixels it makes sense to increase the Max subdivs value to about 6. Try different values if desired.

5: Disable the Use DMC sampler thresh. option. The Clr thresh function should be highlighted immediately. Set its value to about 0.003. The value of 0.003 is very high. Smaller values yield better results at the cost of longer rendering times.

6: Finally open the V-Ray:: Environment parameters rollout and turn on the GI Environment (skylight) override. Its value and toggle will override the skylight settings. At times, professionals use its toggle in conjunction with the VRayHDRI procedural map to generate light and extra sources of GI.

Indirect Illumination Parameters

Next we are going to fine-tune the indirect illumination parameters to achieve good, fast, clean and appealing results.

1: Go to the Indirect illumination tab and open the V-Ray:: Indirect illumination (GI) parameters rollout. In the Ambient occlusion group, turn it on and set the

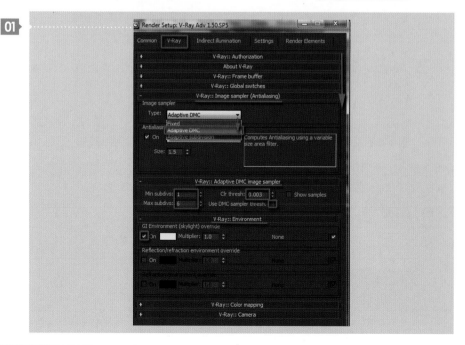

01

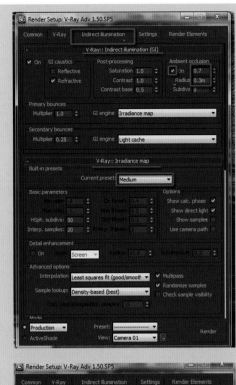

02

value to about 0.7m. The value of 0.7m often yields smooth results; however, you can try different values if desired.

2: Set the Radius value to about 0.3m. This value works very well for items close to the camera and objects in the distance. Try different values, if desired. The global ambient occlusion will help make the image more detailed and appealing.

3: In the V-Ray:: Irradiance map parameters rollout, set the Current preset to Medium. This should be sufficient to achieve smooth GI results for an exterior shot. For interiors, you would normally have to increase its Interp. samples value to achieve smooth results (Fig.02).

4: To clean up any possible light cache artifacts, scroll down and open the V-Ray:: Light cache parameters. In the Calculation parameters group, increase the Subdivs value to about 1500. This value should be enough to prevent any artifacts. For complex interior scenes, professionals at times use values such as 2000 or higher to correct artifacts.

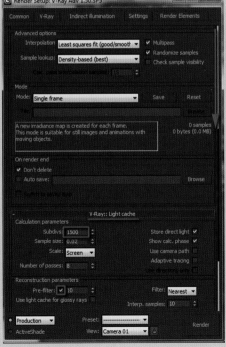

03

5: In the Reconstruction parameters group, enable the Pre-filter function. This will enable the filtering of the light samples to be processed before rendering time. This can potentially save users a considerable amount of time when rendering with a pre-saved light cache file(s). A value of 10 is okay; higher values may result in blurrier light cache results (Fig.03).

Regional Renders

Next we will begin carrying out regional high resolution renders of the scene, to assess the quality or other potential errors, prior to sending the final render. This is a precautionary measure to ensure that there are no unpleasant surprises in the final render.

1: Open the Common tab. Under its Common Parameters rollout, go to the Area to Render group and choose the Region type. Its marquee should appear in the viewport. Use some of the techniques covered in the previous chapters to position the Region render marquee so that it encompasses the ground floor and a fraction of the upper floor (Fig.04 – 05).

2: In the Output Size group, set the Width value to 3000 pixels. Since the Image Aspect function is locked, the Height value should also change proportionally.

3: If you haven't noticed yet, some of the buildings in the foreground are set to be displayed as a box, while others are set to not be visible to the camera or receive shadows. Each property was attributed according to the purpose of the relevant object in the scene. To access these properties, simply select the relevant object and right-click. In the pop-up list, choose the Object Properties option. Test render to see the results (Fig.06 – 07).

The render is looking as good as expected. You may want to make minor changes such as increasing the intensity of the VRayIES lights, or increasing the reflectivity of some of the surfaces, etc.

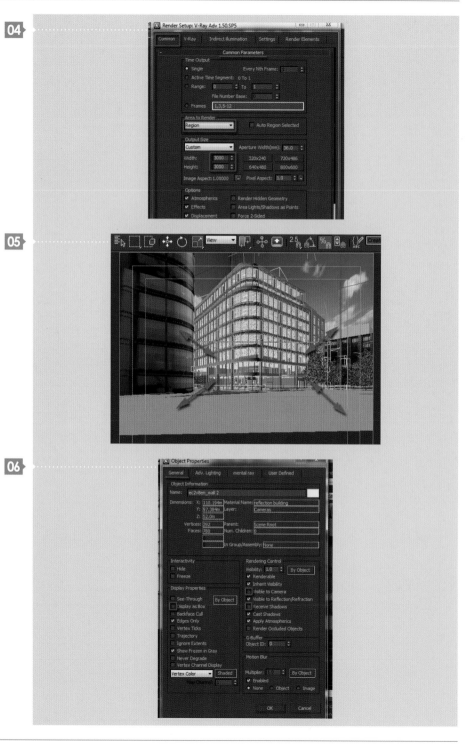

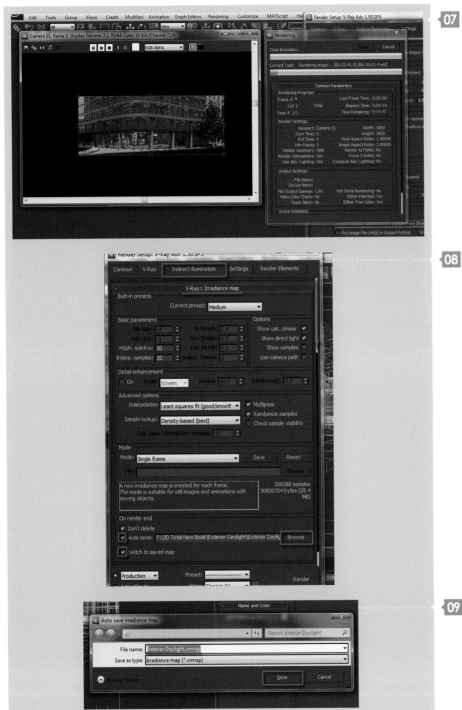

Cache and Irradiance Map Files

07 Once you are satisfied with the results of the high resolution region test renders, you can begin setting up the render to save the light cache and the irradiance map files. Having these files saved will allow you to send the renders over the network/Backburner to be computed as strip renders by multiple machines.

Another great benefit of having these files saved is that you can also make other minor material changes and test render regions of the scene without having to calculate the light cache or the irradiance map again. This also **08** means you don't have to carry out test renders on each element, etc.

Please note that you should not make any geometry or light-related changes (VrayLightMaterial being used as direct illumination, etc.,) once the light cache and the irradiance map files have been saved.

1: Change the Area to Render back to View and open the Indirect illumination tab.

2: In the V-Ray:: Irradiance map parameters rollout, scroll down and go to the On render end group. Enable the Auto save function and click on its Browse toggle. Find the appropriate folder location and name it "External Daylight" (Fig.08 – 09). If you are planning to use the Net Render option or multiple machines, ensure that the file is saved in a shared drive as opposed to a local one (e.g., C or D drive). To close the dialog box, click on the Save button.

09

3: Enable the Switch to saved map function. Once the irradiance map is processed and saved, this function enables V-Ray to automatically switch from default Single frame mode to From file mode.

4: Scroll down and open the V-ray:: Light cache parameters rollout and repeat the steps covered earlier (Fig.10).

Rendering the Cache and Irradiance Maps

Prior to beginning to render the irradiance and the light cache files, do the following:

1: Open the V-Ray tab and scroll down to the V-Ray:: Global switches parameters rollout.

2: In the Indirect illumination group, enable the Don't render final image function. This will allow the pre-rendering passes to take place (e.g., light cache, irradiance map) without culminating in a render (Fig.11).

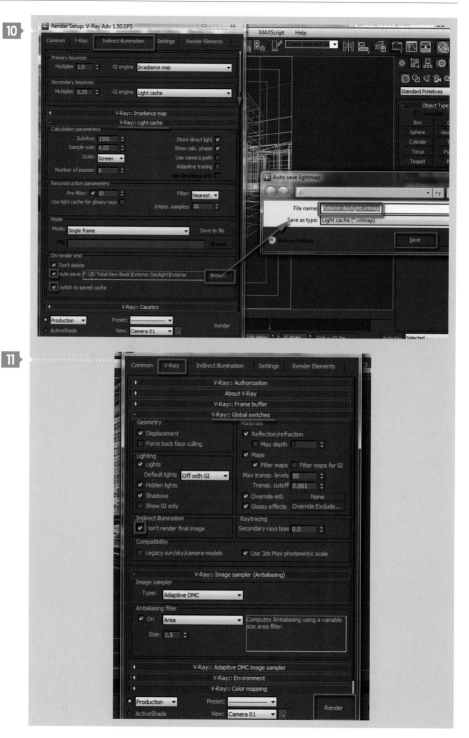

3: Click Render to begin saving the irradiance map and the light cache files (Fig.12).

Note how the irradiance map and the light cache modes have automatically switched from Single frame to From file mode once the pre-rendering process has ended.

Render Elements

Next we are going to add render elements.

1: Open the Render Elements tab and click on the Add button to access the Render Elements dialog box.

2: In the dialog box, scroll down and select the VRayWireColor element from the list. Click OK to close the box (Fig.13).

This element renders the physical wireframe color of each object in the scene. For the best results you should assign different colors to objects in the scene according to their material variations, etc.

When rendered, this element layer will be very useful when picking colors and editing individual areas of the image in post (Fig.14).

Ambient Occlusion

Next we are going to add the ambient
occlusion element.

1: Add the VRayExraTex element from the
Render Elements dialog box (Fig.15).

2: Once loaded, scroll down to the
VRayExtraTex parameters rollout and click
on its Texture toggle.

3: The Material/Map Browser dialog box
should appear. Pick the VRayDirt shader
from the Standard rollout list (Fig.16).
Once loaded, open the Material Editor (M)
and drag the Texture toggle component
to the material slot.

4: The Instance (Copy) dialog box should be
prompted. Choose the Instance copy
method (Fig.17). The VRayDirt parameters
should load up. Set its parameter as you
did earlier (Fig.18). Currently the VrayDirt
parameters are only affecting the surface
normals. The next step is to create
another VRayDirt material to invert this

18

process (e.g., open corners will now be shaded with the occluded color). This will help add extra detail to the render in post.

5: Add another VRayExraTex element as done previously. Name it "VRayExraTex 2" by typing it in the Name field and pressing enter (Fig.19).

6: Load another VRayDirt material in the Texture toggle, as done previously.

19

7: Drag and drop it in a new material slot. Its parameters should appear. Set the parameters as done previously (Fig.20).

8: In addition, enable the invert normal function. We now have two VRayExraTex elements yielding two different AO (ambient occlusion) results. It should be quite interesting to combine the two elements in post.

If desired, you can add other render elements such as VRayRawReflection, VRayRawRefraction and VRaySpecular, etc.

20

Final Render Settings

The next step is to locate or create a folder location for the final rendered image and set up its format properties.

1: Go back to the Common tab and scroll down to the Render Output group. Enable the Save File function and click on the Files toggle.

2: Its dialog box should appear. Name the file "Hero Shot" and chose the Targa Image File (tga) format as the Save as type. Set the TGA file to 32 bits per pixel and turn on Compress and Pre-Multiplied Alpha. The TGA file format is ideal (e.g., raw and with the alpha channels included), however, some professionals often use the EXR file format. Feel free to use a different file formats if desired.

3: Save and close the dialog boxes (Fig.21 – 23).

4: If you are using Backburner, enable the Net Render function. Backburner is quite useful when using multiple machines for frame by frame or strip renders. When using Backburner you will be able to monitor, control and edit the jobs being rendered, as well as the computers being used in the job queue.

5: Finally, go to the Render Element parameters to check which folder location the rendered elements will be saved into (Fig.24).

3ds Max automatically sets the location and re-names the render elements according to the Render Output file name and location.

The Final Render

Before starting the file to render (Shift + Q), open the V-Ray tab and disable the Don't render final image function (Fig.25). It's good practice to always remember to turn this function off prior to sending the final files to render.

Some of the rendered elements such as the ambient occlusion seem to have some artifacts in them (black dots). It is just the manner in which the frame buffer represents that rendered element (Fig.26). It will not be apparent once opened in post (Photoshop).

24//Post-Production

The final stage of the daylight exterior project will be to use cutting edge post-production techniques to bring to life the final visual. This is arguably one of the most crucial stages of the entire process as it can make or break the image. This is also the stage where the client might be looking over your shoulder, providing final comments and feedback. This final stage of the process will also provide users with more flexibility to add and edit changes at a much faster pace.

In this exercise, most post effects will be kept in a PSD file as layers and layer adjustments. This will provide you with the flexibility to edit the file contents at a later stage, if required.

1: In Photoshop, open the rendered file under the name of Hero Shot.tga (Fig.01).

2: Next, in the Layers tab, duplicate the layer by first selecting it and right-clicking on the layer. Its pop-up list should appear. Choose the Duplicate Layer option (Fig.02). It's good practice to work on duplicated layers to prevent damaging the original ones.

3: The Duplicate Layer dialog box should be open. Re-name it as "Render" and click OK to close it. It's also good practice to name relevant layers according to their functions. It makes it easier for another user to understand the file if they need to use it in the future. Most professional companies work in this way (Fig.03).

Layer Colors

Next we are going to change the layer color so the layers are organized by relevance.

1: Right click on the Render layer and choose the Layer Properties option from its pop-up list (Fig.04).

2: In the Layer Properties dialog box choose Red from the drop-down list.

3: Save the current document as Hero Shot. psd, by simply pressing Ctrl + S and saving it as a PSD file format (Fig.05).

The Sky

Let's start by working on the sky material. Production companies often edit the sky and the reflections in post. Open the following files in Photoshop: sky019.jpg, sky012_cleanedup_ small.jpg and the photo reference under the name of Building Photo Reference.jpg (Fig.06). To start replacing the sky in the render, do the following:

1: Select the sky012_cleanedup_small.jpg document and duplicate its background layer, as done previously.

2: In the Duplicate Layer dialog box, rename the new layer "SKY" and set its document Destination as Hero Shot.psd (Fig.07). The new SKY layer has now been dropped into the Hero Shot.psd document.

3: Change the SKY layer color to blue using the steps described earlier (Fig.08).

Resizing and Positioning the Sky Layer

Next we will start to edit the SKY layer.

1: First duplicate it to preserve the original layer.

2: Turn off the visibility of the original SKY layer by clicking on its eye icon.

3: Select the duplicated layer (SKY copy) and press Ctrl + T to enable the Free Transform tool. Its controls should appear.

4: To scale the layer proportionally, simply hold down the Shift key and drag down the bottom right handle.

5: Once you are satisfied with the scale of the document, and while the transform controls are still on, simply nudge the document using the up, down, left and right arrow keys to place the layer correctly (Fig.09).

6: Press the Enter key to exit the transform controls.

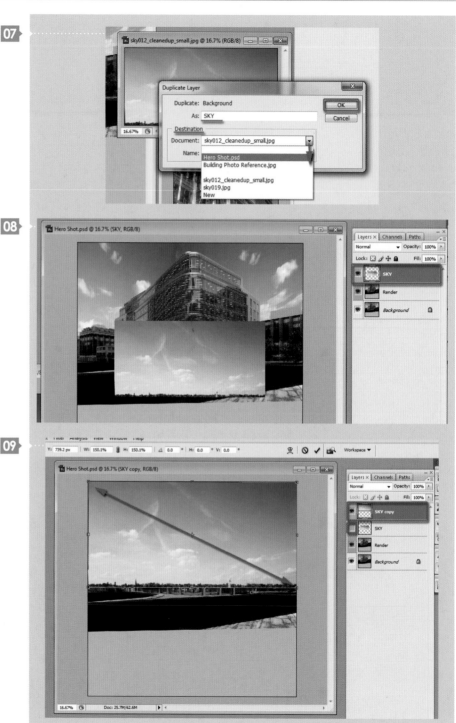

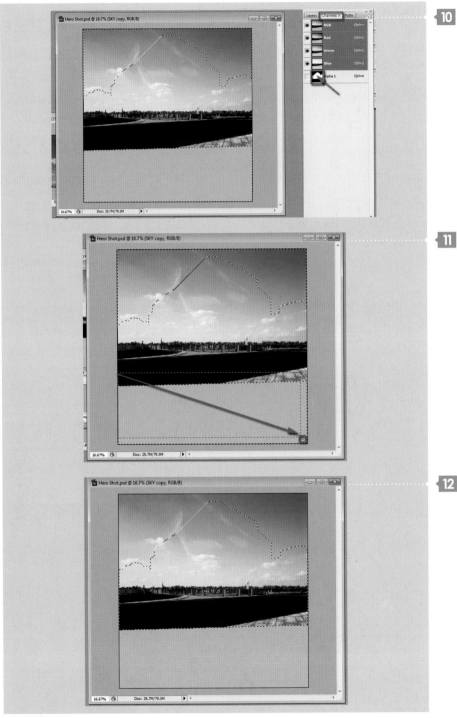

Selecting Unwanted Areas of the Sky

Next we are going to remove the sky areas obstructing the foreground elements.

1: Open the Channels tab. Hold down the Ctrl key and click on the Alpha 1 channel thumbnail. Its selection should appear. This Alpha 1 channel thumbnail was created during the rendering process (Fig.10).

2: The current selection seems to cover the foreground areas as well. To omit those areas from the selection, simply press the M key to enable the Marquee Selection tool, followed by holding down the Alt key and dragging it over the undesired areas of the selection (Fig.11). The foreground selection should now be omitted (Fig.12).

3: Next we are going to save the selection. While the selection is still on, invert the selection by pressing Shift + Ctrl + I. The sky area is now selected.

4: Click on the Selection main toolbar and choose the Save Selection option (Fig.13).

5: In the Save Selection dialog box, rename it "Sky" and make sure the New Channel option is checked. Then click OK to close the dialog box. A new selection has now been saved to the Channels tab (Fig.14).

Removing Unwanted Areas of the Sky

To begin omitting the sky image from the foreground areas simply do the following:

1: Go back to the Layers tab and deselect the current selection (Ctrl + D).

2: Click on the Add Layer Mask button to create a new mask attached to the SKY copy layer. Layer masks are quite helpful when omitting areas of an image without compromising the integrity of the original layer. It also means you can add the areas again quickly (Fig.15).

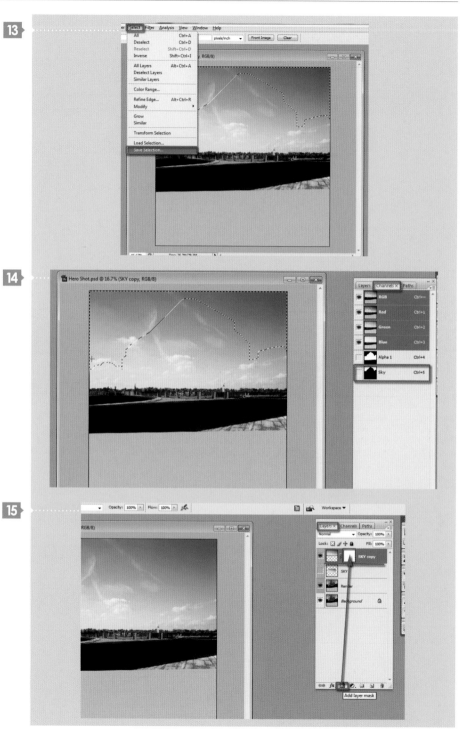

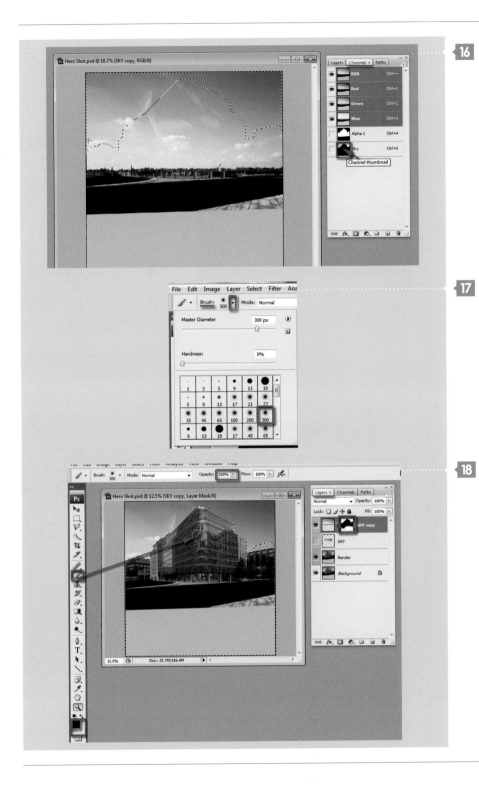

3: To select the Sky channel, open the Channels tab, hold down the Ctrl key and click on the Sky channel thumbnail. Its selection should appear in the document.

4: Go back to the Layers tab and ensure that the mask of the SKY copy layer is selected (Fig.16).

5: Enable the Brush tool by pressing the B key and choosing a brush style. To choose the brush style and/or size, click on its button from the main toolbar and pick the appropriate brush style from its pop-up menu. For this exercise, a feathered brush style was chosen and its size was 300. Once the brush style is chosen, you can use the] key to increase its size, or the [key to decrease it. To close the brush pop-up menu simply click on its button again (Fig.17).

6: While the Sky selection is still on, invert its selection (Shift +Ctrl + I) in the document.

7: Select the layer mask thumbnail of the SKY copy layer. In the side toolbar ensure that the Switch Background and Foreground Colors tool is set to black (foreground) and the Background is set to white. Black omits pixels, and white does the opposite. To switch the colors simply press the X key. Also ensure that the brush's Opacity is set to 100%. Begin brushing around the selected areas. Note how the pixels are being masked away (Fig.18).

Cloud Reflections Selection Area

Next we are going to start adding cloud reflections to the glass front of the building.

1: First, open the render element under the name of Hero Shot_VRayWireColor.tga (Fig.19).

2: Repeat some of the previous steps to add this document into the Hero Shot.psd file. Rename this new layer "Wirecolour".

3: Once in the Hero Shot.psd document, move this layer to the top of the stack and change its color to green. To move it, simply click on it and hold and drag the layer. Since we will be using this image to select specific areas of the document, it's imperative that the layer stays on top at all times. Also, turn off its visibility icon (eye) for the time being (Fig.20).

4: The next step is to create the cloud reflection layer. Select the original SKY layer and duplicate it. Rename it "reflection" (Fig.21). Change its color to orange.

5: Once duplicated, scale it using the transform tools to encompass large areas of the building. You can also nudge the layer around using the arrow keys to make it fit into a specific area (Fig.22).

6: Once you are satisfied with the scale and the position of the reflection layer, use the Wirecolour layer to select the glass areas of the building. Turn on the visibility of the Wirecolour layer and zoom into the document by 50%, at least.

7: Click the Select main toolbar and choose Color Range from its drop-down list. Its dialog box should appear (Fig.23).

8: Use the Eyedropper tool to pick the glass color from the Wirecolour image (greenish color). Use the Fuzziness slider to control the selected areas in the thumbnail (Fig.24). The white area represents the selected areas and black represents the areas that are not selected. A value of 65 worked well. It's good practice to only use this tool when the entire document is deselected. Once you are satisfied with the selected areas, click OK to close the dialog box.

9: While the selection is still on, turn off the Wirecolour layer's visibility and save the selection to the Channels tab using the techniques covered earlier. Name it "reflection" (Fig.25).

Cloud Reflections

Now that the selection is made it is time to complete the effect and hide part of this layer that shouldn't be seen.

1: Select the reflection layer and click the Add Layer Mask button. The unselected areas are now masked out (Fig.26).

2: To blend this layer with the render, choose the Overlay blending mode from the Layers drop-down list (Fig.27). This blending mode worked well. However, feel free to use a different one if desired.

Removing Unwanted Parts

The following steps will help you to omit the cloud/sky from areas where it shouldn't be apparent.

1: Select the mask thumbnail from the reflection layer and enable the Brush tool (B). Ensure that the Switch Background and Foreground Colors tool is set to black (Foreground) and white (Background).

2: Set the brush opacity to about 30%, and begin brushing around the areas where the surrounding buildings are being reflected. This makes sense as most clouds are above the buildings in real life.

Setting the brush opacity to about 30% will enable better control when brushing away (masking out) areas of the layer.

3: To control the brush size, press the] key to increase or [to decrease (Fig.28).

Adding Extra Clouds

Next we will be using some of the techniques covered earlier to add more clouds to the upper areas of the building façade. This will help make the image more interesting.

1: Select and duplicate the SKY layer. Rename it "reflections2" and change its color to orange. In addition, turn on its visibility icon and move the layer up so it sits above the reflections layer. This will help blend the layer more seemingly.

2: Enable the Free Transform tool and scale it proportionately (Fig.29). Also, nudge it up so the clouds can encompass the upper areas of the building façade (where there are no buildings being reflected).

3: Before moving the reflections2 layer, decrease its opacity to help you see through it to make it easier to position. Once you are satisfied with its position, exit the transform mode and increase the layer's opacity back to 100%.

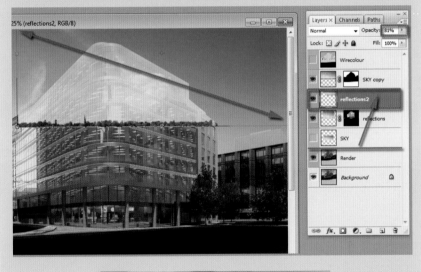

4: Enable the reflection selection saved earlier and create a layer mask thumbnail as you did previously.

5: Change the blending mode to Overlay to see the results. Currently this doesn't look realistic.

6: Click on the Image option in the main toolbar, then go to Adjustments and choose Curves from the drop-down list. Its dialog box should pop up (Fig.30).

7: In the pop-up window you will see an oblique curve running through a small graph. The upper-most parts of the curve represent the brighter areas of the image. the middle parts represent the mid-levels of the image and the lower parts represent the darker areas.

8: To edit the curve begin adding points to it with the cursor (target/cross), followed by moving the curves down to darken the image (Fig.31). The image should now blend better. However, you will still be able to see the boundaries of the reflections2 layer in the document.

9: To rectify this, simply brush away (mask out) the relevant areas using some of techniques covered earlier (Fig.32).

Adjusting the Reflection Colors

Next, we are going adjust the reflection colors slightly to make it more appealing.

1: Load/enable the reflections selection channel saved earlier. When the selection is on, click on the Create Adjustment Layer button.

2: Choose the Hue/Saturation option from its pop-up list (Fig.33).

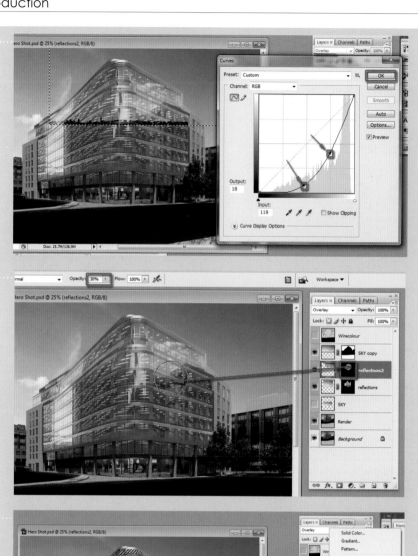

3: In the Hue/Saturation dialog box, pick the Blues option from the Edit drop-down list. Move the Saturation slider to the left slightly (-34). Note how the blue tones have become more subtle and appealing in the image (Fig.34).

4: The cyan tones are also too prominent. Pick Cyans from the Edit list or use the Eyedropper tool to select the relevant color from the layer. Decrease the saturation to about -59. Close the dialog box when you are satisfied (Fig.35).

5: To access the Hue/Saturation dialog box simply double-click on its layer icon thumbnail. Adjustment layers are very useful to work with due to their multiple uses and efficiency when tweaking parts of the image.

Use this technique to create more clouds if you like. If you do, ensure that the other reflection or cloud layers are kept below the Hue/Saturation adjustment layer. This is to ensure that these new layers will also be affected by the Hue/Saturation adjustment layer. Another cloud layer was created under the name of "reflection3".

The Glass Color

Next we are going to tweak the color of the glass using curves.

1: Enable/Load the reflection channel again and add the Curves adjustment layer (Fig.36).

2: Play with its RGB, Red and Blue channel by adding curve points and moving them around until you have achieved acceptable results. Note the changes taking place in the document (Fig.37 – 39). The final result should have more contrast and should include more realistic blue tones.

Enhancing the Lights

Due to the amount of sky and cloud layers that have now been added, the ceiling lights have lost their original yellow tint. To correct this simply select the reflections layer and gradually mask the ceiling light area with the Brush tool using some of the techniques covered earlier. Ensure that the ceiling lights look random and that some lights have a stronger blue tint than others to give an authentic effect. This can be achieved by using brushes of differing opacities (Fig.40).

Adjusting the Ground Floor Area

Next we are going to increase the brightness and the warmth of the ground floor area (shop) using Curves adjustment layers.

1: First, select and turn on the visibility of the Wirecolour layer. This layer will help us select the ground floor area.

2: Enable the Magic Wand tool in the side toolbar and set its Tolerance value to about 10.

3: Begin by selecting the areas you want to tweak (Fig.41). Once you have finished doing this, turn off the layer's visibility and add a new Curves adjustment layer.

4: Use some of the techniques covered earlier to achieve believable results. Ensure that this new adjustment layer is on top of the Curves 1 layer.

5: Finally, rename the new adjustment layer "ShopArea" (Fig.42).

People Size Reference

The next step is to start adding people. People often help to provide added narrative to the scene and building. They also give you an idea about its scale, purpose and functionality.

It is common practice to be selective about the types of people you choose to help sell the design. One of the things that will always work is to add people indulging in some kind of activity as opposed to just posing. It's also good practice to have very few people on their own, many people in groups and others interacting with the space.

It's important to ensure that the light cast on people works with the light in the rendered image (e.g., no direct shadows cast on people in indirectly lit areas, or diffused shadows on people in directly lit areas).

As well as the color and position of the people, it is vital that they are the correct scale in relation to the scene.

1: Before you begin adding people in the document, create a few 3D people or boxes in the 3ds Max scene (make them not renderable and about 1.65m or 1.70m in height). These will be used for scale reference purposes only. Place them in the scene where you think you would like to add cut-out people in post.

2: Take a screen print of the main camera shot by pressing the Print Screen key on your keyboard. The text on your key may vary depending on your model of keyboard (Fig.43).

3: Go to Photoshop and create a new document by pressing Ctrl + N.

4: Paste the screen print into the new document by pressing Ctrl + V.

5: Enable the Crop tool by pressing the C key. The areas needed are the Show Frames areas (the yellow square lines in the outer areas of the frame). Click and drag to begin cropping, and adjust its handles to crop more precisely (Fig.44).

6: Insert this new layer into the main PSD file (Hero Shot.psd) using the approach explained earlier. Rename it "peoplesizes" and move it so it sits beneath the Wirecolour layer. Also, change its color to yellow (Fig.45).

7: The next step is to scale the people sizes to encompass the entire document. Use the layer opacity values to help match this layer with the render beneath it (Fig.46).

Adding People

Now we have our reference guide it is time to start adding the people to the scene.

1: Open the Photoshop file named Couple. psd.

2: Add the first people to the main document (Hero Shot.psd) and ensure that this layer is on top of the peoplesizes layer.

3: Scale it proportionally to match the size of the 3D people depicted on the peoplesizes layer. Once you are satisfied with the scale, turn off the visibility of the peoplesizes layer (Fig.47).

Correcting the People

Next we will need to color correct the Couple layer to help blend it into the scene and add the shadows. Before that though, we should start by creating a group dedicated to the people. This is good practice to keep your PSD organized. To do this, simply click on the Create a new group button (Fig.48).

1: Select the Couple layer and move it inside the group folder. The Couple layer should now be part of the group folder (Fig.49).

2: Select the group folder and go to the Group properties. Rename it "people". Also change its color to red.

3: Open the people group folder by clicking on its arrow (Fig.50).

4: Next we are going to adjust the edges of the Couple layer to help blend them with the document. Select the Couple layer and hold down the Ctrl key, then click on the thumbnail to enable its selection in the document (Fig.51).

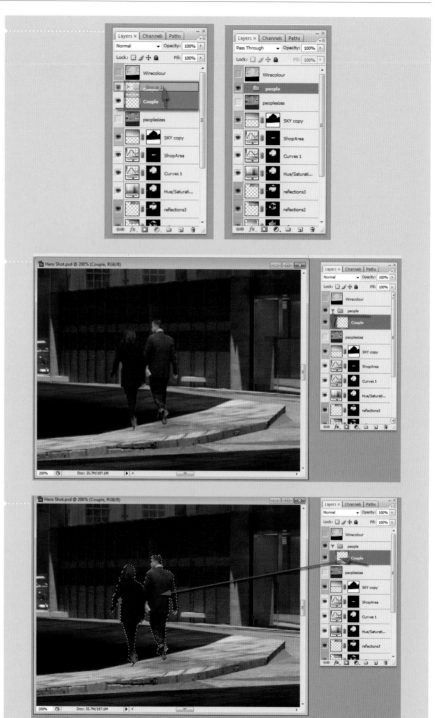

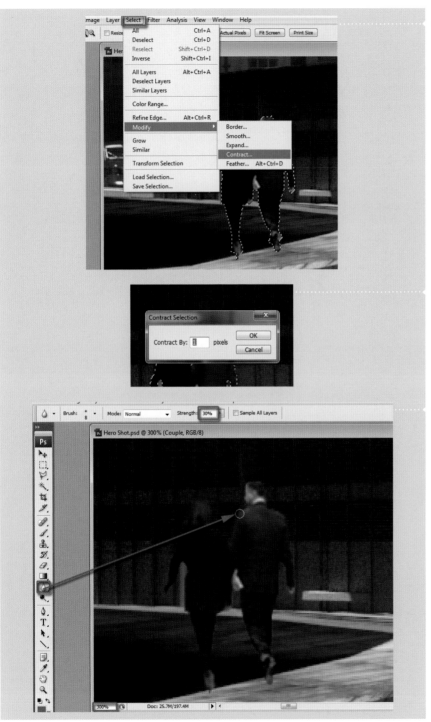

5: While they are selected, click on the Select button from the main toolbar. Scroll down to Modify and choose the Contract option from the drop-down list (Fig.52).

6: The Contract Selection box should pop up. Enter a value of 1 pixel and close the dialog box (Fig.53). A value of 1 pixel seems to have worked well. Invert the selection (Shift + Ctrl + I) and cut it (Ctrl + X).

The Couple layer is looking much better now. It's common practice to adjust the edge of the people to make it look more realistic.

Blurring the Edges

The next step is to blur the edges in order to make it blend seamlessly with the rendered image.

1: To do so, enable the Blur tool by pressing the R key. Set its Opacity value to about 30% and zoom into the document. A value of 30% will help you have better control over the amount of blur used.

2: Begin brushing the edges of the layer. It's worth noting that some professionals use the Global Feather tools on selected areas for quicker results. However, this often doesn't look as appealing as when it is executed manually and certain areas require more attention than others (Fig.54).

Color Corrections

The next step is to use the Selective Color adjustment layer to color correct the Couple layer.

1: Click on the Create New Adjustment Layer button and choose the Selective Color option from the pop-up list (Fig.55).

2: Click OK to close the dialog box. Ensure that this adjustment layer is selected and on top of the Couple layer.

3: To permanently connect this adjustment layer to the layer below (Couple layer), simply hold down the Alt key and hover over the line between the top layer and the layer below. An icon should appear; click on that line to make the connection. You should now see a new arrow pointing downwards (Fig.56). This indicates that the two layers are now connected.

4: You can then begin editing the Selective Color settings in the dialog box to make the layer blend more accurately (Fig.57 – 58). Tweak the Neutrals and the Blacks values to make the layer blend better. You can try different values and colors if required.

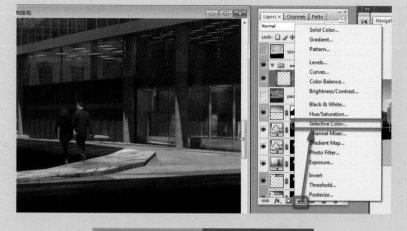

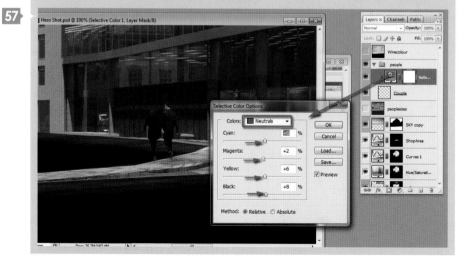

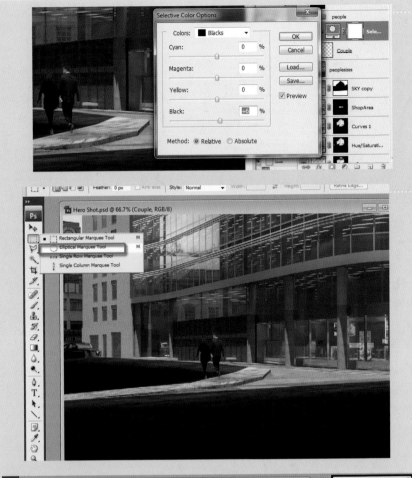

Diffused Shadows

58

Next we are going to create diffused shadows. When it comes to people's shadows it always helps to make them subtly diffused when there are areas directly or indirectly lit underneath them.

1: Go to the side toolbar and enable the Elliptical Marquee tool by clicking and holding on its icon, followed by choosing it from the pop-up menu (Fig.59).

59

2: Select and drag the Elliptical Marquee tool underneath the lady to create the selection.

3: While the area is selected, choose the Paint Bucket tool from the side toolbar and create a new layer by clicking on the Create a new layer button. Ensure that this new layer is underneath the Couple layer.

4: Rename the new layer "diffused shadows" and change its color to gray. While the elliptical selection is still on, fill it with black using the Paint Bucket tool (Fig.60).

60

5: To make the shadows look realistic we are
going to blur them slightly. Go to the
Filter main toolbar and choose the Blur
option, followed by Gaussian Blur from its
drop-down list (Fig.61).

6: The Gaussian Blur dialog box should pop
up. Set its Radius value to about 5.5 pixels
and close the box. Use different values if
desired (Fig.62).

7: To help blend the shadows, add a new
layer mask to the diffused shadows layer
and begin brushing away (mask out)
the edges using some of the techniques
described earlier (Fig.63). In addition,
you may also need to reduce the layer's
opacity in order to help blend the layer
further.

8: Copy the diffused shadows layer and
place it underneath the man next to the
lady. To copy it, simply enable the Move
tool by pressing the V key, then hold
down the Alt key and move the layer to
copy it.

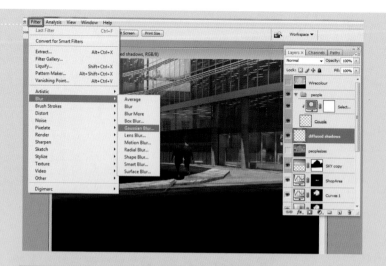

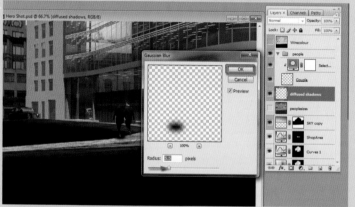

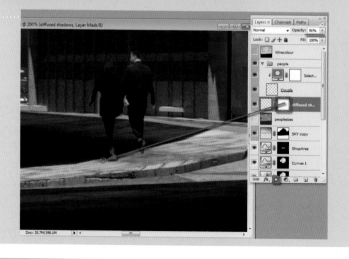

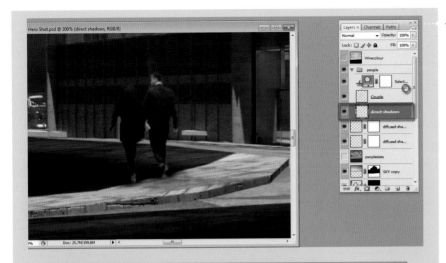

Direct Shadows

Next we are going to create the direct shadows cast by these two individuals.

1: Select the Couple layer and duplicate it using the steps covered earlier. Note in the document that this layer is now on top and the adjustment layer is no longer linked to the Couple layer.

2: To correct this simply move the copied layer underneath the Couple layer. Now that the Couple layer is underneath the Selective Color adjustment layer, simply repeat the previous steps to re-link the two again.

3: Select the copied layer underneath the Couple layer and rename it "direct shadows". Change its color to violet (Fig.64).

4: The next step is to distort the direct shadows layer so it follows the same direction as the other shadows in the scene.

5: Enable the Free Transform tool by pressing Ctrl + T. Move down its top middle handle and right-click to enable the Distort option (Fig.65).

6: Push and pull its transform handles to the right so it matches the direction of the other shadows. Once you are satisfied, press Enter to exit (Fig.66).

7: To darken the direct shadows open the Levels dialog box by pressing the Ctrl + L keys. In the Output Levels group, move its slider to the far left (0.0), and press OK to close the box (Fig.67).

8: Finally, use some the previously described techniques to help blend the shadows into the scene (Fig.68).

Use these steps to add more people and shadows in the document.

Further Tweaks and Additions

There are a few further things that can be added or tweaked in the scene.

1: Increase the brightness of the darker areas in the foreground using some of the techniques highlighted earlier.

2: Use the Dodge and Burn tools to create highlights or to darken areas in the document.

3: Add new items (photos/images etc.,) and tweak them using the tools and techniques described earlier. This will make the ground area and the overall shot more interesting (Fig.69).

Negative Space

Currently there's too much negative space in the document. To correct this, we are going to do the following:

1: Create a new layer, as previously done, and name it "Crop". Also, change its color to orange.

2: Ensure that the Crop layer is just underneath the Wirecolour layer (Fig.70).

3: As previously done, use the Rectangular Marquee tool to create a selection in the negative areas of the document. To add a new selection to the existing one, simply hold down the Shift key while the selection is on and the Rectangular Marquee tool is enabled (Fig.71).

4: Use the Paint Bucket tool to fill the selection with a black color. A new cropped area has been created. Press Ctrl + D to deselect the area.

Tree Leaves

The tree leaves are currently looking slightly too vivid in comparison to rest of the image.

1: To rectify this we are going to start by selecting and turning on the Wirecolour layer. Once you have done this, use the Eyedropper tool to select the trees (Fig.72).

2: Select the ShopArea layer and add a Hue/Saturation adjustment layer.

3: In its dialog box, reduce the Saturation level to about -33 and click OK to close the box (Fig.73).

The ShopArea layer was selected simply to ensure that once the new adjustment layer was created, it would be made on top of it. The Hue/Saturation adjustment layer does not affect the ShopArea layer. Rename the new adjustment layer "tree color" and change its color to green.

Ambient Occlusion

The next step is to add the ambient occlusion element in the document.

1: Open a file named Hero Shot_VRayExtraTex_Map #8747.tga in Photoshop (Fig.74).

2: Select the Hero Shot.psd document, then select the people layer folder. This is to ensure that once the file Hero Shot_VRayExtraTex_Map #8747.tga is merged into the document it sits on top of the selected layer (Fig.75).

3: Select the Hero Shot_VRayExtraTex_Map #8747.tga file again and merge it into the main Hero Shot.psd document using the techniques described earlier. Rename it "AO" and change its color to gray.

4: Change the layer to Multiply blending mode to help blend the layer into the document. Use some of the techniques covered previously to mask out darker parts of the ambient occlusion from areas such as the windows, sky, façade, etc (Fig.76).

5: Reduce its layer opacity to about 50%. The image is now looking much better.

Effects

Prior to finalizing the image it's worth considering things such as adding more clouds, color corrections and tweaking the sky. Use some of the techniques and adjustment layers mentioned earlier (Curves, Levels, Selective Color, etc.,) to achieve this (Fig.77 – 78).

The next step is to apply chromatic aberration and vignette effects to help add more realism to the image.

1: First, duplicate the entire document by right-clicking on top of its edges and choosing to Duplicate it (Fig.79).

2: Its Duplicate Image dialog box should pop up. Rename the new document "Hero Shot effects" (Fig.80).

3: Enable the Crop tool and go to the View tab in the main toolbar. Choose Snap To then Layers from its drop-down list (Fig.81). This will allow the Crop tool to snap into the layers' boundaries when cropping.

4: Select the Crop layer and crop the document using the approaches covered earlier (Fig.82).

5: In order to apply the chromatic aberration and then later the vignette effects to the entire image, you should first flatten document.

6: While the Crop layer is still selected, right-click and choose the Flatten Image option from the pop-up list (Fig.83). Also, choose to discard hidden layers and then click OK to close the dialog box (Fig.84).

Chromatic Aberration

In a previous chapter we manually applied chromatic aberration. For the purpose of this exercise we are going to use a Photoshop filter to emulate it.

1: First duplicate the background layer and rename it "CA" (chromatic aberration).

2: While the CA layer is still selected, go to the Filter main toolbar, followed by choosing the Distort function from the drop-down list and then Lens Correction (Fig.85).

3: Its dialog box should appear. Most of its parameters are self-explanatory. Zoom in to 100% for a closer look at the changes.

4: For the purpose of this exercise we are only using the Fix Red/Cyan Fringe parameters. Move its slider to the right slightly (+16) to shift its channel. Try different values and parameters if desired.

Click OK to close the dialog box (Fig.86).

5: Add a new layer mask thumbnail to the CA layer and begin masking away areas where the chromatic aberration effect is too prominent. Use some of the techniques covered earlier to achieve this. This will make the visual more realistic and appealing (Fig.87).

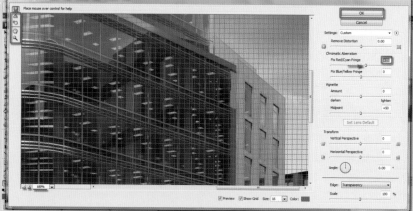

Vignette

It's always best to create the vignette effect as a separate adjustment layer for better control over its appearance, size and shape. To achieve this we will do the following:

1: Enable the Elliptical Marquee tool and create a selection by clicking on the top-left corner of the document, followed by dragging it across to the bottom-right corner. You should end up with an oval-shaped selection across the document (Fig.88).

2: While the selection is still on, feather it by going to the Select main toolbar, clicking Modify, and choosing the Feather option from its drop-down list (Fig.89).

3: Set its Feather Radius value to about 200pixels (Fig.90). Note that this value worked well for the size of this document. You can try different values if desired. Click OK to close the dialog box.

4: Next, invert the selection (Shift + Ctrl + I) so that when the vignette effect is created, it will only affect the outer parts of the document (Fig.91).

5: Once the selected area is inverted, create the Levels adjustment layer by clicking on its button (Fig.92).

6: In its dialog box, decrease its Output Levels to 0 or drag its slider to the far left point. Click OK to close the box (Fig.93). The vignette effect has now been created. Rename it "Vignetting".

7: Currently the vignette effect looks too prominent. To rectify this, simply scale it out of the document proportionately (Fig.94). Use the Transform tool and some of the techniques covered earlier to achieve this.

8: Reduce its layer Opacity value to about 80% and use the Brush tool in conjunction with the layer mask thumbnail to tweak its appearance (Fig.95). The overall image looks more appealing and realistic now (Fig.96). Save the document as a PSD file (e.g., Hero Shot effects.psd).

Saving as a TIFF

For printing purposes, professionals often save the PSD files as TIFFs, as well as keeping the PSD document. TIFF files are renowned for retaining the overall quality of the PSD after being saved and flattened.

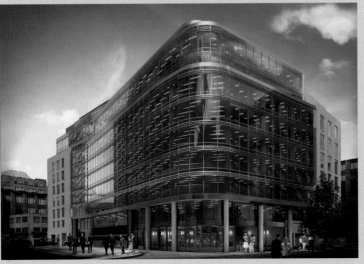

Chapter 05

25//Pre-Production

With the camera and most of the materials signed off in the previous chapter, the main goal at this point is to find a striking photo reference to be used as the base for the lighting and the overall mood.

During this rigorous selection process, the original brief is to present the client with a photo reference that truly captures an exterior office at night.

The following things are very important:

Colors: Some of the most dominant colors of an exterior office at night are the noticeably dark blue tones generated from the skylight. In contrast, there are also burnt yellow colors from the artificial lights washing over some of the predominantly dark blue surfaces.

Lights: The two most distinctive light sources typically found in real night scenes are the natural dark blue skylight and the warm yellow lights. From an artistic point of view, these two colors (blue hues and warm colors) are always complimentary to each other in both day and night scenes:

– The blue color is mostly apparent in the dark blue sky, but it is also on most indirectly lit areas of the scene.
– The warm yellow lights are ever present in most night shots and often contrast with the predominant dark blue tones.

Shadows: Most natural shadows at night are diffused (indirectly lit) and have a blue tint from the skylight.

Highlights: Highlights are another typical effect found in most striking night shots. They contribute a great deal to making a photo appealing. They are mostly present when intense light sources are affecting glossy/reflective surfaces in the scene, or simply when surfaces are being illuminated.

Reflections: Photos that contain interesting reflections are always helpful as references (Fig.01).

People: When choosing people to add in night scenes, professionals would normally take photos of people relevant to the context and at the correct time of the day. If you don't do this, you will be required to color correct and tweak the photos to blend them with the renders. It is common practice to take photos of people involved in some sort of activity related to the scene, as opposed to just posing.

Effects: Post effects such as light trails, vignette, chromatic aberration, glints and blooms from lights will help improve the final night visual dramatically (Fig.02).

Going into the production phase with key photo references provides the client with a clear idea of the camera composition, the lighting effects, the material properties and the additional effects to help improve the final visual. The entire process is designed to help the client understand and preview the impact of their design choices and the art direction, prior to commencing the production phase. Fig.03 is the main point of reference for this project.

26//Lighting

Accessing Your Starting Point

This chapter will focus on lighting the scene
that was planned in the previous chapter. The
starting point of this tutorial will be the fully
textured file from the daylight scene.

Start by opening the scene named Exterior_
Night_VRAY_Start.max. Go through the scene
to check its content and current parameters.
Do another quick test render (Shift + Q). You
will notice that the scene doesn't seem to have
the sunlight object in it and the Environment
Reflection geometry is hidden. Also the scene's
viewport style is set to a Bounding Box mode in
order to speed up the viewport performance.
Switch it to Wireframe or Smooth + Highlights
mode if necessary (Fig.01).

Editing the V-Ray Sky

Next we are going to edit the VRaySky
parameters so that it resembles the night's sky.

 1: Open the Material Editor (M) and the
 Environment and Effects dialog box by
 pressing the 8 key.

 2: In the Environment and Effects dialog
 box, go to the Environment tab and open
 the Common Parameters.

 3: In its Background group, drag the
 VRaySky toggle from the Environment
 Map and drop it into a material slot.
 Choose the Instance (Copy) method
 and hit OK to close the dialog box. The
 VRaySky Parameters rollout should now
 be loaded (Fig.02).

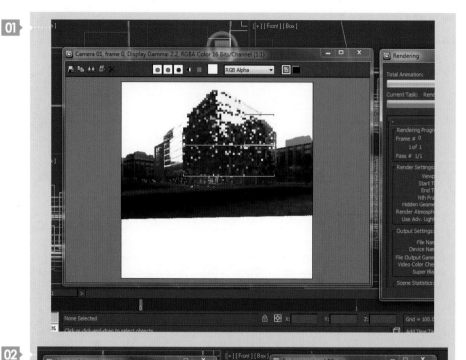

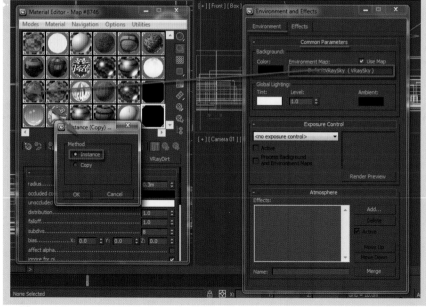

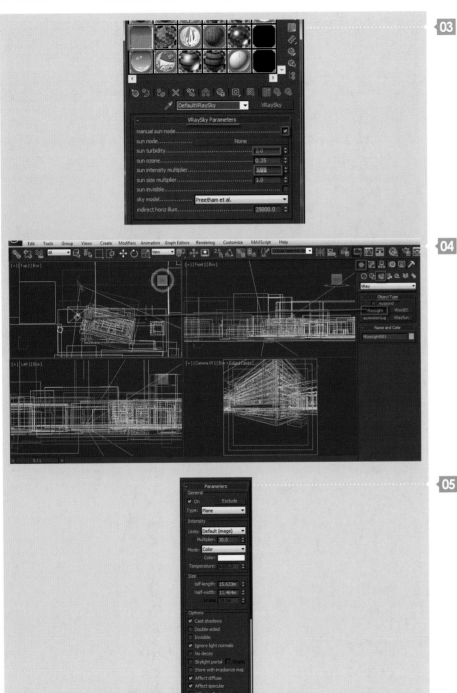

4: To begin editing its parameters, enable the manual sun node function. Following that, decrease the sun turbidity to about 2.0 and the sun intensity multiplier value to about 0.01 (Fig.03).

Note in the material slot thumbnail how the changes are occurring. Try different values if desired. Run another test render again.

Sky Dome Lights

The sky is looking much better now. Next we are going to create a sky dome light to emulate a night scene.

1: Ensure you have all four viewports on display (top, front, left and the camera angle). Go to the Command panel and open the V-Ray light group as you did previously.

2: Under the Object Type group, click on the VRayLight button followed by clicking and dragging the cursor in the top viewport to create it. The VRayLight should now be created (Fig.04 – 05).

Adding a Sky Dome

The next step is to open the photo chosen during the pre-production phase to use as the reference to light the scene.

1: Open the reference image called Night photo reference.jpg in 3ds Max, using steps described previously. You will notice in the photo that the blue sky tones are being cast on the side of the building and that the yellow lights contrast with this nicely. The next step is to try to imitate these colors in the 3D scene.

2: While the VRayLight object is still
selected, open the Modify panel and pan
down to the Intensity group. Click and
hold on its color swatch to open the Color
Selector dialog box (Fig.06).

3: Click on the Sample Screen Color button
and pick the blue tone from the reference.
The blue tone in the photo reference
should now be captured in the Color
Selector values. Alternatively, simply type
in R: 0.0, G: 0.0, B: 2. Click OK to close the
dialog box.

4: Change the light Type to Dome and
pan down to its Options group. Note in
the viewport how its shape has changed
(Fig.07).

5: In the Options group, turn on the Invisible
function. This will hide the dome object in
the render without affecting its impact in
the scene or GI.

6: Turn on the Store with irradiance map
function. This will prevent the scene from
yielding artifacts generated by the low
sampling subdivs of the sky dome and
will also help decrease the rendering
times dramatically (Fig.08).

7: Finally, disable the Affect reflections function. This will prevent the sky dome from being visible on reflective surfaces. Test render the changes (Fig.09).

Adjusting the Reflections

The render looks okay. However, the sky color and the reflections are not coherent with the overall blue tone generated by the sky dome object. Also the scene looks slightly too dark.

1: First, we are going to unhide the Environment Reflection geometry by clicking on the Unhide by Name button in the Display command panel, and choosing the Environment Reflection name from the Unhide Objects list.

2: To automatically find the relevant name from the list, simply type the first few letters into the Find name box. At times you might need to click on the Name bar to bring up all objects starting with your chosen letters. Click on the Unhide button to close the dialog box (Fig.10).

3: Next we are going to brighten up the scene slightly. Open the Render Setup dialog box (F10) and then go to the Indirect Illumination parameters. Increase the Primary bounces Multiplier value to about 1.5 and the Secondary bounces to 1.0.

4: The next step is to replace the current sky bitmap of the Environment Reflection geometry so it resembles the night sky. Open the Material Editor (M) and select the Environment Reflection material slot. There will be a pre-prepared texture bitmap called sky019_Night .jpg (Fig.11).

5: Locate and load the file in the VRayLightMtl Color toggle. Finally, decrease its current value to about 1.0 and test render the results (Fig.12 – 13).

Adjusting the GI

The render is looking much better now. However, increasing the direct illumination has made the GI less blue and incoherent with the new sky bitmap.

1: Select the light dome object and open the Modify panel. Increase its Intensity multiplier value to about 150. This will increase the influence of the light dome color in the scene. Feel free to try different values.

2: While the light is still selected, copy its Color swatch into the GI Environment (skylight) override.

3: In the Render Setup dialog box, open the V-Ray tab and scroll down to the V-Ray:: Environment parameters rollout. Turn on its function. Select and drag the color swatch from the light dome and drop it into the GI Environment (skylight) override color swatch (Fig.14).

4: A dialog box should be prompted. Choose to Copy and close the box.

5: Do another test render to see the changes (Fig.15).

Adjusting the Artificial Lights

The color of the reflections and the sky are more consistent now. The overall blue tone is not exactly the same as the photo reference, but it's at a stage where it can be easily adjusted in post-production to match perfectly. The next step is to change the color of the ceiling lights to try to match the photo reference more closely.

1: In the Material Editor select the Ceiling light material slot and go to its Color #1 toggle (Map #8740).

2: In its Co-ordinates parameters, scroll down and open the Output parameters rollout. In the RGB Color Map group, select the Red channel's higher point curve and move it up to about 2.882.

3: Select the Green channel's higher point curve and move it down to about 0.62.

4: Finally, select the Blue channel's higher point curve and move it down to about 0.048 (Fig.16). Note how the yellow tones have become prominent. If you are satisfied with this, go back to the main VRayLightMtl parameters by clicking on the Go to Parent button.

5: Once in the main parameters, decrease its
Color value to about 3.0 and test render
the results (Fig.17 – 18).

Boosting the Color of the Lights

The render has improved dramatically. The next
step is to copy the VRayIES lights across to all
of the floors to boost the yellow color and to
reinforce the number of lights in the scene.

1: Turn the viewports to Wireframe mode
to speed up the process. Select the object
named _floor-offices using the Select
from Scene (H) dialog box (Fig.19).

2: Once this is selected go to the Top viewport and change the Selection Filter type to Lights. When you have done this, hold down the Ctrl key and select all the lights in the scene using the Rectangular Marquee Region tool from the main toolbar (Fig.20). You should now have all the floor slabs and lights selected. It is necessary to do this to avoid selecting unwanted objects. Isolate the selected objects (Alt + Q).

3: Select the ground floor IES lights only and begin copy/instancing them across the ground floor area.

4: Once you are satisfied with their respective positions, copy/instance them across all the floors (Fig.21).

5: Finally, move them around randomly and ensure that they are within the floor slab boundaries (Fig.22).

6: Test render the scene to see the results
Don't close the render frame buffer
(Fig.23).

The render has now improved substantially,
however the building now looks too evenly
illuminated.

To correct this simply delete some of the lights
randomly. Another approach to fixing this is to
adjust it later in Photoshop using some of the
render elements.

Adding Reflections

The next task is to add more reflections to
the glass front of the building and allow the
lights to pass through it. Due to the amount
of illumination in the building the reflections
are not very apparent, which is true to real life.
On this occasion however we will change this
slightly to make the image look more visually
appealing.

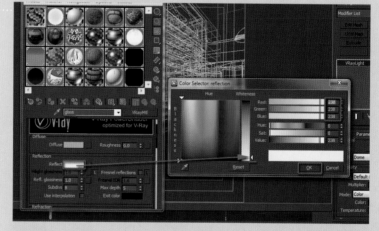

1: Start by selecting the glass material slot in
the Material Editor.

2: In the Reflection group, click and hold
the Reflect color swatch to bring up its
dialog box. Move down its Whiteness
slider to nearly white (R: 238; G: 238; B:
238). Click OK to close the dialog box
(Fig.24). The reflectivity has increased
substantially now.

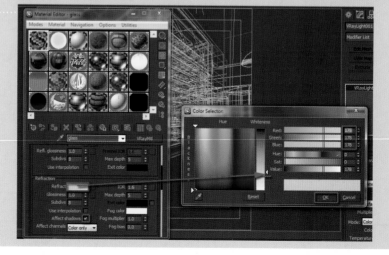

3: We are also going to make the glass
slightly less transparent in order for the
reflections to be even more apparent. Pan
down to the Refraction group and click
on its color swatch to bring up the dialog
box.

4: In the Color Selector dialog box, move up its Whiteness slider slightly (R: 178; G: 178; B: 178).

5: Finally, enable the Affect shadows function. This will allow the light to pass through the glass (Fig.25).

Final Test Render

Before you test render the results, duplicate the last rendered frame buffer to compare the results. To do this simply click on its button and begin test rendering (Fig.26 – 28). This concludes the exercise.

The next chapter will take users through to the final stage of the production process: rendering.

27//Rendering

This chapter will guide you through the process of setting up key rendering parameters in order to achieve acceptable results. Some of the techniques implemented in the previous chapters will be deployed to ensure a high quality finish. At the same time we will be planning the transition of the final visual and its render elements from 3ds Max to Photoshop.

Indirect Illumination Parameters

We will start by opening the most recent, saved version of the 3ds Max file named Exterior_Night_VRAY_Start.max. First we are going to tackle the Indirect illumination parameters.

1: Open the Render setup (F10) and go to the Indirect illumination tab.

2: Scroll down and expand the V-Ray:: Irradiance map parameters rollout.

3: Change the Current preset to Medium. This pre-set should be sufficient for most exterior and interior scenes without drastically increasing render times. When working on complex, interior nighttime scenes you might be required to use higher pre-set values to achieve smoother results. Alternatively, professionals may also choose the Custom preset and then tweak its core settings to achieve specific results.

4: In the Basic parameters group increase the Interp. samples value to about 90. This value should be sufficient to smooth out any possible irradiance map artifacts that might become visible when rendering high resolution images, especially when using a dome light.

The Irradiance Map

The next step is to set V-Ray to save the irradiance map file. This technique will later prove to be useful when sending strip renders through the Backburner and over the network.

In addition, if you are later required to replace textures and colors in the scene, having previously saved the irradiance map will help shave off a considerable amount of the render time.

1: Pan down to the On render end group and enable the Auto save function. This will ensure that the irradiance map is saved during the rendering process.

2: To name the file, click on the Browse toggle and name it "Exteriornight.vrmap" in the Save irradiance map dialog box (Fig.01). Ensure that the file is saved in a shared folder (network) as opposed to your local drive (C or D). This will prove crucial when using distributed rendering (DB) or net rendering through the Backburner. Click Save to close the dialog box.

3: Finally, turn on the Switch to saved map function. This will enable V-Ray to automatically switch from the Single frame mode to From File mode after both maps files have finished saving. It's worth noting that when the Switch to saved map function is enabled, you should never save the Max file before the irradiance and the light cache maps

01

having been saved, otherwise V-Ray may automatically switch the mode to From File without saving the maps first.

Tweaking the Light Cache Map

Next we are going to tweak and save the light cache map.

1: Scroll down and expand the V-Ray:: Light cache parameters rollout.

2: In the Calculation parameters group increase the Subdivs value to about 2500. This value is high enough to correct any potential artifacts caused by the dome light. It's worth mentioning that a value of 2500 would also be sufficient for most interior scenes.

3: Finally, in the On render end group enable the Auto save function and name the light cache map "Exterior night. vrlmap". Also enable the Switch to saved cache function (Fig.02).

Rendering Irradiance and Light Cache Maps

Next we are going to increase the image sampler (antialiasing) quality to high resolution and render the scene to save the irradiance and light cache maps.

1: Open the V-Ray tab and expand the V-Ray:: Global switches parameters rollout.

2: In the Indirect illumination group enable the Don't render final image function. This option allows V-Ray to calculate the pre-rendering process (light cache, irradiance

map, etc.,) without kick-starting the main rendering process. Always ensure you switch off this function before sending the final render.

3: Scroll further down to the V-Ray:: Adaptive DMC image sampler parameters rollout and expand it.

4: Increase the Max subdivs value to about 6. A value of 4 is often okay as it is the equivalent of 16 samples (square of 4). However, due to this scene being a night shot some of the details could be lost in the distance, hence the reason for increasing the Max subdivs to 6.

5: In the Clr thresh function box decrease the value to about 0.003. The lower the value, the better the quality. A value of 0.003 is often good when rendering images at 3000 pixels or higher. Lower image output sizes may require lower values to compensate for the lack of quality (Fig.03).

The Common Parameters Rollout

The next step is to make some adjustments in the Common parameters rollout.

1: In the Output Size group, increase the Width value to about 3000 pixels. Since the Image Aspect and Pixel Aspect functions are locked, the Height value should also change automatically.

2: Click Render to save the irradiance map and the light cache files (Fig.04).

3: Once the pre-rendering pass has ended, the irradiance map and the light cache

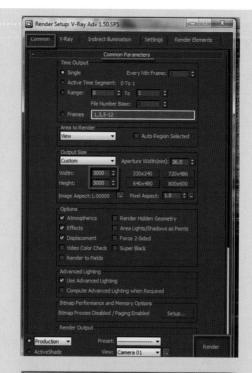

mode should automatically change to From file Mode. Go back to the V-Ray rollout parameters and disable the Don't render final image function (Fig.05 – 06).

Regional Renders

Next you will need to do some regional renders to access the scene.

1: In the Common parameters rollout, change the Area to Render to Region, followed by adjusting the region marquee corners to fit specific areas of the viewport (Fig.07 – 08).

2: Click Render to assess key areas of the scene prior to sending the final render. This methodology is frequently used to detect any possible artifacts that might have gone unnoticed while test rendering at lower resolutions.

The Final Render

Once satisfied with the region renders, change the Area to Render back to View to prepare for the final render.

1: In the Render Output group enable the Save File function and click on the Files toggle to access its dialog box (Fig.09).

2: Name the file "Hero Shot_Night.tga" and save it as a Targa Image file. For this exercise this file format worked perfectly.

3: Click on the Setup toggle to bring up the Targa Image Control dialog box. In the Image Attributes group, turn on the 32 Bits-Per-Pixel format option. This will add more pixel information to the image.

4: Also enable the Compress and the Pre-Multiplied Alpha function. The Pre-Multiplied Alpha option will embed the Alpha channel information into the targa image file.

5: Click OK to close the dialog box (Fig.10). It's worth mentioning that some professionals also use the EXR file format. EXR files are useful because of the variety of different channels and information that can be embedded into the file. However, they can be quite fiddly to open in post-processing applications such as Photoshop.

Render Elements

12 Next, open the Render Elements parameters rollout. The render elements listed in a previous chapter are still loaded, but disabled. Since we already have some of these elements from the previous render, we are only enabling the last three render elements from the list: VRayRawReflection, VRayRawRefraction and VRaySpecular.

It's worth mentioning that once the render elements are enabled, 3ds Max will automatically use the directory path and the **13** file name being used in the Render Output. Finally, prior to sending the final file you can choose to either render as a Net Render or as a Distributed Render, depending on your resources and office render setup. Distributed rendering and net render functionalities have been covered in an earlier chapter. A standard rendering type was used for this exercise.

Once the scene has finished rendering, note the range of useful render elements available for one to tweak within post (Fig.11 – 14). This concludes the chapter. Save and close the 3ds **14** Max file incrementally.

28//Post-Production

This chapter will take you through the process of transforming a good render into an amazing one, by simply implementing some of the best post-production techniques used by top professionals. Most effects will be kept in layers in order to provide users with ultimate flexibility to edit them at any given time.

Furthermore, we will be using some of the previous techniques, layers and masks from the daytime version of this scene to help finalize the image.

It's worth mentioning that in a real production environment, it is possible to make the raw renders extremely similar to the photo reference directly in 3ds Max. However, it's far more flexible and efficient when working with a client to make changes in post-production, as you'll be able to make them quickly.

Let's start by opening the pre-rendered file named Hero Shot_Night.tga (Fig.01). Also open the previously saved PSD file (Hero Shot.psd) from the daylight version of the scene (Fig.02).

Preparing the PSD

We are going to start by duplicating the background layer of the Hero Shot_Night.tga document, as we did in a previous chapter.

> **1**: Rename the new duplicated layer "render" and change its color to red. This will help highlight its importance. It's common practice to duplicate the layers in order to prevent damaging the original layer irreversibly (Fig.03).

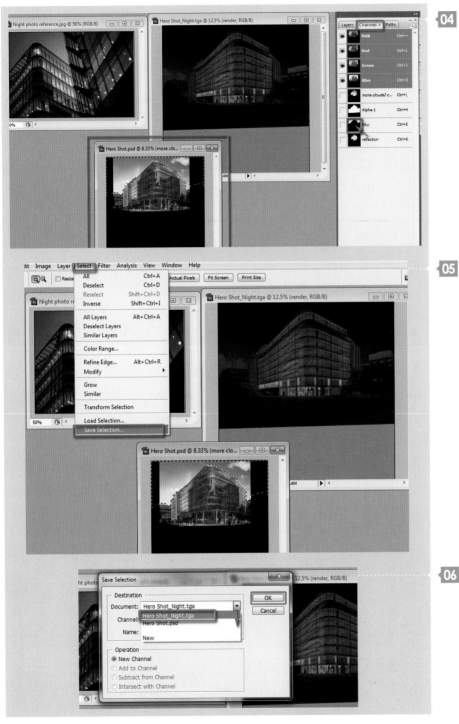

2: Open the file named Night photo reference.jpg. This document will be used as a point of reference to help match some of the render color tones more closely to the photo reference.

Merging the Sky Channel

The following step is to merge the sky channel selection from the Hero Shot.psd into the Hero Shot_Night.tga document.

1: Select the Hero Shot.psd document and open its Channels tab. Enable the Sky channel selection by holding down the Ctrl key and clicking on its thumbnail (Fig.04).

2: Next we are going to save this selection into the main Hero Shot_Night.tga document. Click on Select on the main toolbar and choose Save Selection from its drop-down list (Fig.05).

3: Its dialog box should be prompted. In the Destination group choose HeroShot_Night.tga from its drop-down list and rename it "Sky" (Fig.06).

4: Click OK to close the dialog box. The Sky selection channel should now be part of the Hero Shot_Night.tga document. This is a similar approach to merging layers, selecting the layer's duplicate and choosing the document destination (Fig.07).

5: Select the Hero Shot_Night.tga document and save it as a PSD file (Hero Shot_Night. psd).

Creating the Sky Color

The following step is to create a similar sky to the sky in the photo reference.

1: Enable the Sky channel selection by using some of the steps covered earlier.

2: Back in the Layers tab, select the render layer and add a Solid Color adjustment layer on top of it by simply clicking on its button and choosing it from the pop-up list (Fig.08).

3: The Solid Color adjustment layer should now be created. To adjust its color simply click and hold on its color thumbnail.

4: The Pick a solid color dialog box should appear. Use the Eyedropper tool to pick the darkest point of the sky's color from the photo reference. Click OK to close the dialog box once the color has been picked (Fig.09).

5: Rename the adjustment layer "sky" and change its layer color to blue.

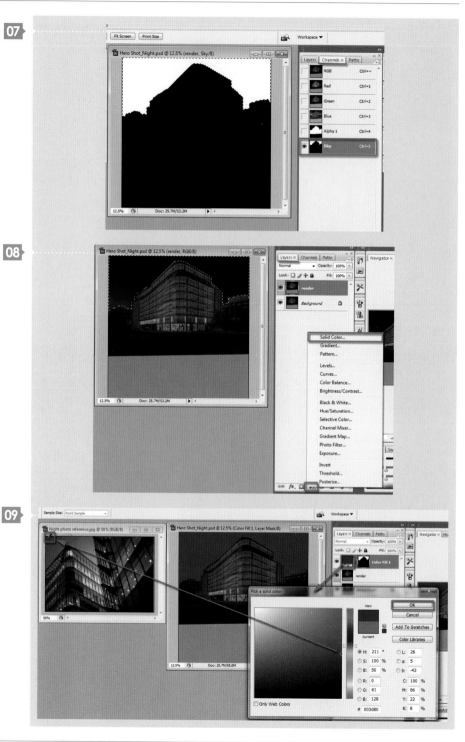

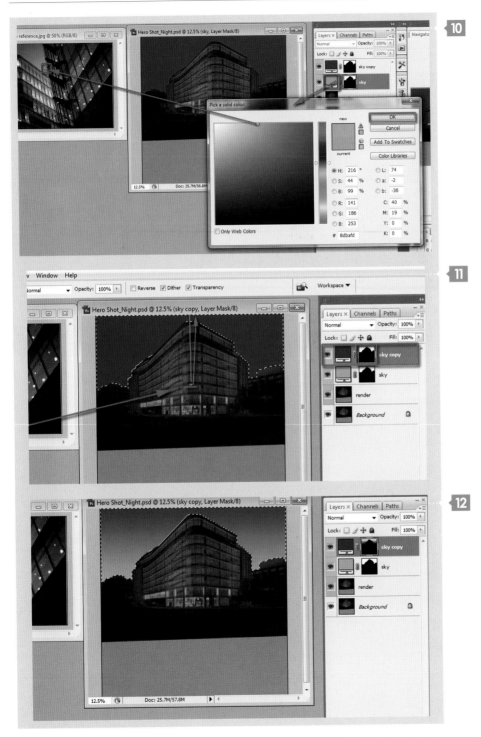

6: Duplicate the sky layer and select the sky layer below. Open its color thumbnail dialog box and use the Eyedropper tool to pick the brightest tone of blue from the sky in the photo reference. We should now have two hues of blue (Fig.10).

7: The next step is to use the Gradient tool from the side toolbar to emulate a similar sky to the photo reference. Enable the Gradient tool and select the channel thumbnail of the sky copy layer.

8: With the cursor, click and drag the Gradient tool from the center point of the image to the very top of it (Fig.11). A nice gradient should now be created (Fig.12).

Matching Colors

The sky colors now resemble the photo reference. The next task is to match the rest of the scene with the blue tones of the sky.

1: While the sky selection is still active, invert it (Shift + Ctrl + I) and add a Selective Color adjustment layer.

2: Its dialog box should appear. To match its blue tones with the photo, set its Neutrals colors to Cyan: + 30, Magenta: + 4, Yellow: + 23 and Black: - 6 (Fig.13).

3: In the Blues colors section set the sliders to Cyan: + 13, Magenta: – 15, Yellow: -1, Black: - 4. Click OK to close the dialog box. Try different values if desired (Fig.14).

4: Rename the adjustment layer "blue tones" and change its layer color to violet. Also move the layer down so it's positioned below the render layer. It makes sense to place most layers below the sky layer (Fig.15).

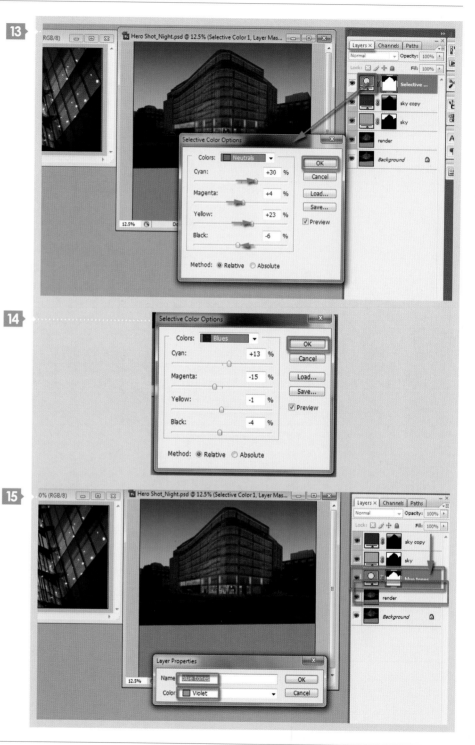

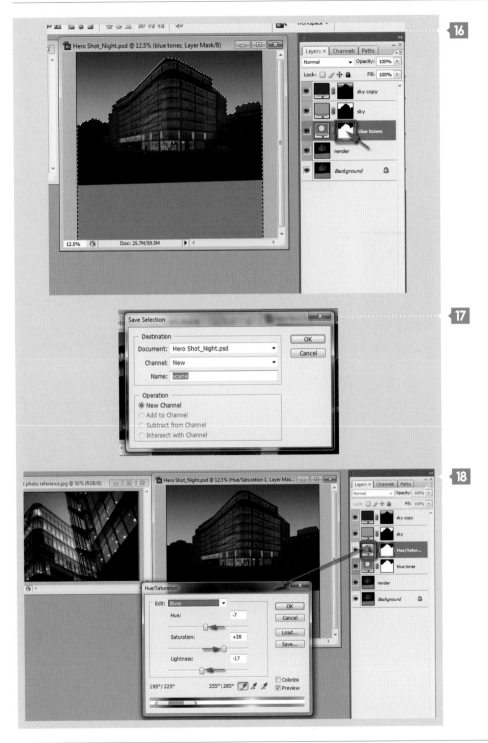

16

5: Reselect the blue tones selection by holding down the Ctrl key and clicking on its channel thumbnail (Fig.16). While the selection is active, save it as a new selection channel by using some of the techniques highlighted earlier. Name the new selection "scene"(Fig.17).

6: Next we are going to reinvigorate the blue and the yellow tones. Add a new Hue/Saturation adjustment layer while the selection is still active.

17

7: Its dialog box should appear. In the Edit group set the Blues to Hue: − 7, Saturation: + 38 and Lightness: - 17 (Fig.18).

18

8: In the Yellows section set it to Hue: 0, Saturation: + 20 and Lightness: 0 (Fig.19). The yellow and blue hues match the photo reference more closely now. Click OK to close the dialog box.

Tweaking the Lights

The next step is to begin tweaking the intensity of the lights inside the building.

1: In Photoshop open the render element named Hero Shot_Night_ VRayRawRefraction.tga. Note in the document how the bright lights of the office floors have been fully captured.

2: Merge it into the Hero Shot_Night.psd document using some of the techniques covered earlier. Ensure that it sits below the blue tones layer and change its layer blending mode to Lighten. Blending modes worked well in this scenario, however feel free to experiment with.

3: Rename it "inside lights" and change the layer's color to yellow (Fig.20). While the intensity of the lights inside the building looks okay, it currently looks too evenly lit to be perceived as realistic.

4: To rectify this we are going to open the render element named Hero Shot_Night_ VRayRawReflection.tga in Photoshop and merge it into the Hero Shot_Night.psd. This fully reflective render element will be tweaked against the inside lights layer to achieve a more realistic effect.

5: In the Hero Shot_Night.psd document, choose Color Dodge as its blending mode and rename it "reflection" (Fig.21).

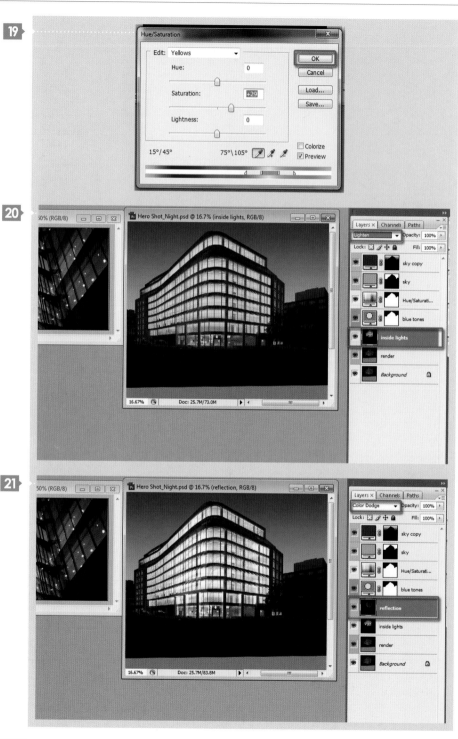

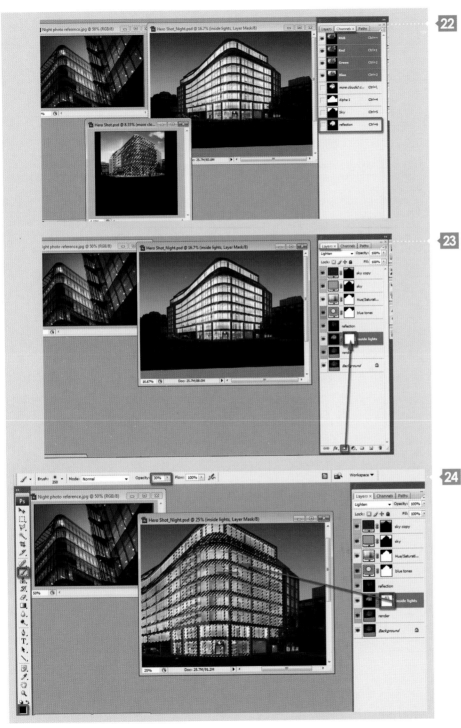

6: Also change its layers color to green and ensure that it sits above the inside light layer. The positioning of the layers in the document is quite crucial, depending on the type of effect required.

Making the Lights Look Less Uniform

Next we will begin tweaking the look of the interior lights using a mask to emulate a less evenly lit building facade.

1: First, select the Hero Shot.psd document and save its reflection channel selection into the Hero Shot_Night.psd document, as previously done (Fig.22).

2: Next, in the HeroShot_Night.psd document select the inside lights layer and add a layer mask to it, as previously shown (Fig.23).

3: Enable the Brush tool (B) and set its opacity value to about 30%.

4: Load the reflection channel selection and begin brushing away parts of the building façade, to make it look less evenly lit (Fig.24).

Color Corrections

The façade is looking more realistic now. However it could benefit from further color correction.

The first task is to color correct the reflection layers.

1: Select the reflection layer to ensure that the next adjustment layer sits above it.

2: Re-enable the reflection channel selection and add another Hue/Saturation adjustment layer on top of it.

3: Before editing it we are first going to link this new adjustment layer to the layer below it. This is to ensure that it doesn't affect other layers in the document. To do this simply hold down the Alt key and hover over the middle line between the two layers.

4: A symbol should appear while you are hovering. It's an indication that you should click there. Simply click on it to link both layers. Both layers should now be connected and you should see an arrow pointing down.

5: Rename the Hue/Saturation layer "less red" and change the layer's color to orange.

6: Open its dialog box and set the Saturation and Lightness values in its Red Edit group to -100 (Fig.25).

7: Set the Yellows Saturation value to -17 and Blues to + 44 (Fig.26 – 27).

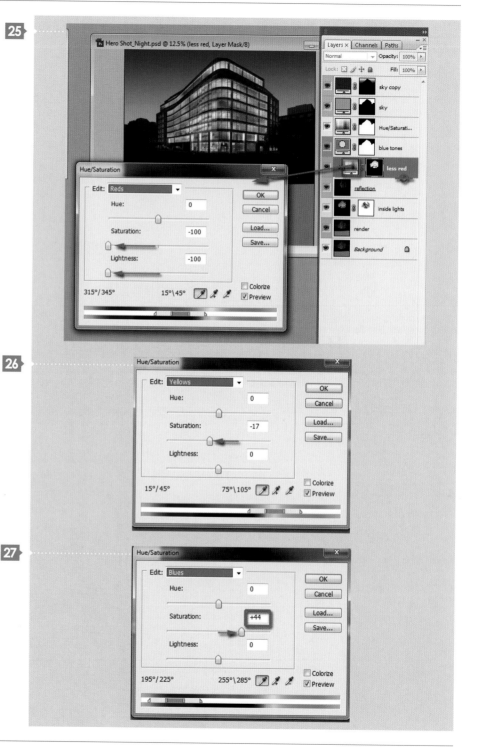

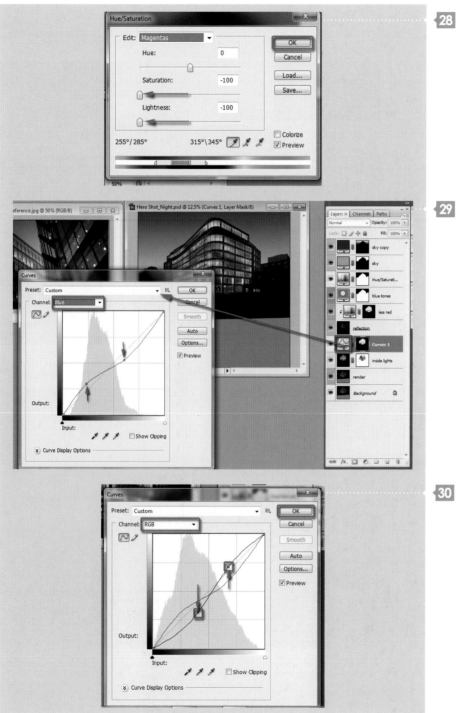

8: Finally, set the Magentas Saturation and Lightness value to -100 (Fig.28). Note in the document how the changes are affecting the glass façade.

Curves Adjustments

Next we are going to add another adjustment layer to the façade.

1: Activate the reflection channel selection and select the inside lights layer, followed by adding a new Curves adjustment layer on top of it.

2: In its dialog box, add two curve points on the Blue channel curve. The first point should go on the upper part of the curve and the second on the lower part.

3: Move the upper point downwards to create a yellow tone to the brightest area of the glass façade. Move the lower point upwards to add blue tones to the darkest areas of the façade (Fig.29).

4: Go to the RGB curve channel and add two more points to the curve and adjust them to create more contrast to the overall glass façade (Fig.30). Click OK to close the dialog box.

5: The next step is to select the inside lights layer mask thumbnail and adjust its appearance to match the photo reference. Use the Brush tool and some of the techniques highlighted earlier to achieve a good result. In the process, try to emulate the fading colors of the glass and the light depicted in the photo (Fig.31).

Adding the Foreground

Next we are going to start populating the scene by adding and adjusting some of the people used in the Hero Shot.psd document.

1: In the Hero Shot.psd document, select and merge the layer named Foreground into the Hero Shot_Night.psd document. Ensure that it sits on top of the less red layer (Fig.32).

2: Create a group layer and rename it "people". Change its color to orange, and select and move the Foreground layer inside the group. Use some of the techniques covered earlier to achieve this.

3: Open the people group folder and select the Foreground layer mask thumbnail. Begin masking away parts of the layer, but not the shop front area of the ground floor and some of the tarmac and pavement detail. Use some of the techniques covered earlier to achieve good results (Fig.33).

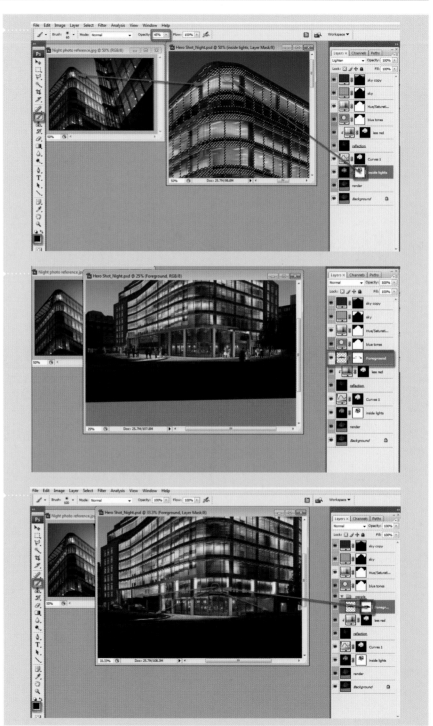

The Clone Stamp Tool

The following step is to use the Clone Stamp tool to replace specific areas of the Foreground layer.

1: Press the S key to enable the Clone Stamp tool from the side toolbar.

2: To begin using it, simply move to the desired area of the layer and hold down the Alt key, followed by clicking once. This is to instruct Photoshop about the area to be cloned.

3: Next, simply move to the area that needs to be replaced and begin clicking and dragging away with the cursor.

4: Replace parts of the people and some of the shadows in the foreground. You can also use this technique to replace other parts of this layer or other layers if necessary (Fig.34).

Integrating the Foreground Layer

The next step is to begin adjusting the Foreground layer to integrate it with the rest of the document. The same approach can be used to integrate cut out people into the document.

1: Select the Foreground layer and add a new Curves adjustment layer on top of it. Do not edit it yet. Click OK to close its dialog box.

2: Hold down the Alt key and hover over the middle line between both layers to see the connecting sign. Click it to connect the layers (Fig.35 – 36).

3: Once you have done that you can begin editing the adjustment layer. Click on the Curves thumbnail to open its dialog box.

4: Go to the Blue channel and add two curve points as you did previously. Begin moving the points upwards to add some blue tones to the layer (Fig.37).

5: Finally, go to its RGB Channel and add a point on a lower part of the curve, followed by moving it down gradually. Note in the document how the layer is blending in seamlessly. Click OK to close the dialog box (Fig.38).

Color Balance Adjustment Layer

The next step is to select the ground floor area in the document and add a Color Balance adjustment layer on top of it.

1: To select it, use some of the techniques covered earlier and in the previous chapters.

2: Once the Color Balance adjustment layer had been created, link it to the Curves layer.

3: Open the Color Balance dialog box and set its values to +34, +9 and - 100. These values worked well, however you can try different values if you like (Fig.39).

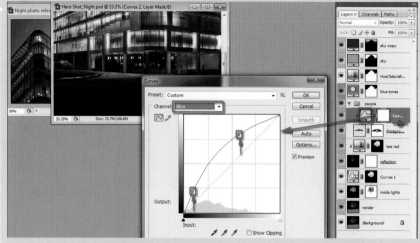
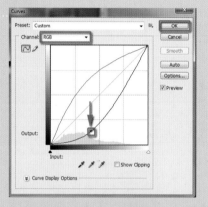
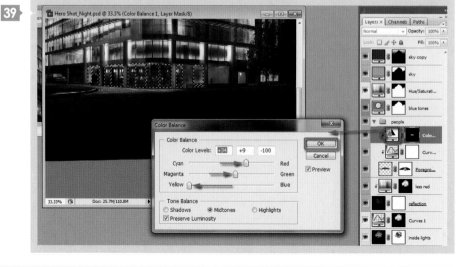

Photo Filter Adjustment Layer

Reselect the ground floor area in the document and add the Photo Filter adjustment layer on top. Add an orange tone to its Color to help integrate the layer with the rest of the document (Fig.40).

Levels Adjustment Layer

To fully integrate the image we should now add a Levels adjustment layer.

1: Once the adjustment layer has been added, link it as you have done previously.

2: Open its dialog box and set its middle Input Levels to about 0.45. Click OK to close the dialog box. While this last adjustment layer made the image look integrated perfectly, other parts of the document have also been darkened (Fig.41).

3: To correct this, reselect the ground floor area in the document and use the Brush tool to mask away the Levels adjustment layer from the selected areas. Note in the document how everything has become fully integrated now (Fig.42).

Adding Additional Layers

To add some sense of scale to the shot and to make it more interesting it is good to add people.

1: Open the PSD files named Lady standing.psd, Couple.psd and lady walking.psd.

2: Merge them into the Hero Shot_Night.psd. Ensure that these layers are inside the people group folder, and above all the previously created layers (Fig.43). If the people group folder becomes too complicated, create a new sub-folder to organize the layers.

3: Begin scaling and positioning the layers while using some of the techniques covered earlier.

4: Next you will need to merge some of the layers from the Hero Shot_Night.psd document. These layers are the Wirecolour, Crop and AO layer. Note how the AO layer has added an extra depth to the shot (Fig.44).

5: Ensure that the AO layer is below the people group folder. In addition, the Wirecolour and the Crop layer should be above all the other layers.

Adding Light Trails

The following step is to begin adding elements that will help make the image look more appealing.

We will start by adding light trails, as they often add a great deal of interest to external night shots.

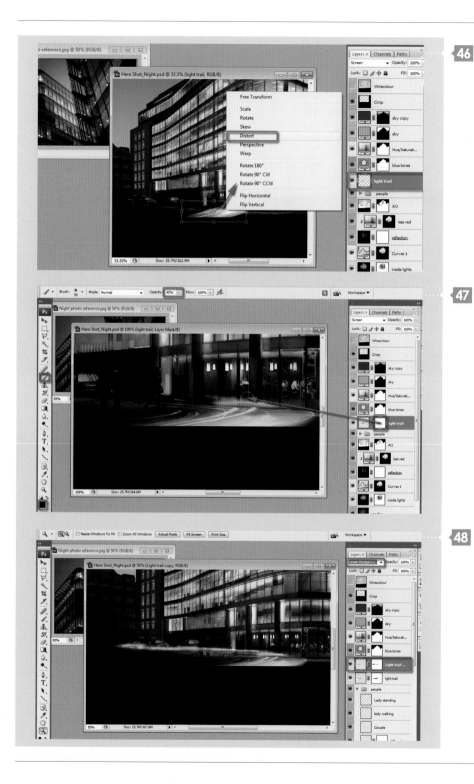

1: Open the PSD file named light trail.psd. This is a nighttime photograph that contains light trails generated by a car's headlights.

2: Merge it into the Hero Shot_Night.psd document and ensure that the layer sits above the people group folder.

3: Use Screen layer blending mode to help integrate it into the document. Also, change the layer color to yellow (Fig.45).

4: Next, we are going to edit the layer to fit a specific area of the document. Enable the Transform tool (Ctrl + T) and right-click to choose the Distort option from its pop-up list (Fig.46).

5: Push and pull the box's handles to make the layer occupy the chosen parts of the foreground area.

6: Once you are satisfied with the results, exit the Transform tool (by pressing Enter).

7: Add a new layer mask to the file and brush away any unwanted areas. Use some of the techniques highlighted earlier to achieve the desired effect (Fig.47).

8: Create another light trail layer (duplicate it) to extend it along the road. Use Linear Dodge (Add) layer blending mode (Fig.48).

Adding Lights to Background Buildings

At night it's common to see lights on in some of the surrounding buildings. The next step is to use Photoshop to emulate this effect.

1: Open the file named window lights.psd in Photoshop. Merge it into the Hero Shot_Night.psd document. Ensure this new file sits below the blue tones layer (Fig.49).

2: Turn off the visibility of the window lights layer and begin drawing around one of the building windows in the document.

3: Create the first selection by clicking and dragging the Polygonal Lasso tool (L). Use Shift to add to a selection or Alt to subtract from a selection (Fig.50).

4: Once the first window selection is created, turn the visibility of the window lights layer back on, then copy the selection (Ctrl + C) and paste (Ctrl + V) it (Fig.51).

5: It now looks as if there is a light on in a window in the background. Rename this layer "Light Glass" and change its layer color to orange. Turn off the window lights layer again (Fig.52).

6: Use this technique to make it look like there are more lights on in the buildings in the background.

7: Ensure that the new window lights created match the camera angle. Otherwise it may look odd.

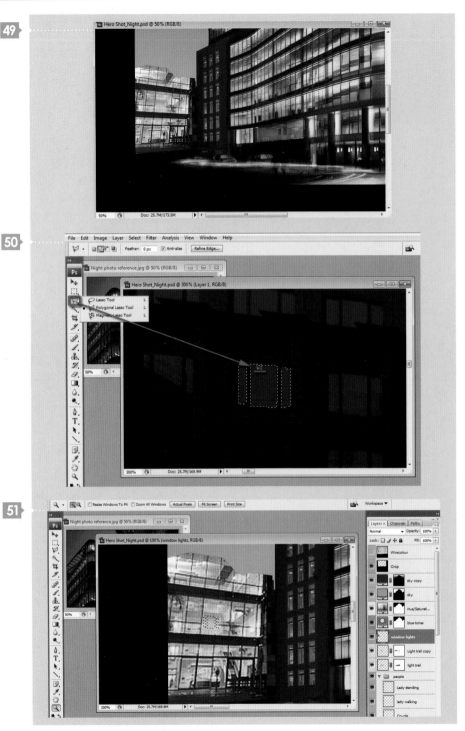

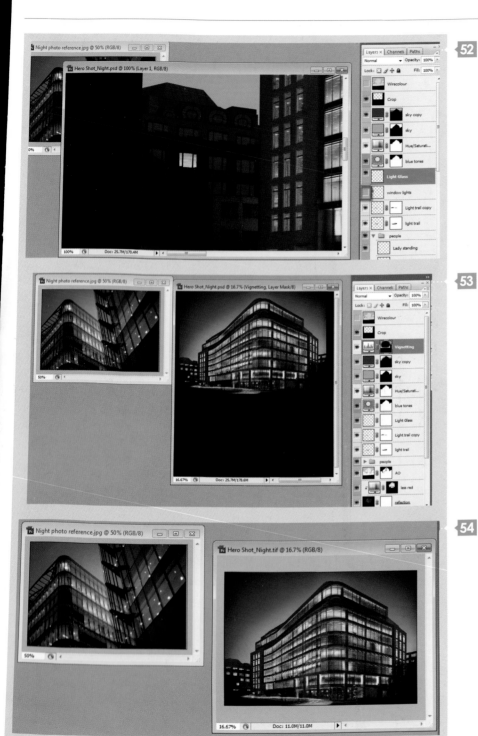

8: Once you have finished, collapse all the new light layers into one by simply selecting all the relevant layers, followed by right-clicking and choosing the Merge Layers option from the pop-up list.

It's worth mentioning that this could be achieved directly in 3ds Max, however it's more flexible to execute these kinds of details in post-production when working for a client.

Final Touches

Finally, create the vignette effect using some of the techniques highlighted in a previous chapter. Re-adjust the sky's contrast if you feel that it needs tweaking. You may also want to take this opportunity to edit or adjust some of the other layers using some of the techniques covered earlier (Fig.53).

Finish the image by creating the chromatic aberration effect and cropping the document using techniques covered earlier (Fig.54).

Conclusion

While every effort was made to ensure all important subjects and techniques were covered in this book, it is simply impossible to incorporate every single one, due to the immense number of approaches that could be used to achieve quality results.

For this reason a logical workflow has been used and demonstrated in detail to provide you with all the tools you will need to come up with similar results. I truly hope you have found the book helpful, insightful and easy to follow.

Index

Photoshop for 3d artists|v1

Enhance your 3D render! Previz, texturing and post-production

"Since I started working in CG I've been looking for a book that teaches everything a 3D artist needs to know about Photoshop and drawing techniques, and this book does that perfectly and even more. I'm learning new things from every chapter. This is a must-have for every professional or student who wants to be a 3D artist."

Rafael Grassetti | Freelance Senior Character Artist
http://grassettiart.com

Photoshop for 3D Artists offers artists the chance to learn from some of the most talented and technically skilled individuals working in the 3D industry today. Featuring the likes of **Andrzej Sykut**, **Fabio M. Ragonha**, **Zoltan Korcsok** and **Richard Tilbury**, this book covers a variety of Photoshop tricks and techniques that will allow an artist to take an existing 3D model or render and turn it into a professional, top-class image. Compositing passes, adding particle effects, improving lighting and color adjustments are just a handful of the featured topics that help to make *Photoshop for 3D Artists: Volume 1* a timeless resource for beginners and veterans alike.

This book is a priceless resource for:

• Matte painters and concept artists for the TV, film and game industries
• Lecturers and students teaching/studying fine art courses
• 3D artists who want to improve their texture and backdrop paintings
• Hobbyists who want to learn useful tips and tricks

Available from www.3dtotal.com/shop

Book Specifications
Softback - 21.6cm x 27.9cm | 224 Full Color pages
ISBN: 978-0-9551530-3-7

3DTOTAL.COM
Visit 3dtotalpublishing.com to learn more about our book range